MAKE
A HOME
OUT OF
YOU

MAKE A HOME OUT OF YOU

A Memoir

Ginelle Testa

SHE WRITES PRESS

Published 2024
Printed in the United States of America
Print ISBN: 978-1-64742-744-3
E-ISBN: 978-1-64742-745-0
Library of Congress Control Number: 2024904177

For information, address:
She Writes Press
1569 Solano Ave #546
Berkeley, CA 94707

Interior Design by

She Writes Press is a division of SparkPoint Studio, LLC.

Names and identifying characteristics have been changed to protect the privacy of certain individuals.

CHAPTER 1

James is the one, I told myself. *I'll die if he leaves me.* Tapping my phone every two minutes, I huffed and puffed every time I didn't see a reply. I'd try to look away from the screen for ten seconds or so, but sometimes I couldn't go five seconds without flipping the phone over again. No text. Not even dots.

We'd been dating for two weeks. We'd hung out twice, once for dinner and once at his house. James and I couldn't have sex because I'd just had a gynecological procedure, electrocuting my cervix to zap precancerous cells that were the gift of HPV. Otherwise, we most definitely would have done it. I actually considered going against the doctor's orders and doing it anyway. Because who waits to have sex?

I had met James—wonderful, sweet, handsome James—on Tinder, but he lived just down the street from me, which I took as a sign we were meant to be. There I was, twenty-six years old, a perfect age to be when you find *the one*! He was in construction, I thought. And our first two dates went so well, I could tell we had a future together.

Tap.

Tap.

Tap.

Nothing, blank screen. My last text to him read . . .

I'm not really friends with men because I'll likely sleep with them or fall in love with them . . . or both.

I think we'd been talking about how he had a lot of female friends in his life. I was jealous and wanted to share why so few men were present as friends in my life. That's totally normal, right, not to have male friends because you can't stop yourself from sleeping with them? Twenty minutes passed. An hour. Then two hours with no response. *Why* wasn't he texting me back?

It was probably nothing. He was probably just busy.

Or was it *something*? Was he already tired of me? Had I done something wrong? I wasn't good enough—that had to be it. Not good enough for perfect James.

I took quick, choppy breaths as I stomped across my apartment, thinking while I paced. I hadn't blown everything by texting something stupid, had I? Something lame? Something weird? Needy? Clingy? *What? What* was it??

I read my text again. And again. It was okay, I thought. Nothing in there made me sound crazy. So *why* wasn't James answering? Didn't he know how much he meant to me?

I was aware this was a routine—being obsessed with the idea of having a future with someone I barely knew—but told myself this was normal. This was what it meant to fall for someone; this was how real relationships started.

I thought maybe I should try to meditate, but the thumping and booming and churning in my chest made it clear there was no way I was going to sit still. I stared at the green meditation cushion on my floor. It seemed to look back at me with judging eyes.

I didn't meditate and instead went to bed.

The next day was a Saturday, and at 10:00 a.m., there was still no word from James. But he and I had made plans. We'd said we were going to hang out on Saturday. Why hadn't he confirmed? By then I was a frazzled wreck of anxiety with a death rattle

throughout my stomach and chest. I couldn't bear the idea of losing him. It would be the death of me—he was *the one*.

I shot him another text.

Hey! What time do you plan on coming over?

Then I sat there in my painted-on makeup and red dress that hugged my curves. For a few minutes, silence. Nothing. I felt the tightness in my chest.

Then I heard a buzz. I looked down at my phone and felt firecrackers going off throughout my body. He answered! Now, after almost fourteen hours of torture, he answered.

To be quite honest, I'm still taken aback by your text last night. I don't know if I want to come over.

I gripped my phone. My eyes darted around the room. My breathing became fast and shallow. I needed him to come over. I was desperate for him to come over. I needed to know that he still wanted me. I had cleaned my apartment. I'd showered and made up my face and put on a sexy dress. He had to come over to be with me!

I tapped and replied.

Do you want to talk about it? I can explain more in person.

I put the phone faceup next to me on the couch and stared at it, desperate for it to light up again.

He replied. *I don't know . . .*

Oh my god, I thought. *Fuck. I messed this up. I have to convince him I didn't mean what I wrote.* Even though I did. I very much did.

I promise there's more to it.

Send.

Then I closed my eyes and waited for the buzz that might give me another minute of relief.

Nothing.

I got up and walked over to the fridge. I pulled out a pickle jar, placed it on the counter, and twisted the lid off. The scent of salty pickle juice wafted into my nose. I reached into the jar, pulled out a pickle, and wrapped it in a paper towel, hoping that focusing on the crunch and the salt would be enough to keep me sane. Maybe eating would help calm me down. Breathing heavily through my nose, I chomped.

My phone buzzed.

All right, I'll come over.

My muscles unclenched and I could breathe again. I sucked in a deep gulp of air, then let it out through my mouth. Deep breaths, as my meditation practice had taught me. I ate the rest of the pickle and went to brush my teeth again.

An hour later, I heard the merciful knock of his hand on my front door. I opened the door to greet him, and the February New England air attacked my face like a swarm of stinging bees.

"Hey," he mumbled and walked in, not making eye contact. The screen door slammed with a *BANG*. I stared at him, but he was gazing down. I reached in for a hug, and he reluctantly gave one back. *I've got to fix this*, I thought. We settled onto my couch about a foot apart, and I fiddled with my hands, waiting for him to say something.

"So, you wanted to talk." His eyes were gentle but squinted. He had his hands on his lap, his fingers interlaced. Each muscle from my head to my toes tensed. I wanted to reach out and touch his hands.

"I mean, I do have male friends sometimes."

Lies.

"Just not all the time."

More lies.

"I don't always sleep with them or fall in love with them."

All of it, lies.

He nodded his head with the corners of his mouth turned down. His eyes met mine for the first time that morning. I leaned in to kiss him on his lips, and he kissed me back. We exchanged a few gentle kisses, then began to kiss with tongue. My hand slipped into his, and I tugged.

"Let's go to my room."

He shrugged, a smile spreading across his face.

Still holding his hand, I led the way to my bedroom, where we both lay down on my bed. I got on top to straddle him, and we began passionately kissing. He put his arms around my back, squeezing. We still couldn't have sex because of my procedure, but I had an idea.

"Take off your pants. I wanna go down on you." I thought this would fix everything. I'd make him feel so good he couldn't live without me.

"Are you sure?" he asked, looking puzzled with his eyebrows bunched together.

"Yeah, totally." As I pulled back my long brown hair and secured it with the hair tie that had been tight on my wrist, he unbuttoned his pants, hesitated, then began to pull them off along with his underwear.

I helped him get them over his feet and positioned myself between his legs. I looked up at his face, and he seemed to be already breathing heavily.

"You okay?" I asked.

"Yeah, yeah, I'm good," he said, smiling.

I looked down at his penis and took him in my mouth. He moaned, and I felt I most definitely had control over this situation. I had the power. He was now mine.

I worked my magic, pulling him in and out of my mouth, switching it up by using my hands with lots of saliva. As he was moaning and grasping my sheets, the anxiety within me

started to dissipate. Everything was going to be okay. I had this.

I was down there for some time before he clenched his whole body and finished inside my mouth. He made one last grunt, and I wiped my lips.

"That was fabulous," he said as I slid back up the bed until we were nearly face-to-face. He lay with his arm stretched above his head and a smile beaming across his face. His peaceful energy calmed me and gave me hope. I slid closer and snuggled up against him.

It worked, I thought. *He's going to stay with me. He's mine.*

We hung out for a while and made small talk, but within a half hour, he left.

The text came within the hour.

I'm sorry, Ginelle, this just isn't going to work. I think you have some work to do on yourself.

His words hit me like a punch in the gut. It felt as though I was breathing through a straw. My eyes darted around the room as I thought of something, anything, I could say to make him stay with me. I came up short. Feeling defeated, I decided not to text him back. Nothing was going to get him back. I sighed. Then my thoughts sprinted to the real hell behind what just happened: I'd now have to be alone again.

Single again? No way. I grabbed my phone and re-downloaded Tinder, Bumble, and Hinge. I'd show him.

I spent the next few hours swiping through pictures of people of all genders, starting conversations, and making plans. James had rejected me (in a text!), but in under a minute, I'd started looking for my next pair of lips, the next lap, the next loving arms. As usual, I was desperate to try to make a home, somewhere, anywhere. I was searching in other people for a loving

place to live, preferably forever. I wanted someone to provide me with the safety, warmth, and love that a house filled with people was supposed to provide. I never wanted to feel like I was out in the cold, alone. That was my worst nightmare. I wanted to be bundled in someone's arms by their fireplace, with them holding everything together for me. I thought this would make me feel whole, which was a feeling I was often missing.

"Ginelle!" My mom shouted at me from upstairs. I was in eighth grade, and I'd just walked through the door after getting off the bus. *Oh man, here we go*, I thought.

"What?" I spat under my breath and shuffled down to my room, hoping she wouldn't follow. I flicked on the light and suspended my breathing.

She flew down the steps and leaned against the frame of my door. She jutted her finger at me. "I don't appreciate you smoking weed in my house. It's not going to happen again." At five foot six, she was only a couple inches taller than me and a rail-thin one hundred pounds. I was scared of her anyway.

Rolling my eyes, I finished taking off my jacket. It had been a long day at school because I was getting bullied—girls threw little shreds of paper in my hair in music class and called me weird. We weren't all that different, so I never knew why they bullied me. Maybe they were just mean girls.

All I wanted was to go onto my computer to get into chat rooms and find some connection. But my mother just stood there, snarling. I knew she wasn't going to punish me, because she rarely did, but I didn't need her down here, darkening my life even further.

"We already went over this," I said, averting my gaze and pretending to look for something in my bag. "It's not even your house. It's Jack's." I was referring to my stepdad; their

relationship was rocky. I commonly jabbed low blows at my mom to hurt her feelings. She threw a lot of jabs herself.

"Don't talk back to me, you ungrateful bitch!" As she screamed, the blood boiled up her face to the top of her ears.

"Whatever," I said, shaking my head. She leapt from the doorframe and grabbed my arm with one hand and my throat with the other.

My eyes bulged as her blonde hair hung over my head. She grabbed my face and dug into my skin with her long stiff nails.

"Lettt goooo!" I grabbed her shoulders and pushed, but the damage was done. Blood trickled across my cheek. "Asshole," I muttered as I wiped it on my shirt.

"I'm not fucking around. Don't do it again." Then she turned around and marched upstairs as if she hadn't just slashed her own daughter's face. I slammed the door and stared at it for a moment. I wanted to cry, scream, run, and hide all at the same time.

My chest burned as I jumped onto my computer and pounded in the address of the gaming website I'd gone on for the past year. I went into the chat rooms and messaged a random guy.

nellietnh: *Hey, wanna trade gold for a nude webcam peep?*

I was thirteen years old.

aliensRreal3: *Um, YES*

We negotiated the amount of gaming gold he'd pay me and hopped onto video chat.

Slipping off my cherry-red bra strap, I glanced at the webcam with a sly smirk. At first, I held my hands over my chest. My blood pumped as I imagined the thrill on the other side of the screen. Perhaps an older man—in his thirties, his jaw dropped, a smile across his face, touching himself. His camera was off while mine was on.

I slid my pants off and my panties, then started to grind my couch to create the image that I was humping someone. I

continued to tease the unknown stranger for a few more minutes, feeling the tension from earlier leave my body each time I shimmied my hips. This tease continued for about five minutes, then I blew him a kiss and shut off my camera. Right away, I could feel my jaw was no longer tight. My shoulders dropped a few inches, and relief flooded my system as I felt more relaxed than I'd felt all day. Someone being there with me, wanting me, somehow made everything better, even though I wasn't actually turned on. I was just putting on a show for gold game coins and attention. I feared too much talk, so before it got more heated or he started to say anything more to me, I typed into the chat:

nellietnh: *Now that u got ur show, please transfer the gold to my account.*

aliensRreal3: *Yes ma'am, god ur hot.*

This man and all the others I'd cammed for wanted to see my body, and I enjoyed the attention. I was used to feeling ugly and unlovable, so these guys—probably creepy old weirdos—made me feel good about myself. To them I was hot, hot enough to pay for. But by then anorexia had dug its claws into me, leaving me feeling fat no matter how thin I was. And I was thin, about 105 pounds and five foot two.

Webcamming for game coins was the solution for both making myself feel better and getting in-game money. By this time, I'd been hanging out in forums and chat rooms with teens and adults for two years. I'd seen the conversations people in chat rooms had about sex and saw the attention men paid to women. Men seemed to worship women on this website, showering them with attention and compliments, so I thought, why not get in on that action?

On the website, I played games to earn coins, which I used to buy outfits and accessories for my anime-like avatar. I dressed her up to talk in forums, complementing her big seductive eyes with things like delicate angel wings or a sparkly blue wand.

After gaming and camming for a few hours, I called my maternal grandmother, Nana. She was my saving grace. I spent every other weekend with her as a kid and still called her regularly as a teen. She was my support system whenever I needed her, which was frequently. I'd call her when things went south with my mom.

"Hey, Nana."

"Hey, Nell. How's it going? I miss you. Haven't talked to ya in a few days."

"I miss you, too." I picked at my cuticles. "Things are pretty shitty with Mom."

"Oh no, what's going on?"

"She just yells at me for everything." Anger roared inside me, then began to release like a pressure valve after telling Nana.

She paused. Then she asked, "Have you ever heard of the Serenity Prayer?"

"No." I wasn't one for praying, but I knew it was a big part of her churchy life as a Catholic. I could feel my breathing grow calmer.

"It goes like this: 'God, grant me the serenity to accept the things I cannot change, the courage to change the things I can, and the wisdom to know the difference.'"

"I like it," I told her. "I think I get it." I was open to hearing her prayers because I loved her so much. And though I didn't much believe in God or Catholicism, I mentally pocketed the prayer for later.

●

The physical violence from my mom didn't get bad until I became a feisty preteen, unless you count that time in fourth grade. My Nana and Papa, my mom's parents, were coming over

on a Saturday afternoon, and my mom was speed-cleaning our house, which was a disaster of dishes, unfolded laundry, crumbs, and sticky spots on the counter. I was reading *Harry Potter* on the couch, not helping, when she shouted at me.

"Fuck, are you going to help or not?"

I shrugged, continuing to read my book, annoyed that she was interrupting me.

"Ginelle, you need to help me clean this house."

"Ugh!" I shouted as I slammed down my book and crossed my arms.

Mom grabbed me by the shoulder of my shirt and tried to toss me toward the kitchen. My feet caught on the rug, and I stumbled backward and smashed my head on the edge of the hardwood coffee table. I heard a loud bang and then instantly felt a sharp searing pain in the back center of my head as if I had been hit with an axe. My vision was blurred as I slid my fingers up to my head, where it throbbed, dripping wet. I looked at my hand and saw it was smeared with dark red blood, and that's when I shrieked.

"Oh my god," Mom blurted out.

I cried and tried to stand up, smearing blood on the light blue carpet and stumbling in a dizzy haze.

"Be careful, be careful. Here." Mom grabbed a towel and placed it on my head. "Put pressure on it. We need to go to the ER, *now*." Then she hurried me out of the house. "You need to tell them you tripped, which you kind of did. I didn't mean to hurt you." I nodded, whimpering with pain but understanding what I needed to do.

I didn't get to see Nana and Papa that day.

I told myself at the time that it was a one-off accident, and nothing like it happened again until years later. And although in those later years there were a few incidents of physical abuse,

the persistent emotional abuse was much worse. She constantly made fun of me for being a klutz, and screaming was her tactic to deal with conflict between herself and me and everyone else in the family, especially her husband, Jack. One time, I watched in fear and awe as she flung steaming mac and cheese right from the pot across the kitchen at him.

To be fair, Jack was an asshole. He would constantly make fun of my mom and belittle her by calling her a crazy bitch. She went through severe depression and had multiple back surgeries that left her debilitated. He was rarely home to help, and when he was, there was always a screaming match with someone's clothes getting thrown outside.

I lived with my mom but talked to my dad on the phone several days a week, and I saw him most weekends. As I grew to be a teenager, I wanted to be around my family less and less, especially the people on my dad's side. My dad was a drug dealer, so we never talked about what he did for a living, but I'd known about his dealing since I was about five, when I had an inkling his dozens of plants that smelled like skunk weren't like the basil plants my grandmother snipped from to flavor our pasta sauce. And I knew that every time we went to see his friends, he wasn't just "handing them CDs."

My dad also was a DJ by night, so I just told friends and curious people who asked that that was what he did full-time. I was embarrassed that he didn't have a "real job," but he always bought me what I wanted, like the newest Juicy Couture purse or the newest tech devices that he said, "must have fallen off the back of a truck." I didn't really care where the stuff came from, but I knew enough not to tell anyone that he'd gotten a discount because they were stolen. In my mind I made excuses for him. This was just how he was. He had a rough upbringing. He wasn't doing anything *that* illegal. My mom and I never talked

about my father's "professional life" because I felt embarrassed and ashamed that he was a dealer, like maybe I shouldn't have been aware of something like that, like my knowing dirtied me somehow.

Dad called me one day after school.

"Hey, Nell," Dad said. Most of my family called me that.

"Hi, Dad. How's it going?"

"Good. How's school for you?"

"It's okay. I'm doin' all right. How 'bout you?"

"Good, going to see Nana soon." He was talking about my other grandmother, who I wasn't close to but saw on occasion.

"Maybe I'll come."

"All right, I'll pick you up Friday. I got a bunch of Red Sox shirts. I'm selling them for ten bucks a pop, and I'm making bank, you know. Driving around and selling them to people at the dentist, Dunkin's . . ."

He sometimes rambled about shit I didn't care about, usually one of his schemes. I set my phone down on the shelf in my room and went over to sit in my comfy padded rocking chair to start up my computer, and he just kept droning on through the speakerphone.

I didn't say a word for at least five minutes.

Eventually, I walked back over to my phone and interrupted him. "Dad, I've gotta go. Love you."

He was affectionate and caring—mainly through buying me whatever I wanted and actually listening to me on the phone when he wasn't scheming. He'd ask me about my life and celebrate with me when I had accomplishments—like good grades in school. Though he tried hard to act like a father by contacting me regularly, he lived in another state. After my parents separated, my mom had moved with Jack to New Hampshire.

Jack regularly took off for weeks at a time for "bike weeks" in Florida, leaving Mom alone at home. Deklan and Cara were my two half-siblings, and both were younger than me. We shared a mother, but Jack was their father, so in this household, I was kind of the outsider. I was never entirely treated as a member of the family as much as a somewhat-related person.

One wintry day when I was about thirteen, Deklan was eight, and Cara was five, Deklan was revving the engine of his four-wheeler, a machine he'd been riding since he was three. My sister was too young for her own four-wheeler, so her dad rode her around on his. I sat, bundled up in snow pants, boots, a hat, and gloves, playing in the snow alone.

"You can use Deklan's after he's done," my stepdad said, nodding at me. I wasn't particularly good at riding those kinds of things, probably because I wasn't allowed to use them very often. My mom didn't participate much in the outdoor antics. Instead, she was a big gamer, and often played games like *Final Fantasy* on her PlayStation. I turned to my games, too, when I felt left out.

●

As I was getting more comfortable showing myself to strange men online, I was hitting rock bottom in my relationship with my body. I was a skinny little thing, but in my mind, I was fat and unlovable. When I looked at myself, I saw legs the size of baby seals, full of blubber. I saw arms that, when pressed against my hand, squished out like giant mushy pancakes. My stomach had a Jeep tire around it. Even my face looked puffy.

I did everything I could to stay as small as possible—restricting calories, exercising like a maniac, and obsessing about my body at all times. I'd grown to feel that an ounce of fat on my

body meant I was failing and wouldn't be as hot to men online or to real-life boys in my future. And that would mean I was worthless.

One morning, I grabbed two granola bars for breakfast instead of one because I was starving. On the way to school, I sat on the bus, fumbling with the bars' packaging and berating myself, thinking, *You disgusting fucking pig. You cannot eat like that.* Smelling raspberry calories through the wrappers, I tossed them in my bag. I ate no granola bars that morning and instead leaned forward and pinched at the imaginary fat on my body, daydreaming about the gnawing hunger pains burning off the fat. Every time I looked in the mirror, I wanted to shatter it with my fist.

While most of the time I was disgusted by my body, when I was in front of the camera for men, I felt desirable. In those moments, I thought I looked like the women I followed for thin-spiration on Tumblr and in magazines, women like early-2000s icons Paris Hilton, Nicole Richie, and Lindsay Lohan. I desperately wanted to look like them, and when I was performing for men, I thought I did look like a gorgeous celebrity, but when I went back into my real life, I was unlovable and ugly again. The attention I got from the internet guys made me feel better about myself, but if anything, it fed my disordered thoughts and actions because I wanted to be perfect. And that pursuit of perfection nearly killed me. The yearning to be thin seemed to have no end. My weight dropped to "underweight" according to the BMI. I now weighed barely one hundred pounds. It didn't matter that my bones were protruding at my hips and my legs were tooth-picks. I was a whale, and I wanted to shrink myself into nothing-ness. I thought the smaller I made myself, the more lovable I'd be.

"Bullshit!" I shouted to Brandon after he slammed down three cards and said, "Three fours." He was one of the skater boys from my eighth-grade class. I leaned more on the "cool" side at school once I got rid of my glasses and got contacts but hung out with pretty much anyone who would drink with me. One Saturday night, my friend Natalia and I were drinking with Brandon and two of his friends at his house. The house was littered with beer cans, and his mom was upstairs but didn't care that five thirteen-year-olds were drinking at her house. I tended to surround myself with people whose parents didn't care, like mine.

"Aw, man," he said. "Got me."

The round continued. Every few minutes, I'd lift my beer and take a gulp. I held my cards in my hands but flopped over so much after several drinks that I almost splayed them on the table for everyone to see. When it was my turn, I tossed a nine and a six face down on the pile and said, "Two sixes." I burst out into a giggle.

"Bullshit," called my curly-haired friend, Natalia, who'd been adopted from Brazil by American parents who also ignored what she was doing. She and I had been drinking together for the past few months, but this was our first time doing it outside her room.

I looked up at her, continuing to giggle. "You got me. I'll drink to that," I slurred. I lifted my beer and took an enormous gulp, spilling some on my sweater. Under the sweater, I

was wearing a tight black strapless dress, which I usually wore because it was slimming. The dress ended mid-thigh. I had worn revealing clothes because we were going to be around three guys, but I wasn't actually into any of them. That didn't matter. It was important for me to be attractive to any guy, anywhere.

After a few more rounds of Bullshit, I got bored of the game and stumbled down the stairs into the basement, where I flopped down on a tattered couch riddled with large brown stains. Then I dozed off.

I was in my sleepy drunken bliss until I awoke to someone's hand inching up between my legs. Startled, I managed to move my head enough to see it was one of Brandon's friends, who I didn't really know. He wore a baggy gray Nike sweatshirt and jeans that hung halfway down his butt. His fingers slipped inside me, but I was too drunk to do or say anything.

What is happening? Oh my god. I groaned. I couldn't move.

My hands shook as I wobbled in and out of consciousness. *What should I do?* I wondered. I wished he would stop.

"Dude, what the fuck are you doing? Get off her," Brandon said. The kid pulled his fingers out of me, and I felt his hand slide away from between my legs.

The creep said, "What? She likes it."

"She's trying to sleep, man. What the hell is wrong with you?" I couldn't see what was happening, but the kid got up and left me alone.

I thanked the heavens for Brandon, the skater boy, but I still couldn't move or talk. He covered me with a blanket.

The next morning, I massaged my pounding temples, lifted the blanket, and looked down to see that my dress was still on my body. Phew. Then I remembered what had happened, which caused me to lean over and throw up on the unfinished

basement floor. I felt violated, and anger erupted in me like a volcano.

Natalia and I were recovering later that day at her house, chugging water and lying in bed. I felt like I was floating outside my body, disconnected from myself. My body wasn't safe, and it wasn't mine. It was my first time experiencing this sort of violation, making me think boys were only safe far away on the internet. I wondered if I should tell her but worried she'd think it was my fault.

It took all my strength to roll over off my back and face her.

"So, something weird happened last night."

"Yeah?" she said, still lying on her back with her eyes closed.

"One of Brandon's creepy friends stuck his hands between my legs when I was sleeping. I was too drunk to do anything."

Natalia jolted her eyes open and sat up. "What?"

"I know, I don't know. It was weird." I closed my eyes but felt Natalia inch toward me.

"That's fucked up, dude. How long did it go on for?" My eyes stayed closed, but I knew hers were on me. Holding back tears, I swallowed hard.

"For a few minutes, but Brandon ended up stopping him."

"He's a good guy."

"I guess, I mean, that guy shouldn't have been fucking touching me."

The next day, I thought about what had happened, and I knew I'd been violated. The overwhelming feeling was as though I'd stepped out of my body and was within arm's distance of it. Being inside of it was just too painful. I kept walking somewhere in the house, then forgetting why I was there and how I got up the stairs.

The floating-above-my-body feeling lasted over a month.

A few weeks later, Natalia got her hands on a pack of caffeine pills, and we decided to give them a go after school. She was a few pounds heavier than me but wasn't as interested in weight loss as she was in getting messed up from the pills. Neither of us had taken them before, but we'd heard the high would be fun. Natalia was as much of a troublemaker as I was, so I loved hanging out with her. She made me feel that my chaotic behavior—drinking and taking caffeine pills—was normal and okay.

When she brought them out, my eyes lit up as I fantasized about how much weight they'd help me lose that day. This could help me drop maybe a whole pound or two. I wasn't just aiming to lose weight, though. I also wanted to get messed up to escape these constant thoughts of not being enough and having a mess of a life.

She popped two pills out and handed me one.

"Just one?" I grumbled.

"Okay, yeah, you can have more. Let's start with two." She handed me a second pill. I swallowed them both.

Hmph. It didn't seem like enough. "All right."

Fifteen minutes went by, and we were sitting cross-legged on the grass. Not feeling anything yet, I looked up at the sky and groaned, "Can I have more?"

"Okay, how many do you want?"

"Three more."

"Three? Ginelle, we don't know what these things will do to us." I felt invincible and scoffed at the idea that something bad could happen to us. I'm not even sure whether I minded the idea of dying.

"It's cool. I can handle it." More pills meant more weight loss.

"All right, suit yourself." Natalia shrugged, rolled her eyes, and popped three more pills out of the foil packaging. Gulping them down with water, I was more than ready to get high on five caffeine pills.

Before long, my whole body began to shake. My heart was beating a thousand miles a minute, and my eyes widened. Standing up, I waved my arms and twirled in a circle. The high was way beyond anything coffee ever did to me.

"Woo! This is awesome," I said. "Let's go on the trampoline."

Natalia had a huge smile across her face. She bolted up, and we dashed over to the trampoline. I jumped up and down as the caffeine coursed through my bloodstream.

After hopping around for a while, we lay on the trampoline, and I thought the netting that bordered the trampoline was spinning. I took a deep breath, taking in the New Hampshire forest smell around me, and became hyper-aware of how fast my heart was beating.

"I-I don't feel good." I sat up and jumped to the opening of the trampoline net. My stomach churned and my throat constricted before the taste of vomit filled my mouth.

"Ah shit, are you okay, dude?" Natalia asked, resting her hand on my back.

"Ughhhh," I groaned as I continued puking. *This is awful*, I thought. *But worth it. I'm puking up my lunch. This is good*, I told myself. But it certainly didn't feel good.

"I told you we didn't know what these things were gonna do. We should have been more careful." She sighed and couldn't help but let out a giggle. "I'm gonna get you some water, I'll be right back." Natalia got off the trampoline and ran inside.

My head hung off the trampoline as my stomach twisted and turned. *It's worth it, it's worth it*, I tried convincing myself.

In the following days, I thought little about my actions. I welcomed the throwing up if it meant weight loss and getting high. Both of those things made me feel I was a more interesting and worthy person, as the weight loss made me feel like Paris and Nicole, and the high made me feel like I could live on Pluto for a few hours, light-years away from my troubles. In those moments, I was okay.

●

When I wasn't experimenting with caffeine pills, I got my hands on alcohol. Directly outside Natalia's room at her house was her parents' massive bar, which they rarely touched. That meant there was always a ton of liquor at our fingertips. That summer before high school, at age fourteen, my drinking began to take off. And so did my interest in real-life boys. A few were coming over that night, including one I liked. His name was Matthias, and he was a year older than me. He loved four-wheelers and dirt bikes, and he rarely went to school.

"What's it going to be today? Gin? Whiskey? Schnapps?" Natalia asked.

"Schnapps!" I said. Though they all tasted equally disgusting. At least this drink tasted like banana.

When it came to calories in alcohol, I never worried about the pounds I might gain or the fat that might form. I thought only of getting messed up and being drunk when the boys arrived, as it'd make flirting easier. It made existing easier.

As the first gulp hit my tongue, a sweet taste with a bite burned from my throat to my belly. My worries slipped away as the liquor sunk into my body.

"More?" I asked.

"We can't drink too much, or my mom will notice. Let's drink some whiskey, too, so we're not taking so much from one bottle."

I shrugged, blissfully unaware of what happens when you mix alcohol. I wanted more.

Natalia got up and went out to the bar to grab the whiskey. I grabbed the schnapps before she even left the room, and once she left, I unscrewed the bottle and gulped.

My stomach clenched, and I coughed up a storm.

Natalia came back into the room as I fumbled to put the cap back on the bottle. "Ginelle! What are you doing? Dude, I told you we couldn't drink more of that. What the heck?"

"It's just a sip. Relax."

"Whatever." She grabbed the bottle and held it behind her back.

As the liquor flooded my bloodstream, I could feel a huge smile overtaking my face. "This. Is. Awesome." My body began to feel warm and cozy, and my worries about my body slipped away.

She set the bottle on her side table and stretched out on her bed, her head leaning against her headboard. I thought, *I should apologize to her*. So I rested my head on her lap and said, "Sow-wee, I shouldn't have done that." Natalia laughed.

"Whatever," she said, "not a huge deal. Just don't do it again."

I looked up at her and realized I wanted to kiss her. The only kiss I'd ever had was a dare on a trampoline with a kid in my neighborhood a few months before this. It was only a quick smooch, nothing particularly interesting. But now I wondered what it would be like for my and Natalia's tongues to swirl into each other's like I'd seen in movies. Although I was drunk, I wasn't drunk enough to try it. I told myself that'd be weird because you're not supposed to kiss your girlfriends. So why did I want to?

Alcohol. Alcohol had become the foundation for my life. It was how I unwound, connected, and felt the closest to myself. It was probably the best friend I ever had. I didn't want to stop drinking her parents' alcohol; I wanted to keep drinking as much as possible.

I did, however, quit camming for guys on game websites. I had my sights set on a real-life guy and decided I was done with creepy men in chat rooms. It was now a few weeks before my freshman year of high school, and I was hoping I'd lose my virginity to Matthias. I was also dreaming he might become my first boyfriend. It didn't matter to me which came first.

Matthias and two of his friends tapped on Natalia's back glass door, which connected to a porch with stairs down to the backyard, perfect for sneaking boys in and out. By the time they arrived, I was already stumbling and slurring. We were careful not to make too much noise as we slipped out of the house, then we walked about ten minutes into the woods and lit a bonfire out of the wood and kindling the boys carried with them. We were in the middle of the New Hampshire forest, so we assumed no one would find us. The boys had brought a thirty-rack of Bud Light.

When no one was looking, I poured half my warm beer onto the ground so people would think I was drinking more than I was. I preferred hard liquor because I could quickly take a shot and feel the effect, but we hadn't brought any.

Natalia also had a crush on Matthias, but she nuzzled up to one of his friends. I snickered internally, thinking, *I'm going to be the one who gets him tonight.*

About an hour into us all hanging out, I found my way onto Matthias's lap, and we began kissing. The scent of his Axe body spray enveloped me, and I pushed into him harder. I felt no shame in making out in front of his friends and pretended his mouth didn't taste like Bud Light. I felt like we were in a rhythm

and maybe I was doing okay, despite it being my first real kiss. He took my hand and pulled me behind a tree, then pulled out a condom, waved it, and smirked. I giggled and said, "Here? In the woods?"

"Why not?"

"Okay." I was nervous, but it was also a dream come true.

I pulled my jean shorts down around my ankles, then lay down on sticks and leaves while he got on top of me. He pulled his pants and boxers down in one swoop, slipped on the rubber, then spit on his hand and rubbed it on the condom. Matthias's back was faced toward the fire, and we were far enough away that shadows overtook his face. I bit my lip and grasped the dirt and foliage next to me with one hand. My other wrapped around his back as he glided toward me. He slipped his penis in and leaned down to kiss me. Then he started pumping in and out, and I could actually feel myself tearing inside. He felt way too big for the space.

I bit my lip in pain but didn't want to tell him because I thought that would be uncool and might ruin the moment. We were making out like crazy while he continued to push in and out of me. It got a little more enjoyable, but it still stung. Suddenly, we heard Natalia shout, "Oh shit!"

We heard multiple footsteps crunching leaves and saw flashlights. Scrambling to pull his pants up, Matthias bolted before I could process what had happened. I pulled my shorts up from my ankles and hurried after him.

"Hudson Police, stop!" shouted an angry man as I booked it through the woods.

Fuck, fuck, I thought. *I'm gonna get busted*. Why did Matthias run? What an asshole. And ow, it hurt. My vagina and my heart. My feet pounded the ground, and the pain worsened as I ran. By some miracle, I didn't trip on anything. I must have been

running for five minutes before I finally got to Natalia's backyard. I'd lost the police.

It was a close one. I burst through her door, the last one there, and they all had bug eyes.

"You good, dude?" Natalia asked.

"Yeah," I panted, trying to catch my breath.

The cops didn't knock on the door, and we settled into her room. She slept in her bed with the friend, the fifth wheel slept on the floor, and Matthias and I snuggled up on the couch in her room. I was pissed at him for leaving me but told myself to forget about it. We spent the night entangled in each other's arms. The following day, he kissed me and left.

I gave him my number that night, thinking he'd text me the next day to tell me how much fun we had, but my phone remained quiet for days, then weeks. No text. No boyfriend.

I went into ninth grade feeling used and abandoned. Again, I experienced that floating outside of my body, feeling like a dirty, used rag. I was mad at myself for being duped but equally mad at him. It turned out boys in real life sucked as much as boys on the internet. I'd now interacted with all ages of boys and men on the internet, and had come to believe that all they wanted was sex, too.

My first encounters with men and boys by age fourteen gave me little hope for the future. Would men always use me? Was that all I was good for? Being a sexual object?

CHAPTER 4

Selena lived down the street from me, and we had become friends because we rode the same bus to and from school. Her mom was as laissez-faire as mine in that she let Selena do just about anything and was rarely home, which left us free to get up to all sorts of shenanigans, like piercing our own ears, exploding plastic-bottle bombs made from toilet-bowl cleaner and aluminum foil, and sneaking out. I loved that we had the freedom to do whatever we wanted. It made life more fun.

Selena had more manic energy than I did, which was a lot. It was her idea once that we amuse ourselves by shoving our arms and legs through the sleeves of a couple of sweatshirts. We stuck our heads out of the top holes and looked like doofuses, waddling and kicking around, screaming and laughing. Goofy, crazy ideas like this were common with her.

Both of our houses were dysfunctional. Her dad was always screaming, and I was terrified to be there when he was home because if I had eaten something or left a dish somewhere, he'd scream at Selena about me while I sat there, horrified. My house was full of screaming, too, just not so much when Selena was there. My mom reserved that for just the family.

●

Of course, the first time I invited a boy over to my house, I had to have my best friend there, because why would I ever do something

alone at age fourteen? This time, I was hoping to make a real con-
nection that wasn't based on sex. I craved a relationship like I'd
seen in *The Notebook*. In the movie, there's a scene where Allie,
watching some birds on the beach, says, "I'm a bird!" To which
Noah replies, "If you're a bird, I'm a bird." I wanted to be like two
people so in love they called each other birds. I wanted to make
a home out of this boy. But I was way too scared to pursue a real
boyfriend alone, so Selena came along.

Diego, a boy from school, handed my bus driver a note from
his parents that said he could come to my house after school via
our bus. Diego was a year older than me, a sophomore who had
moved to New Hampshire years earlier from Peru, so he had an
adorable accent. He was in my study period, and I had a crush
on him. We'd started a conversation, and the idea of hanging out
after school came up after some weeks.

Now, I walked down the aisle and heard the rumble of the
bus engine. All eyes on me, a girl with a boy in tow. I had a hot
sophomore with me who was brilliant but not too nerdy. Diego
was also on the soccer team, so I thought he was hip.

I sat on the seat, and he squished in next to me, smelling of
some sort of fancy woodsy cologne. When our elbows pressed
against each other, I felt an electric pulse throughout my entire
body. I wanted to jump on him and tear his clothes off. I'd had
my first sexual experience with a boy, and I was ready to do it
again. Now, part of me regretted inviting Selena. I reminded
myself I was trying to get a boyfriend, not just sleep with him,
and I tried to calm myself down.

Selena sat in the seat in front of us, and on this day, she was
quieter than usual, but I didn't think much of it. All I saw was the
dark-brown flowy hair Diego had going that flipped out at his
ears, topped off with a backward Yankees cap. Swoon. I tried to
ignore the Yankees part. I was a New Englander, after all.

The fall breeze from the open window hit my face as I fantasized about what the rest of the night would look like. Would we kiss? Would he be my boyfriend? Was my room clean enough?

Selena, Diego, and I got off the bus. We went inside, and the house was empty. I wasn't sure where my mom was, so we went downstairs to my room.

Diego made himself comfy on my bed as I was still taking my shoes off, and I felt my heart beat faster. A boy in my bed. A real live boy. And he wasn't paying me.

Selena sat on the couch while I plopped down next to Diego. "Wanna play video games?" I asked.

"Absolutely," Diego responded.

Firing up my PlayStation, I grabbed a controller for myself and handed the other controller to him. Selena was left out. "You can play next turn," I told her.

"Okay," she said.

We played *Crash Bandicoot* for about forty-five minutes before I handed Selena my controller.

"About time," she grumbled.

I noted her grumble but quickly forgot when Diego pressed his leg against mine, and the impact of the touch was even more powerful than the elbow touch on the bus. I bit my lip.

We continued to play video games but didn't talk much. I kept hoping he'd want to know more about me or that he'd lean in and kiss me. Either one was okay with me. I wanted to get to know him, but I was too nervous to ask questions, so I left the ball in his court. Instead, we just kept playing video games. There was an awkward silence that Selena tried breaking up, "Well, it's my turn to crush you, Diego!" We giggled, and the silence that followed was painful. All we could hear was the smashing of crates in the game.

He left soon after.

The following day, we had study hall together. I waved and just got a head nod before he lowered his eyes to what he was doing. My hopes for our relationship sank down to the bottom of my stomach. I wasn't sure if Diego was disappointed that I didn't have sex with him. Maybe he thought I wasn't that interesting. Maybe I forgot to put away a moldy bowl. But he stopped talking to me at school. He avoided eye contact with me when we passed each other and ignored me in study hall. He ghosted me, and the rejection reinforced my belief that something was wrong with me. I thought about whether I should just go back to camming. At least I got consistent attention there.

My crush passed angrily, and I had a new target with hopeless abandon: Anthony, a boy from my math class. We started chatting in class, and he asked for my AOL Instant Messenger (AIM) screen name. He was a grade above me, a sophomore, with beautiful brown shaggy hair that he wore under Boston sports caps. I had a type.

●

Selena and I sat at her computer, eating pickles from the jar, even though her mother often yelled at us for demolishing a whole container at a time.

I got a ping and clicked my messages. There was a message from the screen name "apacballin," Anthony.

I wanted to be in a romantic relationship with him, to be his girlfriend. I thought maybe, just maybe, he'd be my first boyfriend. I desperately wanted one, as I thought it'd prove that I was lovable and that I could feel the kind of love people experienced in the movies. That kind of love that would make someone willing to die for the other person. Maybe that kind of love would feel as good as drugs. Maybe this time, the guy wouldn't suck.

apacballin: *hey there. hows it goin?*

Letting out a squeal, I raised my eyebrows at my friend.

"Dude," Selena squealed back, "Anthony messaged you!" She was leaning in, just as delighted as me.

nellietnh: *its going pretty well. hanging out with selena. you?*

I tapped my foot and waited for his reply. Selena munched on a pickle.

apacballin: *just got in from hangin out with nate*

nellietnh: *coolcool. not sure what selena and i are up to 2nite.*

I leaned forward in my chair, getting closer to the computer screen. Looking over at Selena, I said, "What if he asks me out?"

"Maybe," she shrugged. Selena and I were dressed in loose T-shirts and shorts, as it was a springtime afternoon. I'd have to change if he wanted to hang out. What would I wear?

apacballin: *nice well i think im gonna grab some dinner. ttyl*

nellietnh: *okay :)*

"Ugh, what the hell? Why didn't he ask me out?" I clicked hard on the Sign Out button and crossed my arms.

"I'm sorry. Boys are lame. Wanna go outside?"

"Yeah, let's do it. Fuck boys."

Soaking in the afternoon rays in her yard, I spotted a red canister of gasoline her father used for the lawnmower. I had a penchant for burning things, and now I'd just been rejected. Again. I was ablaze with energy that threatened to burn the whole town down.

My mind raced. *Why doesn't Anthony want me? Why don't guys ever really want me? Only online guys seemed to, but that's not the real me.*

An idea struck me. "Do you have any matches?"

Her eyes followed my gaze across the lawn to the red plastic can sitting against the shed.

"Ha, all right, I'm in." She ran inside to grab the matches, and I marched the gas can to the street like I was on some kind of action movie mission.

I did a little dance in anticipation and thought we could make a massive fire. It was going to be so exciting. It was going to mean a spark of joy in my life, entertainment for at least a moment.

My fingertips tingled with excitement, and I wiggled my toes while I waited for Selena.

She brought out the matches, and I picked up the container. My breathing was fast. "Ready?" I poured the gasoline all across the street, from one end to the other, some splashing on my shoe, and I thought for a moment that my shoe could catch fire. Then I shook off the thought. The street was a spacious side road in New Hampshire that only residents traveled on, so we weren't worried about traffic. We also weren't worried about the rows of thick pines surrounding us because we were far enough away from them, at least we thought.

Standing a few feet from where the gasoline shimmered on the black pavement, I grabbed the matches from Selena, pulled one out, and lit it. I threw it on the gasoline, and *POOF!* The gas streak erupted into flames four feet high. They danced and shot around; they seemed to be coming for us as they danced toward our faces. The flames were hot on my skin, and for a moment, I thought I'd been burned.

Both of us dove backward in a panic. I landed on my butt on the rough pavement, scraping my bare legs and arms as the thick smell of fire pierced my nostrils. I looked down at my body and then Selena's to take stock. We weren't burned. But the fire was starting to creep down the street toward the trees.

"Fuck. Fuck! FUCK!" I shouted. Selena ran to grab the hose, rushed back, and started spraying water on the blazing inferno.

"It's not working!" she yelled.

"I have an idea!" I yelled as I sprinted to the porch, grabbed a wet gray towel near the bubbling hot tub, ran back, and tried slapping the fire with it.

"There's no way that works!" Selena shrieked, but the fire was getting smaller.

A pang of regret went through my belly, but I was also holding back laughter.

"Is it working?" I shouted. "I can't tell."

"Holy crap, I actually think it's working." Selena dropped the hose and burst out into laughter, and so did I. Soon, we were laughing so hard we could barely breathe. I laughed so hard my stomach hurt. I'd never played with fire so intensely before. We'd barely evaded death, and now we were roaring about it.

"Okay, okay," she said, her eruptive laughter quieting, "let me grab another towel."

Selena went to grab another wet towel near the hot tub. Then she sprinted back to the street and slapped at the fire until she smacked it down to the tiniest flames.

"I can't believe that worked." Selena's chest was heaving. We both took a step back. Fortunately, we had lit only the pavement on fire, so there hadn't been much of anything for the fire to catch onto.

My laughter turned to panic as I noticed the flames had charred the pavement. The streak of black must have been eight feet long and a foot or two wide. There were splotches of black everywhere on the street.

"We are so screwed," Selena whispered.

I burst out into nervous laughter. "Screwed." Selena let out a big belly laugh herself.

The fire was out, so we went back inside.

"Why did I think that was a good idea?" I asked as I let out a sigh. I sat on her living room couch, peeping at the door every few minutes, terrified for her mom to come home.

"What are we going to do?" Selena paced back and forth across the room. It was about four o'clock, and her mom got home at five.

"I don't know. Our parents are going to kill us. I have to go home to eat dinner. I'm not saying shit until your mom calls."

"Ugh, this is a disaster." She blew up her cheeks and then slowly let the air out.

"I'm heading out. Best of luck." I made a "yikes" face and headed for the door.

"Shit, you too." Selena shrugged.

Where the hell did I get the bright idea to torch the street in our quiet little neighborhood? Was I really trying to create in life the charred feeling I had in my heart? Was I hoping I'd get in trouble just so someone would pay attention to me?

I hopped on my bike and rode the ten minutes home, hoping the stench of gasoline and fire might somehow evaporate off my clothes. The sun was setting, and so were my hopes for not getting punished. My mom was going to be pissed. Had I done this out of anger over Anthony not asking me out? What a jerk. It was his fault.

When I arrived home, I booked it downstairs to change my clothes and stressed myself out with my absolute certainty that my mother was going to murder me.

I tapped away on my computer, surfing websites out of anxiety and sending the occasional *eek* to Selena on AIM. I looked at the clock every ten minutes. An hour passed. Then the phone rang, and I cringed.

Storming down the stairs, my mom shouted before arriving at my door, "*What the fuck* did you guys do, Ginelle?"

I bolted over to my bed, then awkwardly sat down, readjusting my legs and rearranging my hands on my lap. I looked down at the carpet, avoiding her gaze. "I'm sorry!" I shouted before she got to my room.

She reached my door and gripped the frame. I thought a vein was going to pop out of her forehead. "'I'm sorry' isn't good enough. You could have killed someone. Or yourself. *Or burned the whole fucking neighborhood down!*"

I looked up at her for a moment, then looked down again, frozen in place. "I know. I don't know what else to say other than sorry." I felt more sorry about being caught than I did about almost setting the whole neighborhood on fire.

She leaned in, sticking her head in my room. "How about you don't pull that ever again? You're grounded. Two weeks. You can't see anyone."

"Okay." I sighed. I didn't protest. I didn't even say anything snotty in reply. It was the first time she'd ever grounded me, and I knew it could have been worse. But I was just glad she wasn't taking my computer away. I couldn't handle not talking to Selena.

We talked the next day.

panda53192: *dude! i'm grounded but can still use the computer and phone. wut about u?*

nellietnh: *THANK GOD. i still have the computer and phone, too. 2 weeks grounded. jeez, did our parents decide together what our punishments would be? lol.*

panda53192: *guess so hehe. have u talked to anthony?*

nellietnh: *ugh, no don't remind me.*

panda53192: *whatever. stupid boy.*

nellietnh: *YUP.*

Since I got to keep my computer, I spent a ton of time on AIM talking to friends. I was still mad at Anthony, but after I got a message from him, that annoyance slipped away. He messaged one day after school. I was about a week into my grounding.

apacballin: *hey punk.*

My eyes brightened as I let my guard down.

nellietnh: *heeey*

apacballin: *i was wondering, would you wanna go bowling on friday by any chance?*

A squeal escaped my mouth. *It's happening!*

nellietnh: *i would love to, but I'm still grounded. could we aim for next Friday? what time? selena will probably come if that's cool.*

Since I brought my best friend everywhere, it was only natural she'd come on my first actual date. And I needed her to help quell my nerves. Maybe this date would be better than that first one.

apacballin: *i'll pick you both up at 8. shoot me your address.*

I replied and logged off. Then I sat on my chair for a moment, dazed. My arms hung down by my sides, and my head tilted back. I let out a sigh of relief. *This is friggen awesome. Maybe I'll actually get to have a boyfriend!*

Selena and I talked on the phone later that night. "So, Anthony finally asked me on a date."

"No way. Dude. That's awesome. Congrats."

"I know, I can't believe it. I told Anthony you were coming." I waited for Selena's response, assuming she'd say yes, but not entirely sure.

"Hell yeah, I'll come."

Selena and I got ready in my cramped bathroom with "Wannabe" by the Spice Girls blasting from my computer in the room across the hall. Selena raised her arms in the air and sang the lyrics. I rocked my body back and forth to the song, pausing only for a moment to put on glittery eye shadow in the mirror. It was 7:30 p.m. on a Friday, and Anthony was coming at 8:00.

Selena and I had made it to the other side after two weeks of being grounded. We hadn't gotten in any more trouble beyond the groundings our parents gave us (that is, no run-ins with the law).

I winged my eyeliner in the mirror, making a mess and having to redo my left eye. "I'm so nervous," I said.

"Dork. Don't be. Anthony obviously likes you." Selena smiled and elbowed me. "He's been all up in your AIM grill."

"I guess you're right." I slid a black V-neck T-shirt over my pink padded bra, choosing the slimming color, again, and sucking in my stomach because it felt bulging, despite the fact that he could have scooped me up with one arm. I continued to be self-conscious, especially when it came to boys, and especially because they kept fucking rejecting me.

I thought, *Maybe if I'm just hot enough, just thin enough, he'll like me.*

A few minutes later, Anthony rolled up and took up most of my driveway with his dingy, rusty old Cadillac. Selena and

I hopped in the car, me in the front, her in the back. Gatorade bottles, water bottles, and fast-food bags littered the floor, and a musty smell came from the seat. Hmm, so maybe not as hot as I'd originally thought.

When I looked over at smiling Anthony, who leaned way back in his seat, I forgot all about the mess. He wore tan cargo shorts, a Celtics jersey, and a backward black hat that rested beautifully on his amazingly shaggy hair.

"Mr. Jones" by the Counting Crows played on his shitty car radio, and, helping myself to the dial, I blasted it. He grinned, raised his eyebrows, and nodded, clearly impressed by my music taste. We drove to the alley bopping our heads to the music.

When we arrived, he offered to leave his license and credit card with the cashier.

"That's so sweet of you, thanks." I beamed. *He must like me.*

"Well, neither of you youngins have licenses, do ya?" Anthony teased. He'd just had his sixteenth birthday.

Feeling my face turn red hot, I grabbed my shoes and darted toward our alley.

As Selena typed our names into the console, she elbowed me and lifted her eyebrows up and down. I giggled and pushed her back.

She was up first and rolled a six. Next, I was up. Anthony returned from registering our lane and said, "Go get 'em," with a thumbs-up and a grin.

I only knocked over four pins, but Selena high-fived me anyway. Her presence did quiet my nerves. Anthony rolled a strike. God, he was perfect.

While Selena was up again, Anthony picked up my street shoe off the floor and tossed it into the trash, saying, "Ballin'!" I smacked him on the shoulder, then retrieved the garbage shoe.

"I'm sorry, that was mean." Anthony frowned and looked down at his own shoes.

"That *was* mean," I said, tilting my head. "It's all right," I mumbled. Even though his joke wasn't nice, it didn't strike me as a red flag.

We finished bowling, and I was grateful I'd brought Selena, as she felt like a buffer for my nerves. On the ride back, "Cute Without the 'E'" by Taking Back Sunday blared through the speakers as I kicked my feet up on the dashboard. Anthony hammered his fingers on his steering wheel as if performing a full-blown pop-punk concert. Selena and I adored TBS, so we screamed to the song along with him. We continued like this all the way home.

At a red light, Anthony suddenly turned down the music and looked at me. "Hey, wanna keep hanging out?"

"Yeah, totally," I answered. "Selena, is it cool if we drop you off?"

"Oh, okay," she said quietly.

I had no idea how disappointed she was. At that moment, again, all I saw was Anthony.

We dropped Selena off first. She mumbled a good-bye and then shut the door with a thud. Looking out the window as she walked away, I bit my lip and made a humming noise under my breath. *I'm alone with him!* I thought. *Oh my gosh.* I turned to him to hash out the plan. It was past 10:00 p.m., and there was no way my mother was going to let him come over that late.

"So, you're gonna have to sneak into my house. I live on the bottom floor, and you can come in through the window. I've snuck out before pretty easily."

"You got it. I'll park down the street and be super quiet."

"Okay, see you soon," I said. He nodded, smiling when he dropped me off. I wanted to hug him, but it seemed weird. I

strolled down my driveway, casually at first while he was in view, then did a little dance when I saw his taillights.

My mom didn't generally greet me when I got home, so I wasn't worried about her coming in. When I got into my room, I threw the moldy bowls, silverware, and cups that littered my room into my closet. I'd snuck out of my room before, but hadn't snuck anyone in. Now I felt like a badass.

I opened my screen and left the window open a crack. Within a few minutes, it creaked open, and Anthony wiggled his way in. I thought everything was going well, then—*CRASH!*—he slid down onto the bureau next to the window, knocking my jewelry and headbands to the floor. I froze for a second, worried my mom had heard and would be on her way downstairs in a second. But there was no sound upstairs. Anthony's hat fell off, and he struggled to straighten his clothes after tumbling in.

He dusted himself off, and we giggled. I put my finger up to my mouth and showed him where he could take his shoes off. Anthony was chewing gum, so I thought he must be planning to kiss me.

"I didn't take you for a Taking Back Sunday fan. What else are you hiding from me?" he whispered, and smirked. *I don't know*, I thought. *That I'm terrified? That I think you'll leave me immediately? That I think you only want sex? That I'm fucking fat and ugly?*

"Guess you'll just have to wait and see." I nudged him with my stomach churning.

Relieved that I had made my bed before he came in, I gestured toward it. "Want to watch something?"

"Sure," he said, and made himself at home by jumping on the bed. I followed his lead and then flipped through the channels and ended on a cartoon we watched for a few minutes before his arm grazed mine. The scent of his Abercrombie cologne made

me lose my breath. I looked at him and saw kindness in his eyes. He had stopped teasing me and instead leaned up and kissed me softly, sharing his minty lips.

I pulled back for a moment, giggling, then leaned back in. I couldn't believe this was happening. Pressing against Anthony's wet lips, I placed my fingers on his cheek, brushing against his hair, my thumb under his chin. I pulled him toward me, and his tongue found its way into my mouth.

He's being so sweet, I thought. *Maybe he won't leave.*

We kissed, then he gently pulled away. He must have seen the concern crinkled on my face as I wondered if he'd leave.

"Ginelle, you know I like you, right?"

"You do?" I perked up.

"Duh," he laughed, pushing some hair out of my face.

"Okay, I believe you." But I still thought he was going to leave, like everyone else. I kissed him back ferociously to prove myself and will him into staying. He lay back on the bed as I straddled him. He started to gently tug at my shirt, and I helped him take it off. Then, my bra. He smiled up at me with a big grin, and I thought this wasn't a bad idea. Right? I wouldn't get my feelings hurt.

I got off him, then we shuffled the rest of our clothes off, and I lay back on the bed. He fumbled with a condom he pulled from his wallet.

He managed to get the condom on and then stretched himself on top of me. I spit in my hand and rubbed it on him to get the condom wet, and he opened his mouth to let out a moan. Soon after, he was inside me, ramming himself in and out. I had had sex only that one other time, so I wasn't sure what the speed was supposed to be, but was pretty sure Anthony was going too fast.

"Slow down," I giggled, grabbing his bare hips on both sides.

"Oh," he laughed awkwardly, "sorry."

As he slowed down to a pace that felt good, I wrapped my arms around his back, beginning to get into it. I wondered if he'd meant it when he said he liked me or if he'd leave after we finished having sex. I closed my eyes and moved with him for just a few seconds before I felt him tense up, grunt, and roll over.

Again, I wasn't sure how it was supposed to go, as I'd never watched porn, but was pretty sure it was supposed to take longer.

"Sorry," he groaned again.

"All good. That was fun." I laid my head on his shoulder.

I paused, nervous. Then I said, "We should do it again sometime." I stared at the ceiling, afraid of making eye contact because I felt stupid.

"Yeah, of course, Ginelle."

Breathing a sigh of relief, I fell asleep in his arms, cuddling naked. The next morning, he left early before my mom could find him.

●

That night with Anthony turned into many more. We had moments of passionate kisses, beach trips with friends, and adventures like going to theme parks. It was really sweet, and so was he. He treated me like a princess, making me feel like the home I was building in him was solid.

But Selena slowly stopped calling me, and I stopped calling her. I missed her, but I was distracted by the boy in front of me. Finally, a guy had stuck around, and I was going to do everything in my power to make sure it stayed that way.

Sometimes I saw Selena on the bus, and we'd make small talk, but eventually, we began sitting in different seats. On the days I didn't ride the bus, I drove to school with Anthony.

Although we were young, Anthony and I had many sleepovers in my room. His parents rarely wondered where he was, as his dad was a drunk and his mom was a pothead. My mom didn't allow sleepovers with boys, but she also didn't check to make sure I wasn't having any.

When I discovered that sleeping with boys could make me feel safe, I wanted to do it every night. The feeling of Anthony's warm body pressed against mine eased my nerves and chronic anxiety.

Anthony became my first real boyfriend at the end of my freshman year in high school. A few months into dating, I was getting comfortable with him. I'd gotten to the point where I didn't care if he saw how chaotic my life was or how messy my room was. Moldy bowls and spoons stayed scattered on the shelf, my dirty clothes littered the floor, and there was cat hair all over my couch. As my household was pretty careless in regard to cleanliness and parenting, I grew up feeling careless, too. And all my disordered eating had also led to a brewing depression, which made me care even less about order and tidiness, so silverware and bowls sometimes cluttered my room for weeks or more at a time. My mom would yell at me to clean, but there wouldn't be any consequence for not cleaning, so I'd ignore her.

Four months into dating, Anthony and I were hanging out in my room when I said to him, "Selena is pissing me off. She said I'm obsessed with you." Selena had gossiped about me, and word had gotten back through Natalia.

"Hm, we should do something about it. Her family has money, right?" We lay tangled on the bed.

"What are you suggesting?" I raised my eyebrows and rolled my head toward him.

"Let's rob her house." He gave a tilted smile and pursed his lips.

"Rob her house?" I asked, genuinely confused.

"Yeah, we could pawn what we find and look for cash."

"I mean, I guess." *What the heck?* I thought. This didn't sound like an idea that was going to end well, but I went along with it, although I didn't know why. I suppose I was worried about losing his love if I didn't go along with his big ideas.

"When is the best time to rob her?"

I knew that Anthony frequently robbed people. Right around this time, he had just barely escaped getting caught stealing from someone's locker at the YMCA. I thought it was funny and bold to do to strangers but wasn't thrilled at the idea of robbing someone I knew. Selena and I weren't close anymore, but she was still my friend. I went along with it anyway. I helped my new boyfriend plan to steal from the home of the girl who had been my best friend.

"I know the code to Selena's house. We could go after school when she has track practice?"

"Let's do it."

My stomach cramped as nausea rolled through.

●

A few days later, we parked on the street next to Selena's house, away from the neighbors' view. I knew that her parents would be at work. Selena was at track practice, and her brother was at school. I clenched and unclenched my fists as we crossed the grass of her backyard, trying unsuccessfully to calm down. I had so many memories of this backyard: good times in the hot tub, lighting the street on fire, and laughing our heads off.

What was I thinking now?

We snuck around the back, and my fingers trembled as I typed in the garage code for Selena's house. The garage door opened, and

the noise startled me, even though I knew it was coming. Anthony was leaning over my shoulder, waiting for the door to open. We had no plan, except to grab as much shit as we could.

He stormed in and I followed. Anthony ran up the basement stairs and opened the door to the living room. I wanted to back out, but I kept going forward. It felt like I'd just dropped down a roller coaster, my stomach in my throat. I walked into her place, which was as familiar as my own home. I trudged up the stairs behind my boyfriend and followed him to Selena's brother's room, littered with clothes and games. Anthony found the kid's Xbox and shoved it into a bag with as many games and controllers as he could grab. I poked around the kitchen, nausea wrecking my stomach as I felt boiling remorse over everything we were doing. I then found a coin jar and grabbed it. *This is so fucking stupid*, I thought. *What am I doing?*

Oh well, they'll never know it was me.

This is so wrong.

It will be okay.

What garbage I am for doing this.

She's being a jerk to me about Anthony.

This is so wrong.

Anthony found twenty dollars in Selena's mom's room, and I said, "Can we go now? What if they come home?" I knew they were all away, but I worried anyway. I couldn't face any of them, not like this.

If they caught me, I'd have to see the shame on their faces.

I'd have to look Selena in the eye and say, "Yes, I did this to you, my old friend. I robbed you."

I'd have to watch as her ten-year-old brother came home to find that his most prized possessions were gone.

I'd have to watch her mom burst into tears as all the trust was broken.

"Fine," Anthony grunted. "But we didn't get that much. We can pawn the Xbox."

We left out the back door and slinked to the car.

Right away, we went to a pawn shop in the same town we'd stolen from and successfully sold the Xbox. When we walked out with the cash, I felt the guilt roll up my stomach into my throat, making me want to vomit.

"Let's spend the day in Boston!" Anthony suggested.

I nodded eagerly, as we might as well get out of town.

On our ride there, I got a call from Selena's mom. She was bawling.

"Please tell me it wasn't you, that it was someone else."

I paused. *Fuck*, I thought. *Fuck, fuck, fuck*. I hadn't really considered that I'd have to face Selena's mother. Or anybody else. I thought we'd just get away with it.

"I saw you guys on the pawn shop camera, Ginelle. Why did you do it?"

"I'm s-sorry," I said. What more could I say? All the years Selena and I spent together, down the toilet. I thought back to our silly sweatshirt game, the fire we lit together, our times on the bus, all the sleepovers, and all the laughs. It was all gone. For what? Sixty dollars between the twenty from her room and the Xbox? *Man*, I thought, *I'm an idiot*.

"I'm not going to press charges, but you are no longer welcome in my home," Selena's mom said quietly but sharply. We hung up, and I held back tears.

●

On the school bus, Selena didn't speak to me, wouldn't even look at me. *Thank God I have a boyfriend*, I thought. Otherwise, what

would I do with my grief over losing my best friend? After that, I threw all my attention into my relationship with Anthony. I had a couple of friends that I hung out with occasionally, but I spent most of my time with him.

There was something toxic about Anthony that I couldn't quite put my finger on. It was more than the robbery. I had a feeling he was bad for me, but I didn't listen to that feeling. There was an edge to Anthony, a negativity, and following him into his deceitful plan was like walking down a dark alleyway: it stressed me out, but I kept walking to get to the end. I knew it was a bad idea, but I stuck around because it was thrilling and validating to have someone love me so much.

The Monday after the robbery, Anthony walked up to my maroon locker at school and said, "Hey, babe."

He glanced down at what I was wearing and stopped talking. I was sporting a pair of gray yoga pants that perfectly shaped my butt. "When did you get those pants?" He looked solemn.

"Last weekend with my dad, why?" I shuffled books in my locker.

Flushed, he pulled me close to my locker and whispered, "Ginelle, you can see your whole butt."

"Okay?" I smirked. I was pretty pumped about it. I looked hot.

"People are going to see you." He looked around, then glared at me.

"Okay. Whatever, I'm headed to class." I slammed my locker door and walked away, fully aware of how good I looked from behind.

After that day, my yoga pants mysteriously went missing, never to be found again. I internalized this to mean that my boyfriend's passion and fierceness reflected how deep his love went for me, and that made me love him more.

We spent as much time together as possible, isolating ourselves from all our friends, and that was fine with me. Once I had "love," I never wanted to be without it again.

●

Before I met Anthony, I had been making a home in booze, but when I met him, he became my home, and I felt high from having someone in my life who loved me. I was still drinking or using drugs about once a month, but it wasn't a big part of our relationship or my life. Booze was hard to come by at age fourteen because I didn't know anyone who could get it, so I often used other substances that were easier to get my hands on, like canned air desk cleaner from a friend's parents' office.

One of my friends, Jill, and I were at her computer when she said, "I heard you can huff dust cleaner and get high. Wanna try it?" Jill was a troublemaker like me who lived on my street. She was a year younger but even bolder than I was.

"You know I'm in." We shuffled to her room, her gripping the bottle.

We got up on her bed and sat crisscross applesauce, facing each other.

"Who's gonna go first?" I asked.

"You do it," she giggled, handing me the bottle.

"All right." I wanted to play it cool, but I was trembling. "How do I do it?"

"Just press the button and suck in through the straw," she smirked.

"Okay, here goes nothing." I sucked in as hard as I could, and within seconds, black spots expanded and shrank in my vision, and my hearing went in and out as I heard Jill laughing.

"This is awesome!" I said, hearing my voice as if it was a gargled Charlie Brown voice. The high lasted about ten seconds.

She stuck her hand out. "My turn." Jill grabbed the cleaner and huffed immediately. "Woah!" she shouted. "Holy crap." She slammed it down and lay on her back, laughing.

"Right? It's wild." We passed it back and forth a few more times, murdering God knows how many brain cells. Like with Anthony, I knew this was bad for me, but I really didn't care.

●

Six months into being with Anthony, my disordered eating was at its peak. I was still a teeny little thing, barely one hundred pounds at five foot two. One day after school, I made him stop at the grocery store so I could grab a whole roll of cookie dough. In the days prior, I'd eaten so little I felt woozy, and now I craved something high in fat and sugar.

As Anthony drove us to the gym, I unraveled the wrapper on the cookie dough. I looked at it and thought, *I'm going to burn all this off. It's no big deal.* Then another side of me said, *Of course, it's a big deal. You're fucking disgusting.* I pulled off a piece of it, and the sugary goodness melted in my mouth. Hardly leaving enough time to taste it, I grabbed another chunk and shoveled it into my mouth. Anthony looked over and said, "You good?"

"Yeah, yeah, I'm gonna burn it off," I mumbled through bites.

"Aren't you gonna feel sick?"

"I'll be fine," I said, jamming more dough into my mouth.

When we got to the gym, I'd eaten a little less than half of the roll. I didn't feel sick yet, but I was disgusted with myself. I thought, *I'm a disgusting cow. How could I have done that?* I

slammed the remaining cookie dough into the trash outside the gym and opened the door to head inside.

Tears streamed down my face as I vowed to burn it all off.

Anthony loved to play basketball, and I was obsessed with working out. I hopped on the elliptical and pushed for ninety minutes until I was on the brink of collapse. *Must. Keep. Going.* My legs eventually buckled underneath me.

No matter how much Anthony said he loved me just as I was, I desperately wanted to be smaller, and I couldn't eat anything without obsessing over the calorie count and fat content. He didn't quite encourage my desperate need to be thin, but he didn't discourage it, either. He'd let me know when foods were high in fat or calories and wouldn't say anything when I exercised until I nearly passed out. I appreciated that he didn't nag about any of it because it meant I could continue my disordered habits in peace.

CHAPTER 6

As I lay down on my bed one afternoon after getting home from school, I gawked at thin celebrities in *Teen Vogue*, like British supermodel Kate Moss, whose arms and legs were thin as toothpicks. I dreamed of how few problems she must have with a body like that, and I constantly compared myself to her by pinching at the imagined fat on my stomach. Looking at her gave me my daily dose of thinspiration, which motivated me to keep working out.

I was just about ready to get up and play the game I had on my bedroom floor, *Dance Dance Revolution* (*DDR*), a game I loved because I loved stomping my feet to music and I loved burning calories, when Anthony grumbled at me. "Could we like go out and do something? I'm sick of sitting around."

"I wanna play *DDR*!" I said. It was something I did obsessively, every day.

"I want to go out," he growled as he got up and began moving toward me.

I held the magazine to my chest. "Come on, Anthony, it won't take long."

Suddenly, he ripped the magazine from my hands, threw it on the floor, then ground his foot back and forth on it, ripping the pages out.

"Jesus C-Christ," I stuttered, backing away on the bed like a startled crab. "What the heck is wrong with you?"

I hugged my knees, and my whole body went on alert.

"We're going out. Let's go." His eyes were burning with rage. I hugged my knees tighter.

"I said I don't want to," I whispered.

He grasped my arm and pulled. "Come on."

"What the hell?" I pulled my arm back, but he was stronger than me and yanked me up off the bed. I put my shoes on in silence, and we went out.

I thought this was L.O.V.E. I didn't have a model for what love was supposed to look like—Mom and Dad split before I was born, and Mom and Jack's relationship was a mess. They were rarely kind to each other, and even less seldom affectionate. I saw "love" expressed through passionate fighting and being snippy, so that's what I thought it was supposed to be. Rarely kindness. On top of that, my favorite movie at the time, *The Notebook*, had taught me that love was full of physical altercations and screaming fights. Noah showed his adoration for Allie by scaling a Ferris wheel and threatening to jump if she didn't go out with him and by lying in the street and demanding she join him.

If our love looked anything like that, we were doing it right, right?

Something inside me knew that I was wrong about anger and hurt being love, but I stuffed the feelings down and told myself that passion equaled devotion.

The Notebook describes its protagonists as such: "They didn't agree on much. In fact, they rarely agreed on anything." That was the kind of love I thought I wanted, so it was the kind I settled for.

●

A few weeks later, the fighting got worse. One late night while I was sitting at my computer, typing away on AIM, and Anthony

was sprawled out on my bed, a guy friend from California messaged me on AIM.

"Why is Doug IMing you?" Anthony asked.

"Because we talk sometimes?" I typed a reply to my friend.

"I don't want you talking to him." Getting up off my bed, he darted over to look over my shoulder.

"I'm going to if I want to." Rolling my eyes, I continued typing.

"I'll fucking kill him." His voice changed from angry to deadly. He smacked the mouse out of my hand onto the ground, and I looked up at him. His face matched his voice.

"Okay." My hands retreated to my sides. *He lives in California, psycho*, I thought. Doug was one of my only guy friends I had met online and didn't strip for.

"Don't give me a smug look. I know Doug is trouble." He picked up the mouse off the ground, slammed it down, clicked the *X* at the top of our conversation, then signed me out.

"Whatever." I crossed my arms.

He grabbed me by the shirt and lifted me like a rag doll, then slammed my back against the wall.

"Ow, Anthony, what the hell!" A sharp pain shot through my collarbone, and I thought he might have broken it. *Owwwww.* Putting my hand up against my collarbone, I trembled. I thought he'd kill me.

"I said . . . I don't want you talking to him." Spit flung from his mouth and landed on my cheek.

"Okay, what the frick, just let me go."

He dropped me, and I crumpled to the ground. Too terrified to cry, I wondered what to do. Mom couldn't hear what was going on because I was in the basement, far away from the rest of the house. I could run, though I thought he'd probably chase me. I could fight back, but then I'd get the shit kicked out of me. I

could sit here in silence, then he'd probably hit me again. I guess I could just cooperate and do as he asked.

"I won't talk to Doug," I mumbled as I lifted my crumpled body from the ground.

Even my mom had hurt me, but I'd never felt scared that she'd actually kill me. This was different. This was terrifying. I was beginning to let myself believe that something might actually be wrong here.

●

The day after Anthony slammed me against the wall, I didn't want to ride to school with him, so I rode the bus. Selena and I sat near one another but not next to each other. She had iced me out after the robbery—not a word between us since—but she must have seen the massive bruise on my collarbone, because I got called down to the school resource officer later that day, and he questioned me.

"Miss Testa, you have a large bruise on your collarbone. Did someone do this to you?"

"Um . . ." I thought for a second about whether I wanted to rat Anthony out or not. "I don't know . . ." I mumbled, still thinking. Should I tell him?

"If someone's hurting you, it's important we know. I hope you know it's not okay, and we just want you to be safe. Now can you tell me who did this to you?" he asked sternly with his eyebrows squished together.

"It . . . it was my boyfriend." I looked down at my hands as I picked at my cuticle, holding back the waterworks.

"I'm sorry this happened to you. I got your boyfriend's name from the person who reported this. I'm going to have to follow up with his parents to suggest anger management classes. We can

talk to your parents about pressing charges if that's something you want."

"No, no. He didn't mean it. Or, I don't know. I don't want to press charges."

"We don't want this to happen again. I would recommend taking some space from him."

I had no intention of taking space, and I hoped he wouldn't do this again.

I saw Selena get on the bus after school and I followed her. The closer I got to her, the more I felt like Bruce Banner becoming the Hulk. I sat in the row in front of her and turned around to face her. "Why the fuck did you do that?" I hollered. She didn't answer, which enraged me further. "Well?" My goddamn former best friend betrayed me, I figured, thinking nothing of the betrayal I had done to her.

"Dude, he's hurting you," she answered. "I don't care if we're fighting. It was the right thing to do." She looked out the window, away from me.

"He loves me," I said. "He didn't mean to hurt me. Plus, I'm far from innocent myself. One time, I threw a computer monitor at him." I leaned in, awaiting her response.

"Ginelle, I don't care about that. I care about your well-being." Selena stood her ground.

"Whatever," I grumbled. My stomach burned with guilt as I thought about how she still cared, even though I'd robbed her.

We both rode the rest of the bus ride in silence.

Anthony messaged me on AIM when I got home.

apacballin: *babe, im sorry about what happened last night. Wont happen again. I promise. my moms not gonna make me go to anger management because i don't need it. i love you.*

I sighed at the message and thought about what to say. *Will he really change? How do I know this won't happen again? Why did*

his mom react like that? Well, she rarely cared about anything he did, so I figured it was in character for her to not make him take responsibility for attacking his girlfriend. I took a deep breath and replied.

nellietnh: *love you, too.*

A few weeks later, Anthony and I were driving with my friend Jocelyn in the back seat. She was a blonde goody-two-shoes friend. She was one of my rare friends who never wanted to do drugs or drink with me, but I liked her anyway. She was funny and nice to me.

"I don't want to listen to this." I changed the station from Lil Wayne to the pop station.

"We're listening to it," Anthony demanded as he changed it back.

"Whatever, why are you being such a douche?" I rolled down the window to get some fresh air.

"Don't call me that." He looked from the road to me, back to the road.

"Fuck you," I murmured. Meanwhile, my friend was in the back seat, darting her head between Anthony and me, probably awaiting the inevitable—he was going to hurt me again.

Reaching over while swerving in and out of our lane, Anthony yanked my seat belt across my neck, choking me with it. Cars were honking as he just barely missed side-scraping them.

"Stop being a fucking bitch." Anthony pulled harder and flashed his eyes from the road to me.

Whimpering, I said, "Please let go, you're hurting me." He was staring forward but choking me hard.

"Let her go, Anthony!" Jocelyn hollered from the back, punching him on the shoulder.

He unclenched his fingers and drew them back to his side. I grasped my hand on my throat, rubbing it, and quickly wiped my tearing eyes with my other hand, not wanting him to see he'd made me cry.

We drove the rest of the way, about ten minutes, in silence as I wondered how I could possibly stay in this relationship a moment longer. And what was Jocelyn thinking? *She must think I'm an idiot for being with him.* I wondered, *Am I?*

He pulled up to my house, and I quickly got out without giving him a kiss, hug, or even muttering a good-bye. Jocelyn and I quietly went to my front door. As we were taking our shoes off, she shook her head. Then once we were behind the closed door of my bedroom, she sat down on my bed and looked at me with eyes as wide as an owl as I took my jacket off. "You can't be with him. He's dangerous," Jocelyn said.

"I know. You're right. I just love him so much. But this has to stop." I scrunched up my face, holding back tears. Thoughts rushed through my head: *What if he's my person, and I'm letting him go? What if he's my bird? He loves me. But this can't keep happening.*

Later that night, after Jocelyn went home, I picked up my house phone and stared at it, thinking, *This is it. This is the end. I'm ending it. But what if I never get over him?*

I dialed his number and held my breath. He picked up after a few rings.

"Hello?"

"Anthony . . ."

"Ginelle, I'm really sorry for today." He sounded as if he was almost in tears. "It won't happen again."

"I c-can't do this anymore." I stuttered, sitting on my floor, my back up against a wall, leaning on my elbows, which were resting on my thighs.

"What do you mean? We can't break up. I love you." His breathing was speedy, and so were his words.

"We have to." I paused. "It's all too messed up. We're fighting all the time." I wondered if this was a mistake as I closed my eyes and pressed my palm against my forehead.

"I'll die without you. Ginelle, please don't do this." His voice cracked and for a moment, I felt bad for him. Maybe he really was sorry.

Still, my mind was made up.

"I'm sorry, I really am. I wish things could be different."

"Ginelle, I—"

I cut him off. "It's over." I hung up the phone. Then I let out gut-wrenching sobs that I feared would never stop.

What if I need him as much as he needs me? I can't, though. I just can't.

I wiped my eyes, then got on my computer to find solace in instant messaging. About a half hour later, the phone rang. My mom called down to say it was for me.

Uh-oh. I got up from my bed to pick up my nearby phone. "Hello?"

"My world is spinning, and you're the only one who can stop it," Anthony slurred.

"Are you drunk? What the hell? It's a Wednesday night. Get over yourself. We're done." I felt sure of myself and proud of it. I'd had enough. I didn't want to be beaten up again, and I sure didn't want to die. I deserved better.

"Please, Ginelle. I'll go to anger management," he begged. "I know my mom said I didn't have to, but I will. I'll do it." Desperation dripped from his every word.

"I can't do this, Anthony." I went to hang up again, but he got in the last words, his tone changing dramatically to deadly.

"Bitch. I'll fucking kill you and bury your body behind Noodle Delight."

I clicked End and placed the phone down, staring at it. I figured I should lock my windows and doors. Where we lived, break-ins were uncommon, so we left our doors unlocked at night. Not tonight or any night in the near future. What if he tried to come here? I locked my window, then locked all three doors to the house.

Sobbing, I crawled into bed and panicked, wondering what I should do. What if he really came after me? Unable to sleep, I spent the next hour bundled up in my bed, staring at the window Anthony used to wedge himself in and out of multiple times a week. I expected him to show up to kill me.

Around 10:00 p.m., I knew it was late, but I needed to call someone. I couldn't sleep. Talking to my mom wouldn't have been helpful because she rarely, if ever, seemed capable of offering me motherly sympathy. I thought back to the time I fell off my bike and she laughed at me, calling me a klutz. Why would this time be different?

I called Nana.

"Nell? Is everything okay?" she said in a groggy voice.

"I, uh, I broke up with Anthony." I let out a deep sigh. She had met him a few times and thought he seemed sweet. My Papa, on the other hand, didn't like him. He said he got a "weird" vibe.

"Oh, sweetie, I'm so sorry to hear."

"He's dangerous, Nan. I'm afraid he's going to kill me. He threatened to."

"Holy crap. We should call the police."

"No, no. I don't want to call the police on him."

"Ginelle, that's a big deal. Can you tell your mother?"

"What's she going to do?"

"Why don't you at least sleep upstairs tonight? I'd feel better if you weren't alone in the basement."

"I can do that."

Wrapping my comforter around me, pillow in hand, I went to sleep on the living room couch upstairs. Anthony didn't come to my house, as far as I knew.

He called my house several times over the next few days, and I had told my mom to say I wasn't home. Each time the phone rang, I cringed. I wanted to talk to him, to hear his voice, but every time I imagined the conversation, I envisioned him saying he'd kill me. That kept me away. I actually feigned illness and stayed home from school on Thursday and Friday to avoid seeing him.

The following Monday, I was walking down the hallway at school with Jocelyn. We were stopped at my locker when she said, "Incoming." I groaned and knew exactly what she meant.

"Hey," I heard Anthony say while my head was buried in my locker, "can we talk?"

As I shut my locker, I realized Jocelyn was still standing by me. She was gripping her books and rolling her eyes.

"No, Anthony, we can't talk," I said, looking at him and feeling that twinge of sadness I knew so well. Devastation, even. I loved him, and now he seemed so pathetic. That must have meant he was sorry, right? His hair looked disheveled and unwashed, and he had bags under his eyes like he wasn't sleeping.

"Please, I said I'm sorry," Anthony pleaded.

I saw Jocelyn gritting her teeth like she was holding back from giving him a piece of her mind. I just wanted to disappear. I grabbed Jocelyn by the arm, and we stormed away in the other direction.

Surprisingly, Anthony left me alone after that. I carried on from him after our breakup. It stung. Depression threatened to take over, as I couldn't sleep well and was dragging through my classes, but I didn't want to feel the feelings, so I moved on as quickly as possible to the next hot guy. This is where my serial dating began. I dated a few people, not getting serious with anyone just yet because I was scared of being hurt again. There was Matt, who brought me a bouquet of flowers on our first date. I thought that was overkill and never called him again. There was Henry, who I ended up cheating on in a drunken blackout. Then there was John, who was my friend even though I had a huge crush on him. That didn't stop me from hooking up with his friends.

I couldn't quite quell the longing of missing Anthony, but I didn't turn back.

Before the end of my sophomore year, I met Holly in gym class, and we started hanging out because neither of us had many friends. We were similar in that we were both reckless party animals who slept around a lot, so she quickly became my best friend. Decorated with glittery eyeshadow, thick mascara, strawberry lip gloss, and crop tops, she also tried to make homes out of boys.

One night in the summer before our junior year, we went to a party together, and I was on the hunt for one such home for myself.

The party was at a random guy's little apartment in Nashua, New Hampshire, where there was nothing on the white walls except some holes that looked about the size of a fist. The furniture consisted of a couple of cigarette-burned gray couches, a beer pong table, and fold-out chairs.

A dozen people were partying—playing cards and beer pong. They were maybe old enough to buy beer, which I liked because I felt cool around college-aged people.

I looked over at Holly, who chugged her beer alongside me. *Plunk.* The ball hit the dirty water that filled the red Solo cup of our beer pong game, splashing filthy water onto my red Abercrombie tank top. I lifted my Bud Light from the sticky table to my lips and tipped some back. The beer landed sour on my tongue, and I loved the fizz running down my throat. I also liked

the hoppy taste much better than when I was younger. Beer drinking was growing on me.

It was our turn to throw the balls, so Holly tossed one toward an opponent's cup and missed. We weren't great at beer pong and had to drink every time the opposite team landed a shot, but getting drunk was our goal, so no loss there. *We're gonna get nicely messed up tonight*, I thought.

My phone buzzed. I flipped it open to look at the screen. Ray, a guy four years older than me, was trying to hit me up to hang out. In the past, he'd connected me to people who could get me beer and drugs. I flipped my phone closed and put it down without answering, as it was my turn to toss the ball. I wanted to nail this, so I focused, braced my legs, and held the ball tight in my right hand before I launched it, sinking it into one of the middle cups on the other side of the table. Holly cheered; it was their turn to drink! My flip phone buzzed again with a text. I opened it.

We're tryin to party.

Ugh, I thought. *Whatever, I'll ask if Ray can come. He'll probably bring drugs and booze.*

"Hey!" I shouted over the rap music at the host, who was sitting on the edge of one of the gray couches on the side of the room. "Can my friend Ray and his buddies come over?"

The host turned his mouth down and scowled. "I guess," he said. I knew why he was upset. More males meant less of a girl-to-guy ratio, which meant less chance he could hook up with someone. He was kind of a scumbag, but he and I weren't all that different.

Our opponents sank two more cups, and Holly and I took a gulp from our beers. After finishing beer three, I headed to the fridge to grab another. As I staggered, my vision was shaky, and

I could feel myself smiling as if it was Christmas morning and I was opening a pile of presents. Being drunk felt so damn good. For once, my mind wasn't racing with thoughts of my body, home, or boys. All I was thinking about was my hand wrapping around my next ice-cold Bud Light. I opened the fridge, snagged one, and then walked back to the beer pong table.

Holly and I continued to play, losing miserably and drinking every time one of our cups was hit with a ball. I burst into laughter when our opponents sunk our last cup and we lost. Then I leaned too heavily on the table and knocked my beer over onto the carpet.

"Klutzo!" Holly shouted as she grabbed my beer can off the ground. "Here, there's shtill shome left." She was drunk.

"Y'know, yer the best." I grinned at Holly as I wrapped my arm around her silky-smooth shoulder and snagged the beer. We stumbled toward an empty spot on the couch across the room.

"Nnnooo, you're the besht!" she replied as she wrapped her arm around my shoulder, a big smile on her face.

"I just am sho glad we became friendsh."

"Me toooo! You rock." We plopped down on the couch and let our arms drop.

Feeling close to her at this moment, I leaned my head on her shoulder and smelled her tangy Victoria's Secret perfume, which made me want to snuggle into her further. My hand dropped beside hers on the couch. Her hand felt smooth like she'd just put lotion on. We sat like this for a few minutes, then I lifted my head and peered over at her. Her smile was now even bigger than it had been—she must have been as drunk as I was. Her lips were super close to mine, and I thought, what if I kissed her?

Inches from her face, I looked down at her lips and planted a wet kiss on her mouth. To my surprise, she didn't pull away. She

just kissed me back with lips that tasted like her strawberry lip gloss. My hand found its way to her leg, and I squeezed. Soon her tongue slipped into mine, and we made out in front of everyone at the party. I heard a guy near us go, "Woah!" But I was completely focused on Holly. Sure, I felt like we could be doing it for the attention, but it also felt like I was kissing a more delicate version of a man, and I loved it. Her lips felt juicy and supple. Maybe it was time to make a home out of Holly.

We continued going at it for a few minutes until my phone buzzed. *Ugh*, I thought. I pulled away. "That may be Ray," I said. I didn't want to stop, but he was probably arriving. Holly pulled away a few inches and readjusted her shorts and her position on the couch as I picked up my phone.

Ray: *Hey, we're here. Let us in?*

I turned to Holly and said, "Shit, I'm drunk. We suck at pong. Let's not play again. Or should we play again to keep getting drunk?" I laughed. "Ray and his crew are here. I'm gonna let them in." Holly and I locked eyes for a moment, and I wanted to kiss her again but thought I'd probably get another chance that night.

I stumbled to the door, giggling over our kiss and holding my hand to my lips. I opened the door to find Ray had arrived with two other guys whose pants were barely hanging on to their asses. All three guys wore dirty white Nikes, baggy jeans, and Boston sports shirts, reminding me of the creep who had stuck his hand between my legs at a party three years earlier. They gave me a weird feeling at the back of my neck, something like when I stuck my hand in the gross beer pong water to retrieve a ball and caught some hair on my fingers.

"Welcome to the party," I mumbled, regretting having invited them because I could have still been kissing Holly. They pushed by me, two eighteen-packs of Natural Ice beers in hand.

One of Ray's friends had a gaunt face with a grimace and brushed my arm as he walked by, making the hair on my arms stand up. Could they get any creepier?

Ray strolled in with arrogant confidence despite having a chunky body and a nose that looked like a pig snout. It was as if he'd pushed a frying pan against his nose until he'd smashed it in place for good.

My gut feeling said, *Don't be friends with him, he's a creep, bad idea*, but I kept him around anyway because I cared more about the alcohol and drug connection. Besides, I was terrible at listening to my gut.

Ray and his friends came over with me to join Holly. She was deep in conversation with a girl with a spray tan, metal hoop earrings, and long, beautiful bleached blonde hair. A pang of jealousy twisted through me. I chugged the rest of beer number four. Ray handed me a Natural Ice, and I cracked it open. My head felt dizzy as I started beer five.

My eyes feeling heavy, I tried to look anywhere but at Holly. As I hung out with Ray, I said, "Let's play beer pong." I grabbed his arm and dragged him to the table. Holly was still engrossed in her talk with blondie, and they were sitting shoulder to shoulder next to each other on the floor. They were just talking, but they were awfully close. *Ugh*. Jealousy burned like a flame in my belly.

I turned back to my game for a moment. My eyes felt even heavier as I attempted to sink shots. I missed every one, doing even worse than earlier. At this point, the crappy fold-out table was the only thing keeping me from hitting the ground. As my balance and knees gave out, I slumped into a fold-out chair next to it, which saved me from falling.

"Hey, Ray!" I slurred. "Can I have John's number?" A friend of his, a total babe. The one I had a crush on but had only met in passing at parties.

"Sure," he said as he sat in a chair next to me, pulled out his phone, and gave me the number.

Feeling brave from the liquid confidence, I leaned forward in the chair, flipped open my phone, and typed in John's number. I shot off a text.

Hey, cutie! It's Ginelle.

I crossed my fingers and made an *eek* noise.

"You okay, weirdo?" Ray said. *Me, the weirdo?* I thought. *You're a weirdo.*

"Yeah, I'm good," I said as I placed my phone on my lap, eager for a response.

John texted back almost immediately, and another squeal escaped my lips. Ray rolled his eyes.

Hey stranger. It's nice to hear from ya. How's it goin?

"I'm inviting him," I said to Ray.

"He's a tool," Ray grumbled.

"He's your friend, ya jerk." I shoved Ray.

I wrote, *Just partying! You should come by. We're in Nashua.*

I realized I had forgotten about Holly for a moment, so I turned to her. She was challenging a guy to take a shot while teasing him by sitting on his lap.

He wrote, *Aw, I would. But I'm working.*

I heard cheering, saw people playing beer pong, and then saw Holly sticking her tongue down the guy's throat.

After this, everything went dark, like somebody had knocked me out from behind.

●

The following day, before even opening my eyes, I wondered what in the world I had done the night before. My mind raced and I squeezed my eyes tight while I felt all around me. I was lying on a hard surface. *I must be on the floor*, I thought.

I wondered if everyone at the party knew I'd blacked out, or if they'd thought I was conscious of what I'd been doing. Did *I* know what I'd been doing? What *did* I do? Fuck. What if it was terrible? What if I got naked or fought someone or had sex with someone? Oh dear.

Not wanting to open my eyes, I thought a silent prayer. *God, please have me not have done anything stupid last night.* I didn't really believe in God, but I decided to borrow Nana's God because I was desperate.

Light slowly started to make its way into my vision. As my eyes trembled, I peeped one eye open, feeling the hard floor underneath me and the warmth of someone's body next to mine. Their arm was pressed against my arm. I wondered who the hell I had slept with. This pit in my stomach was gnawing at me, my body throbbed, and my head pounded. I lay on the carpet so solidly, it was as if I'd been thrown down a flight of stairs and left there. *Oh my god.* I stared at the ceiling for a moment.

Holding my breath, I turned my head and saw Holly asleep beside me. We were on the floor of the spare bedroom, still at the apartment.

Phew. I breathed a deep sigh of relief. My body relaxed its death grip, and each of my muscles loosened. Nothing must have happened. Suddenly, I remembered the kiss. I bit my lip and smiled. Hopefully, she didn't think it was weird. We probably wouldn't talk about it because it *was* kind of weird. My grandmother was a Catholic, and although she never said a bad word about gay people, the religion had plenty to say: being queer is a sin you burn in hell for. Life was hell enough; I didn't need an eternity of damnation, so I decided that might be it for my gay escapades.

I sat up, yawned, and stretched my arms. Feeling pulsing in my temples and a soreness at the back of my head, I raked my

fingers through my hair until I felt a lump in the lower center part of my head. I winced at the pain and shuddered that I had no idea what had caused the lump.

I looked down to see I was still wearing my red Abercrombie shirt and plaid shorts, but my bra was missing. So was my undershirt. *Oh no.*

Still lying down, Holly opened her eyes and started laughing. "Ginelle, you have a condom stuck to the back of your shirt."

No, no, *no*. Who did I have sex with? One hand gripped the carpet as I grasped at my back, trying to find the condom. "Uh, what? What happened last night?"

Holly's eyes opened wide. "You don't remember?"

I shook my head. My fingers found the disgusting wet condom, and I flung it off me as my other hand dug further into the carpet. "Nothing," I said. What did I do? How could I not remember anything after Holly made out with that guy? I had a sinking feeling in my stomach, intuitively knowing I'd done something really bad, something really stupid. The feeling weighed me down and made me fold into myself. I wrapped my arms around my legs. My head was still pounding, and it wasn't just the hangover. It was the goddamn bump.

"What happened last night?" I closed my eyes, trying to replay the night before but coming up blank. All I saw was blackness, but the pulsating pain in my head told me something more had happened. I could tell it was something big.

"You slept with Ray," she said, frowning. I scrunched up my face.

Oh fuck. Ew. "How?" I demanded. "How did that happen?" The sinking feeling in my stomach crashed and turned to rising nausea. I wanted to puke. *Ray?* I wondered. *Why Ray of all people? How did this happen? He's disgusting.*

Holly was silently playing with a string on her crop top.

"Please explain," I pleaded, picking up my hands and gripping the sides of my head. I could hear the *lup-dup* noise of my heart pumping—as if I had the earpieces of a stethoscope crammed into both ears. And then I suddenly remembered John. Oh my *god*. What was *he* going to say? He'd think I was a stupid slut.

"How did I even get to kissing him? I'm so confused. He repulses me."

"I don't know. You two were beer pong partners, and then it just started happening. You were making out like crazy in the kitchen, and Ray brought you into the guest room."

"Oh my god! This is so fucking bad." Tears pooled in my eyes. "What about John?" Holly knew all about my John crush. I felt like I couldn't breathe.

"Ray's friend sent a video to him of it happening." Holly hugged her knees and looked up at me with wide eyes.

A fucking video? *What?* There was evidence of my shit show? Who the fuck recorded something like that? (This was back in the early 2000s when cameras weren't part of phones.)

"Ughh," I groaned. "I blew my chance with John, then." My voice was unsteady, and I tried to pinch back tears.

"Maybe not. You never know. You were super drunk." Holly shrugged. That was our usual excuse. We tossed it around after pretty much every party we went to.

"I guess we'll find out." I groaned. "I need something to eat." Despite how nauseated all these discoveries were making me, I needed to get something into my stomach. I figured Holly wouldn't eat with me because Holly never ate, which was why she looked like Kate Moss. I regularly compared myself to Holly and always felt bigger and therefore gross, despite being maybe only about ten pounds heavier than she was. For all the time I spent with Holly, I could count on one hand the times I saw her eat.

I flipped over onto my stomach, outstretched my arms, and lifted myself from the ground to examine my surroundings. A guy I didn't know was passed out on the bed next to us. My feet weighed a thousand pounds, but I got them to move. I stepped out into the hallway and made my way to the chairs near the kitchen to get my purse. More people were scattered on the couches and the floor, fast asleep.

Opening my purse, I gasped. My camera was gone. Was this a prank? I opened my wallet. I was missing forty dollars in cash.

What happened last night? I wondered. It had to have been Ray or his friends, I just knew it. He took advantage of me all drunk and willing and then stole my shit. I paced back and forth in the living room, my heart booming in my chest. *What am I going to do? John is going to hate me, and everyone is going to think I'm a big whore. Oh god, there's video proof, too. I never want to fucking see that thing. This is a nightmare.*

On my way home from the party, I was dying to get out of my head and body and drown my sorrows in food. I berated myself. *Stupid. You're so fucking stupid. I can't believe you did that. You friggen slut.*

The overthinking wouldn't stop. I pulled into 7-Eleven and braced myself to face the clerk, because I was a disheveled mess and figured I knew just what the cashier would think—that I was doing the walk of shame. It would be so much better if she just thought I was fat. I grabbed a package of vanilla wafer cookies off the shelf and slowly marched over to the register.

The clerk was a lady who looked to be in her fifties or sixties, gray-haired and chewing gum. She was barely paying attention. "Your total is $2.95," she said, looking out the window.

I shoved my debit card in the reader and waited five excruciating seconds. "Thanks," I mumbled as I hurried out of there. Immediately upon slamming my door, I tore open the package

and shoved all the flaky cookies in my mouth. Binge eating was my new way of coping with trauma, and I had begun to gain weight. I hated carrying extra weight but didn't have the self-control with food I'd had two years prior. Gaining weight was as terrifying as everything that had just happened to me, so as I stuffed the sweet bites of goodness into my mouth, I could feel self-loathing spread throughout my insides. *God, I can't do anything right*, I thought. *Now I'm fat and getting fatter. Great.*

When I got home, I went straight downstairs. My mom thought I was at staying at Holly's the night before, and she never bothered to check with any of my friends' parents, so I hurried right to the bathroom without hearing a word and began stripping my clothes off. My belly was bloated, and my entire body felt tense. I stared in the mirror and tried to replay what had happened the night before. There were no bruises or cuts except the sensitive lump on the back of my head. I wondered if the fact that there were no signs of rape meant I hadn't been raped. Surely, I could have bumped my head anywhere. Like, when I went to the bathroom? No, that didn't make any sense. I had no idea. I was blackout drunk, so of course I had no idea.

I turned the shower on as high as it would go, tested the sweltering heat with my fingers, and then stepped in. The water running over my head was too hot, but I just stood there, hoping to burn away the shame. I tried to practically scrape my skin off with my loofah and warm vanilla sugar body wash.

No amount of soap or hot water could wash away how nasty I felt—about what happened and about myself for letting it happen. Or did I *make* it happen? I squeezed my breasts. They felt like they weren't mine. Had Ray touched them the night before? The thought of him made me shudder and squeeze my eyes shut. *Why?* I thought. *Why did I get so drunk?* Again, I tried to piece together missing details of the night and came up with nothing.

The thought of texting John made me gag because he knew I'd slept with his disgusting friend, but I knew I needed to do it.

I jumped out of the shower, dripping wet, and took out my phone.

Me: *Hey.*

I was scared to say more because I wasn't sure he'd even respond.

John: *Hey, you ok? I heard you were really drunk last night.*

Phew, he didn't hate me! At least it seemed like he didn't.

Me: *Yeah. I was a hot mess. I'm pretty embarrassed about it tbh.*

John: *It happens to the best of us.*

It was a short answer, but an answer nonetheless. I felt some relief.

Me: *I wish what happened with Ray didn't happen.*

John: *I hear you. What can ya do. That was pretty messed up that someone filmed you.*

He had that right. I wanted to forget that fucking night ever happened, but now there was video of it floating around. I could murder someone I was so mad.

Me: *Trust me, I'm livid.*

John: *You don't deserve that.*

Me: *Thank you. We should hang out sometime.*

John: *Let's do it!*

I looked at my phone, smiling.

●

The whole following week, I felt like I was floating outside of my body, spacing out a lot and just not being present in class or in conversations. My skin felt like a foreign war zone, unsafe to occupy, so I dealt with it by disassociating. I'd look in the mirror at school, and I couldn't recognize the person I saw.

It was like I was a separate entity living outside of my body. It was a weird-ass experience to feel as though I was watching myself from the outside, like I was observing some montage of a girl in a movie, walking around in a daze of shame. It's sort of like that feeling of being in a dream, but not having full control over your movements, unable to snap out of it. It was scary, and it was the first time I'd experienced anything like it.

Whatever nastiness had happened to me, I felt I'd asked for it because of how drunk I got. But at the same time, I knew I didn't deserve to be taken advantage of. Ray was twenty-one, five years older than me, which meant that just the act of having sex with me was a crime. I wasn't old enough to consent. I was also shit-faced, so what kind of responsibility should he carry relative to that? If someone is so clearly shit-faced that they can't reasonably give permission, isn't the person who has sex with them guilty of assault or rape?

had stolen weed from my dad in the past but graduated to taking opiates from him because I'd heard they had the potential to get me more fucked up. I saw my drug-dealing dad only on the weekends, and though he primarily dealt pot, he also had oxycodone and some other drugs I wasn't familiar with and wasn't smart enough to Google before using. I'd seen oxys before—white circular pills—but the orange pills were new. So at the beginning of my junior year, I snuck into my father's kitchen and opened a drawer where I knew he kept drugs.

I pocketed a medley of whatever I could find: six-sided orange pills and circular white pills in varying sizes, two of each. Not so many that my dad would notice, but just enough that I thought they'd get Holly and me messed up.

Despite my dad's glaring imperfections, I thought he was the best. He let me eat ice cream for breakfast and always told me he loved me at the end of a call. I never got in trouble with him, and he never found out I was stealing his drugs—that I knew of.

At this time, my mom and stepdad were going through it, and as it turned out, my little orange and white pills would come in handy during the cyclone that was about to rip through our lives.

●

My stepdad, Jack, was a Harley and car dude. He owned a car lot and always brought the newest and sexiest cars and bikes home

to drive. One afternoon, I went with my mom, Jack, and my two half-siblings, Cara and Deklan, to check out a new house that Jack was hoping to buy. He told us to pick out our rooms, but the house was one room short. There were only three bedrooms.

"Don't worry, Ginelle. We'll build you a room downstairs," Jack said. *Oh. Okay*, I thought. It was a finished basement, so maybe it wouldn't be so bad.

Because he was my stepdad and my siblings were his blood, I felt like I didn't belong, like I was the black sheep, the reject. My innocent siblings were also watching me reign hell on our household with my drug use and drinking, which left me feeling even more like an outsider.

There were quite a few times when the cops called my house, like the time my friend and I stole his mom's car before we had our licenses, and the time I was busted at a party for underage drinking. My siblings were eight and five years younger than me, so they weren't getting into any trouble. Only me. And when it came to the new house, only I happened to not have a room.

On weekends, I went away to be with my dad's side of the family and my mom's parents, Nana and Papa. That's where I felt at home—going out to eat, having dinner cooked for me, being taken out shopping for things I needed like new underwear and socks. While I was away, Mom, Jack, and the kids did family things, like four-wheeling or hanging out with Jack's friends. I hoped we'd spend more time as a family with a new house, that maybe there would be a new start.

Instead, about a week later, I found my mom sobbing at the kitchen table. I tiptoed into the kitchen and asked hesitantly, "Are you okay?"

She dabbed her eyes with a tissue and cleared her throat. "A woman who apparently has been sleeping with Jack called. She got herpes and is blaming me."

Holy crap, I thought as I stood there stunned, not speaking.

"She's probably just causing drama, but Jack wants a divorce."

"W-what?" I stammered.

"It's *your* fault!" she shouted, rage in her eyes.

I felt frozen in place. *My* fault? "Uh, *what*?"

"He wanted to send you to boot camp, but I said no," my mom spat at me, getting up from the table. "Now we're fighting. If you weren't so rotten, this wouldn't be happening."

I went from feeling sad to numb to angry as all hell. I spat back, "It's not my fault if your husband thinks you're a miserable bitch."

I meant it. I thought he'd left her because she was mean. This was a mess, though. What were we going to do? What was going to happen with the house we lived in? And what about the house we were now supposed to live in?

"Go downstairs!" my mom shouted as she stomped across the tiled kitchen floor and landed a foot from me. Knowing my hysterical mother would hit, push, or slap me if I didn't listen, I scurried down the stairs.

I hustled to my room, pulled out a stash of cheese curls from behind my bed, and stuffed them into my mouth one by one until I'd eaten half the bag. Self-loathing soon sank in, and I told myself I was a disgusting fat pig. I hated myself for bingeing, but it was one of the most effective coping mechanisms I'd found to help me deal with any feelings that came up. If I ate, I didn't have to feel. It was immediate gratification but was always followed by regret and self-loathing.

One morning a few weeks later, as I was getting ready to go to school, I walked up the stairs and heard my mom sobbing at the kitchen table again. I sheepishly stepped into the kitchen, ready to be yelled at again. I needed to get my breakfast, so I had to go in.

"It was his plan all along," she sobbed, talking to me but not looking at me, only staring off across the room at nothing I could identify. She looked exhausted. Her slumped posture made me think she'd given up.

"What?" I mumbled, just having woken up.

"That bitch, Helena, who called me about herpes. That's his mistress. All along he planned to buy the house for her and the kids and kick you and me to the curb."

My stomach dropped. For a moment I actually felt bad for her, but soon afterward I felt worse for me. Now, really, what were we gonna do? All I could think about was not wanting to move to Boston where the rest of my family was. I wanted to stay with my friends in New Hampshire. Not saying anything, I stared at my mom, now crouched into a ball on a wooden chair, squeezing a bunch of tissues to her face. I had a strange urge to hug her, but I tucked it away in my mind. Hugging the mother who hit me would be too weird.

"Not only that, but I found out that for the past five years, he's been moving all his money into his best friend's name. He's been planning this for *five* fucking years, and now the lawyer says he has nothing to give me. I'm so fucked."

But Jack had a car business, a new house bordering on a mansion, and all the fancy vehicles he could ever want. What did she *mean* he had no money? I waited for her to blame me again, but the accusations didn't come.

"I'm sorry, Mom," I mustered. "That really sucks."

She sat there for a long while without responding, and it felt like a moment of tenderness between us unlike any in my recent memory. It was an odd feeling I couldn't reconcile in my mind. Were we being nice to each other now?

"The house will get foreclosed on and we'll be forced to move, I just know it. If he tries to take the kids, I'll fight!" She

slammed her fist on the table, and the force of it startled me. I actually felt bad for her for once. I wondered what my half brother and sister would choose—if they had a choice. My siblings were a lot younger than me, and I didn't spend all that much time with them, which made me sad—there seemed to have been a barrier between us for as long as I could remember. I thought they'd choose their dad if given the choice. Like me, they thought the world of their flawed father.

"I don't know what to say, but I should get to school." I awkwardly shut the cabinet I'd been leaning into for the last several minutes. Now with this awful news, I felt forgotten and left behind, again. It solidified my belief that men sucked, and that I, too, sucked. Because if I was good enough, this wouldn't have happened. If I weren't such a screwup, such a troublemaker, Jack would have loved me. This rejection fueled my desire to get messed up, to forget reality for a while.

●

While the battle was going on between my mom and stepdad, as heard through my mom screaming on the phone, I tried to stay out of it, but I could hear her weeping late into the night. Jack hadn't come home in weeks. I considered consoling her but again thought that it would be weird. Instead, I consoled myself by trying to build a home out of the strange orange pills I'd snagged from my dad. I brought them to school and pulled them out of my wallet during my Health Occupations class.

"Wanna get high?" I asked my friend Jill, who I knew would be game because she and I had already huffed desk cleaner. Jill was teeny. She looked like a twelve-year-old in a sixteen-year-old's body. Again, I compared myself to her and wondered why I wasn't thinner. I thought maybe drugs would help me lose

weight and might also help me forget about comparing my body to Jill's.

"That's an idea. On what?" she asked, shooting me a sly smile.

"I brought pills I stole from my dad. You can swallow it if you want. I'm gonna snort it."

"What is it?"

"I'm not sure, maybe some kind of opiate?"

She nodded with a big grin on her face. "All right, I'm in."

I dropped an orange pill in her hand. She made sure no one was looking and then swallowed it. I nodded at her and raised my hand, asking our teacher if I could go to the bathroom as I stuffed my debit card into my pocket.

I excused myself from class, wanting to skip down the hallway, I was so excited. I was about to go away, to float somewhere other than here, to disappear. When I got into the bathroom, I closed myself in a stall and laid the orange pill on the toilet-paper dispenser, ground it into powder with my debit card, and snorted it. Sucking through my nose, I began to feel the pill bits seep down the back of my throat. They tasted unpleasant, like an orange that had been soaked in bleach or some other nasty chemical. But I ignored the taste and focused on how good I was about to feel. I couldn't wait to feel different.

I returned to the classroom, and within fifteen minutes, the seconds seemed to slow down like I was in some sort of time warp. A mellowness came over my body and I relaxed, as if I was lying on a warm beach digging my toes in the sand. I couldn't pay attention in class, but fortunately, the teacher kept teaching, completely unaware of what was happening to Jill and me. I turned to Jill and saw that her pupils looked like tiny pinpoints. *Holy crap*, I thought. *This is so cool. We're high.*

Our Health Occupations class was two blocks long, so we had time to experience the high together. The drug made me feel

like I was floating on a cloud above the world, looking down on everything from up in the sky. It was a much different floating feeling than the one I felt after being assaulted by guys and then distancing myself. This felt freer, like floating without strings attached. Without worries.

My mind rode the clouds while class happened around me. *Gosh, please let this feeling last forever*, I thought. *I could live here inside this warm, fuzzy blanket, so comforting, like it was just taken out of the dryer. Everything is perfect, and my body isn't mine. It's just a blobby blob I can float outside of.*

Suddenly, my mellowness was interrupted by whole-body nausea, and I knew I was about to vomit. I raised my hand and asked the teacher if I could go to the bathroom again. Her face looked confused and annoyed, but she said yes, and I booked it down the hall. I just barely made it to the bathroom as puke started rising up the back of my throat.

Making it into the stall and dropping to my knees, I grasped the sides of the toilet and released my guts. My stomach muscles clenched and unclenched as all the food I'd eaten at the multicultural fair earlier that day emptied out of me. Ugh. This was awful. But worth it. *It's worth it*, I told myself. After a few minutes, Jill joined me in the bathroom, puking in the stall next to me.

"Dude, what did you give me?" she griped.

"I don't know. I just got them from my dad's drawer." My face was lying against the cold tile of the bathroom floor. It was soothing even though I had no idea what gross germs were there. I thought for a moment that I should be grossed out, then didn't care. I stared at Jill's legs, wrapped around the toilet.

"What are we gonna tell the teacher? Our parents?" she groaned.

"Well, I was thinking." I sort of felt like my dad coming up with a scheme. "That fair today. We can blame it on that." We had

actually sampled foods from all over the world. "It'll be easy to say something we don't normally eat is what got us sick."

"I guess," she said, and retched again.

We must have been in the bathroom for twenty minutes. I puked and puked until I was throwing up nothing but bitter green bile.

Someone eventually opened the door, and I tensed up. I thought I'd been busted.

"Hey, Ginelle and Jill, are you guys okay? I'm supposed to be checking on you," asked a voice from the door of the bathroom. It sounded like a classmate.

I groaned from behind the bathroom stall. "Can you bring me my bag and ask Ms. Collins to call the nurse so we can go home? I think we both ate something bad at the multicultural fair."

Jill said, "Same, I need my stuff, and I wanna go home," as she was in between gags.

"Yikes, okay." The classmate dashed out and quickly returned with our backpacks.

"Jill," I mumbled, "I'm gonna go to the nurse's. Wanna come?" She was still puking and made a grunting noise that I took as a no.

I made my way down the long, winding hallway as I tried not to puke again, then I finally made it to the nurse's station, where the school nurse was expecting me. She laid me down on one of the beds and stuck a puke bucket next to me.

"You poor thing," she said. "I wonder if we'll get anyone else sick from today."

Doubtful, I thought.

Our parents were called, and soon my mom was there to pick me up. Jill never made it to the nurse's office. I think she was stuck in the bathroom until her parents picked her up.

As my mom and I were walking out, she asked, "Are you okay?"

"Yeah, I just ate something weird," I grumbled. "It was the multicultural fair today."

"Mhm." I wasn't sure if she was buying it, but she also didn't pry.

•

My mom never told my dad about any trouble I was getting into. She left out the weed and alcohol, the boys, the fire, everything. I would have heard it from him if she had told him anything. I think she feared his response.

He could be a furious man, on steroids for much of their relationship. I believe she thought he'd show up with a baseball bat to beat up boys or kill me if he knew the shit I'd gotten into. The only time I saw my dad's violent side was when he road-rage screamed at other drivers or when he was on the phone with a pizza shop after our pizza showed up cold. But my mom told me about a time when he broke into her car and cut everything up inside of it. Then there was the time he screamed "cunt" at her across the gym. She said she was terrified of him for much of the time she knew him, but having me had helped him to grow up a bit. The dad I knew was kind most of the time. He never directed this anger at me.

•

I threw up nonstop for hours and was nauseated for two full days. I imagined I was going through an experience similar to that of heroin withdrawal. I wanted to die. But even though I'd felt like total hell afterward, I still thought the high had been worth it. Because the reality of my life was so completely messed up, I basically walked around with the crazed idea that being high, even for a few hours or minutes, was worth any consequence. As a bonus, throwing up probably helped me lose a few pounds.

CHAPTER 9

During our junior year of high school, Holly and I visited her sister Carmen at the Massachusetts Institute of Technology. Carmen wore flowery clothes and lived off campus in a big apartment that smelled of patchouli—sweet, spicy, and musky—and she drank from mason jars. Hardwood floors and green furniture made her apartment feel like a step back into the '70s. It was cool as hell.

Carmen's MIT friends manufactured acid on campus. The college is famous for its scientific geniuses, so that made sense to me. I'd headed to Cambridge armed with ecstasy, and I traded three of my ecstasy pills for two tabs of acid—tiny squares of paper with orange, blue, and purple swirls that reminded me of rainbow sherbet. How dangerous could pretty little pieces of art paper be?

"Stick them under your tongue and wait for them to dissolve," Carmen said.

Holly and I looked at each other, raised our eyebrows, and smiled. I had no prior experience with acid or being around people on acid. I had pretty much no knowledge or awareness of anything having to do with acid, so I placed the tab of acid under my tongue without considering possible consequences, as usual. It tasted like paper; it wasn't pleasant or gross, just kind of neutral. I was used to drugs being yucky, so I was surprised that this one—which was supposed to lead to such a dramatic high—felt and tasted like nothing. Then I braced myself for the effect.

That night I was trying to make a home out of acid, even so soon after ingesting another unknown substance had left me heaving my guts out for days.

My mind when I wasn't on drugs was like a carousel spinning off its foundation, and I just wanted off and into something else. I wanted to forget everything—my history with boys, my food issues, my entirely messed-up family life, everything. All I wanted was to get fucked up and see how it felt, get away from my thoughts and find a new world to disappear into. Drugs usually did this for me.

The tabs dissolved, but after about forty-five minutes, still nothing had happened.

"Why isn't it working?" Holly whined.

"You wanna try some mushrooms?" Carmen said. Holly and I both nodded. I felt a nervousness in my belly. What if we took too much? What would happen to us? Maybe I *had* learned a little something after the school toilet episode, but definitely not enough. I shooed the concerns away.

Carmen took the chocolate-coated magic morsels from the freezer, and I felt excited, ready to change my state of mind. Holly and I sat cross-legged on the floor facing each other, and we each popped one into our mouths. They tasted earthy and bitter. As they hit my tongue, I got ready for the effects. How would it feel? Would it be fun?

Just ten minutes after eating the mushrooms, the couch beside me began to expand. The cushions bulged and grew larger, then shrank back to normal size.

A smile came over my face. "It's working," I said as I felt my heart rate increase.

"Totally!" shouted Holly.

As my heart rate continued to shoot up, the movements of objects around me were too fast. The couches started stretching

and jerking. I felt nauseated. This wasn't what I'd signed up for. Already I wanted *off* the carousel.

"This is, um, kind of scary," I murmured. I closed my eyes and held my head as the world spun around me. *What have I done?* I thought.

"Really? I'm having fun!" I heard Holly shout while my eyes were squeezed shut.

When I opened my eyes, I thought I was in an enormous hole surrounded by dirt, and I thought I saw a dark, shadowy figure above, shoveling earth on top of me. The heavy, wet soil thudded on my stomach, and I couldn't climb up out of the hole. I panted and panicked, grasped at the walls around me, my fingernails becoming clogged with dirt. This was a grave, and I was being buried in it.

Looking above, I could see a shadow but no face. Then a big voice boomed from the shadow, "You must kill yourself, or I will kill you. I'm burying you with the sins of your ancestors." I screamed and grasped at the soil around me and still couldn't get out. My brain had overloaded, and for a second, I stopped trying to climb, and I just squeezed my eyes shut and lay back on the earth. I just wanted it to stop.

Suddenly, I heard a song I'd never heard before playing in the background, with a slow acoustic guitar rhythm and a man singing with a deep voice. The lyrics were as dark as what I was experiencing, something about "making you hurt."

I had no idea where Holly and Carmen were or how to get out of here. But I knew I had to get away from the song and that dirt.

I froze in place as someone or something continued to cover my body in dirt—clumps of it falling into my mouth, wet and earthy. I choked on them and sputtered, "Sssstop."

Splash.

Carmen had dumped water on me, and just like that, the grim music was silenced, and I was back to reality. I gripped the couch, stuck my fingers into its tatters, and held on for dear life.

"What the hell just happened?" I sobbed and leaned over to run my other hand across the wooden floor underneath my feet—no more dirt. My eyes began to focus on Holly and Carmen. What in the world just happened?

"You were tweaking and scared the crap out of me. Don't do that again," Carmen said, her face looking like she'd just seen a ghost. Was that what I'd seen, a ghost?

Holly was lying on her back on the other couch poking her hands in the air as if she was typing on a keyboard. What the heck was she doing? It looked like fun. Why couldn't my trip be fun instead of terrifying? My cheeks burned with envy as I squeezed the couch next to me.

"I need to pee," I said, releasing my grip and heading to the bathroom. Why was I having such a bad trip already? It was bullshit.

I slammed the bathroom door behind me, turned my head toward the mirror, and saw two scaly demons hovering over me. They appeared to be about six feet tall and about three inches off the ground. They were grayish green with slimy skin, like gooey aliens that had just hatched from a monstrosity of an egg. The worst part was the piercing red eyes that seemed to be able to see right into my soul. These dragon-looking bastards were just floating. I backed against the wall and grasped it, hoping to disappear. I was terrified they'd attack me.

I crunched my eyes shut and wrapped my arms around myself, pushing my fingernails so deep into my arms I nearly broke the skin.

The voice boomed again, now not from the demons but seemingly from the sky. "You will kill yourself, or I will kill you." I opened my eyes a peek and hugged my legs.

"Please stop." Salty tears poured down my cheeks and into my mouth. I shut my eyes again hard. I thought maybe if I didn't look, they'd go away.

"You will pay," the voice roared, and I felt a searing pain in my left arm as though someone was both burning and cutting me with a knife—a knife that felt like it had been sitting in boiling water. I peeled my eyes open and saw a thick red line of dark blood forming by my wrist, leaving a trail up my forearm. The blood felt and looked like fire ants trying to burrow into my skin. But I was also somehow aware that no one was cutting me and that I wasn't cutting myself. The cutting seemed to be just happening on its own. I pressed my hand against the open wound, but the thick red fluid dripped all over my fingers.

I screamed as loudly as I could. "Help! Fucking help! Ahhh!" Blood was now flowing from the gash.

Carmen burst through the door.

"I don't know what to do," I sobbed. "It won't stop. He won't stop." I looked down at the blood and then looked up at her.

"Who the fuck is 'he'?" she demanded.

"God. I think it's God. He's punishing me," I sobbed as the blood dripped on the floor.

"Holy crap. Okay, I think it's time for you to drink water and eat food."

"No!" I shouted as I got up and ran past her into the living room. I didn't believe anything would help me; I just wanted to curl up in a ball. I saw a closet near Holly, who was sprawled on the couch—apparently still having a grand old trip full of fun—and shut myself in it. The smell of stale marijuana and

feet wafted up from a pair of shoes stuck under me. The pain in my arm was still there, but I couldn't see or feel the blood anymore.

All I could see was the light from my cell phone. The demons were gone for now.

With shaky fingers, I dialed home on my cell. I gritted my teeth that I needed to call *her* for help. I didn't dare call Nana because I didn't want her to be disappointed in me.

"H-Hello?" Mom answered groggily. I had no clue what time it was.

"Mom, I'm scared," I cried. "I'm in a closet."

"In a closet?" she shouted. "What the fuck, Ginelle? Where are you?" I had to open the closet and hand the phone to Carmen, who was right outside. I shut the door again and heard muffled voices.

What was going on? Dirt, demons, blood, some weird-ass music? Then I had a second of reprieve in the dark. The hallucinations stopped, and I just focused on my breathing and tried to calm down. My arm didn't feel bloody anymore.

But then within minutes, strange hands were yanking me out of the closet. I kicked and tried to pull away, but soon the demons were dragging me out into the open room. They were dripping goo, grinning at me through jagged yellow teeth.

"Ahhhhhh!!" I screamed at the top of my lungs. I fought them as they dragged me onto a gurney. Then there was a flash of a regular man's face with a grayish-green demon body, and for the first time in that horror show, I thought that maybe it wasn't real. I heard sirens nearby, and I stopped thrashing for a moment and let myself get strapped into a medical gurney by three-clawed demon hands. First, a belt across my chest, then my waist, and finally, across my feet. Now I could barely move. *Oh, fuck this*, I thought.

"I don't like it!" I shrieked over to Carmen, who I could see holding her hand over her mouth, tears in her eyes. She was still on the phone. "Let me out!"

The demons carried me down the stairs on a stretcher and loaded me into an ambulance. I continued to scream as loud as I could. All of a sudden, a voice came out of nowhere.

"Shhh, it's okay," a voice that sounded like a lullaby said. Someone—a regular human—reached out and folded their fingers through mine. My gaze followed the hand up its hairy arm to see Anthony's face. He turned up his lips gently, and I felt like I could breathe again for the first time in hours. The dirt that had filled my lungs and the pain in my arm were both gone. I began to see that the paramedics' faces were human, but they were still half demon on the bottom, with thick and spiky stegosaurus legs and creepy green feet that curled into themselves. I still couldn't figure out what the hell was going on. Was Anthony really there? Did it matter?

"Anthony?" I cried out, laying my other hand on his, sandwiching both of mine around his hand.

"I'm here, Ginelle." His eyes looked soft. "I've got you," he whispered, outstretching his hand.

Suddenly, I remembered the deadly look in his eyes when he'd almost strangled me with a seat belt. I jerked my hands to my chest and shut my eyes. Again, I hoped just closing my eyes would make it all go away. Then I began to hum to myself as if I was a baby.

The half-demon, half-human EMTs tried consoling me by telling me that I was safe, but I didn't feel safe. Anthony was gone, and the next thing I knew, I arrived at the hospital. I'd stopped screaming, and I was pulled from the vehicle, almost catatonic with fear and exhaustion.

They pulled the stretcher off the vehicle and dragged me into the hospital. I was so fried I couldn't fight anymore. Plus, I still

couldn't move. I was quietly crying and taking in my surroundings: an emergency room with medical staff hurrying about. A wholly human blonde nurse in blue scrubs wheeled me into a room. I sighed and muttered, "Thank God." Maybe the trip was over.

The nurse stuck a needle in me to take my blood, and I winced at the pinch. She then walked over to the other side of the bed and stuck an IV in my arm.

"For the fluids," she said.

My father lived in Boston, so he arrived at the hospital fairly quickly. He sat in the chair next to me, and I could tell from his jeans and Patriots sweatshirt that he was human. His face was creased with exhaustion and something else. Fear? Anger? Terror? I couldn't tell, but I was scared to find out.

"Are you okay? Your mom sent me here," he said. He didn't sound angry. I think it was concern.

I gulped, still processing all that had happened. "I don't know."

The nurse returned and said, "She has coke, acid, and marijuana in her system."

My dad got up and stood extremely close to the nurse, yelling at her, "She has *WHAT* in her system?"

The nurse took several steps back. "Uh, coke, acid, and marijuana, sir."

"*Coke?* What the hell, Ginelle?" He turned toward me, saying nothing of the hallucinogens or marijuana. I guess the mushrooms hadn't revealed themselves. Apparently to my father, coke was worse than the rest, for reasons I still don't understand.

I had accidentally done coke at a party the night before. The guy I was with told me it was ecstasy, so I snorted it. In my head, coke was worse than ecstasy because I felt it was something you could get addicted to, so I was mad when I found out I'd been tricked. But it was too late.

As the fluids coursed through my veins, there were only humans around me. Human doctor. Human nurse. Human Dad. No more demons as far as I could see.

I don't remember what Dad said as he drove me back home to New Hampshire, just that I went to bed around 4:00 a.m. and slept soundly through the night. When I woke up at 1:30 p.m., I texted Anthony for the first time in a year.

What were you doing in Boston last night?

Huh? he replied. *What are you talking about?*

Confused, I left it for a moment while I went upstairs.

I found my mom leaning against the counter with her brow furrowed. "You know, you terrified me last night," she said. "I thought you were kidnapped. You should know better than to take hallucinogens."

"Righto," I said sarcastically as I noted that she didn't mention the other drugs. I wondered if my dad had told her what they'd found in my system. Also, was this her caring? Once again, I felt a weird mix of wanting to hug her because the night before had been so fucking scary but also feeling it wouldn't be appropriate. My mom and I hadn't hugged for years. It wouldn't have been normal to do it at this point. I know that's not normal for a mother-daughter relationship, but that's the kind we had.

At three o'clock, I had to go to work at a local pizza shop where I'd just taken a job. As I was slipping on my branded red shirt, I thought about how scary the night before had been. Like, really, really scary. I thought, *I don't want to do hallucinogens again. I don't even want to do drugs again. How much of it was real? I guess Anthony couldn't have been there, huh? What even was that song?*

I quickly Googled what lyrics I could remember and came up with "Hurt" sung by Johnny Cash. I couldn't recall ever having heard that song before, but the lyrics mentioned something

about dirt and hurting, and that made the hairs stand up on my arms. I remembered the shadow flinging dirt at me in a hole. What the heck?

I left my house and hopped into my car, and as I drove, the car's ceiling began to close in on me. It was as if I was tripping again, except that this time, I wasn't on drugs—was I? My vehicle seemed to be getting smaller and smaller like a clown car. Pop punk was playing on the radio, and I turned it off to help me focus as every muscle in my body tensed. It was as if I was trying to squeeze away the hallucination. I quickly pulled over, flipped on my hazard lights, and pressed my hand against the ceiling to steady myself. I started breathing really fast, and my heart was thundering, but I kept trying to convince myself that this couldn't be real, that it was only a hallucination. I couldn't get my breathing under control. My face flushed hot, and tears began to pour from my eyes.

For once, drugs didn't offer a joyous escape; instead, they seemed almost lethal.

I had no idea I'd buried so much darkness about my ancestors. It only made sense, though. My cousin was a junkie, and my dad was a drug dealer who was constantly buying stolen goods. When I was little, my grandfather beat someone nearly to death over a dog and went to jail for it. It seemed that somewhere in the depths of my mind, God wanted to punish me for the sins of my father's side. Sitting there in that car, I calmed myself down and was able to look a little deeper into the episode. What I came up with was that something in my mind was not well.

Are you kidding me? Jocelyn texted after I'd told her I could no longer go to Mexico with her because I was grounded from my acid trip. Because of the amount of drugs the doctors found in my system, my mom wouldn't let me go. She wouldn't let me do anything that sounded remotely interesting, nothing that sounded like an open door to more drug trips and hospital visits. I was pissed, because I wanted to go. Jocelyn was pissed at me because I'd ruined our plans, but she was mostly mad because she didn't understand why I was doing drugs at all.

I was bored as hell sitting on the floor in my room, flipping through a *Teen Vogue* because my mom had taken my phone away and grounded me for three weeks, which meant no seeing friends and coming straight home from school every day. It was now week two. I was still shaken by the acid trip, which left me exhausted every day because my sleep was so disturbed by hallucinations, and I had panic attacks while driving. As a result, I actually didn't want to do drugs anymore for the first time in my teen life. I was scared to hallucinate further, and I started having a degree of awareness that I was on a path to destruction. The trip had awakened me to all the damage I was causing myself with drugs: snorting pills even if I had no idea what they were and pursuing potentially deadly combinations. It needed to stop.

I wondered what my life would look like without drugs, but I couldn't picture it. What was it like to think clear thoughts, to

never feel the fog roll in, to always have to be exactly who you were? The extent I could imagine it looked terrifying.

As I sat flipping through my magazine, I looked up to see that my neighbor, Diana, a tough Native American biker chick with thick and glossy straight long black hair, had made her way into my room. She was wearing her usual: a Harley tank top, worn jeans, and scuffed leather boots. "Hey, miss." She eyed me sprawled on the floor and then plopped down next to me. Diana was one of my mom's best friends, and she'd seen me grow up since I was three. She never was afraid to voice her opinion, though she'd never given me shit for anything I'd done. I had a feeling that was about to change. Why else would she be letting herself into my room when I was grounded?

"Hi," I mumbled, knowing a talking-to was coming, and I wasn't looking forward to it. I respected her and actually thought she was quite cool, but I really wasn't interested in a judgy lecture or advice or really anything that might shine a light on my stupid choices. I wanted to shut down and not speak at all because I was afraid of what she'd say in response. Was she going to advise my mother to disown me and send me to boot camp like Jack had originally proposed? This conversation was doomed.

She jumped right in. "What are we gonna do with you? What were you thinking, Ginelle? Cocaine? *Acid?*" She leaned in until her face was uncomfortably close to mine, close enough that I could smell her perfume, sweet and a little spicy. A vanilla-cinnamon combo? *Yes, I'm aware*, I thought. I knew I fucked up and should stop, but I absolutely wouldn't admit that because then I'd have to admit it to my mom, and it would kill me to admit to my archnemesis that *I* was wrong and she was right.

I shrugged, avoiding eye contact and playing with a string on my sweatshirt.

"Do you have a death wish?" Her shoulder leaned against mine, putting pressure on me.

"I'll be fine," I grumbled. I knew I had to climb my way out of the hole I'd dug for myself, but I wasn't sure how I was going to do that. She was probably someone who could help me climb, but I wasn't ready.

"Ginelle, you're gonna get into a lot of trouble. Jail, death, sick, who knows. You're scaring your mother half to death."

My eyes darted around the floor. "I dunno," I shrugged. "I don't think Mom really cares."

"Of course, she cares. She loves you. I'm suggesting your mom take you to therapy. I hope you get the help you need."

"Okay," I mumbled, unsure if Mom would actually go through with that and thinking it probably wouldn't happen because I'd never done anything like it before.

"I love you and I'm worried about you. I'm wishing you the best." She got up, walked out, and gently closed the door.

Whatever. I knew she was right, but I hated that she talked to me like I was a delinquent. And I was scared to face the genuine possibility that I had a drug problem. She was forcing me to face it head-on, and I just wasn't ready.

What would it say about me if I became someone who didn't do drugs? Who would I be?

⬤

As I went to sleep that night, I experienced that eerie feeling I'd gotten during my acid trip, like someone was following me and was going to attack. I awoke in a sweat, panting and wondering where I was as I searched my surroundings for something familiar, like my couch or a pile of clothes. I let out a breath when I noticed that, although my room was dark, there was one little

nightlight by the door, and it created just enough light to see the path out my door. I glanced over at the corner near my window and screamed when I saw a demon stooped over, its eyes glowing red. It was staring straight at me, crouching like it was going to attack. I squeezed my eyes shut and pulled the blanket over my head and felt for a moment that I could hear its labored breathing. I thought, *This can't be real. It's not real. You're okay*. I shook my head and my hands as if trying to rattle away the demon. Slowly, I pulled the covers back down and peeped an eye out. No demon. I felt safe to go back to sleep but couldn't really rest because I wondered if the creature was going to come back again. Every few minutes I'd open my eyes. I'd check my clock again and again and watch thirty more minutes pass. Then thirty more. Then thirty more. At around 4:00 a.m., I finally fell back to sleep.

A few hours later, I awoke in a panic. My alarm went off, and I jerked my head around the room looking for the demon but didn't see anything. *Jesus Christ*, I thought, *that was fucking scary last night. I definitely am never doing drugs again*. In my panic, it was hallucinogens I was swearing off, but the horrific experience also squashed my desire to do other drugs. Like when you get ripped on vodka and puke your guts out. The next day you think you never want to hear the word *vodka* again, but you also don't want anything to do with tequila, rum, gin, whiskey . . .

I got myself out of bed and dragged my butt upstairs to get breakfast. I was hoping my mom would still be sleeping, but no luck. She was sitting at the kitchen table, playing on her phone. Dread washed over me as I got closer to her.

"You're going to therapy on Thursday. You don't have a choice," she said flatly, without looking up.

"Ooookay," I shrugged. That wasn't so bad. I wasn't opposed to therapy, although I didn't know anyone who worked with a therapist. Now with Diana and my mother double-teaming on

the idea, it looked like I was going to know someone who worked with a therapist. Me. I had no idea what therapy entailed, but I knew that a therapist was supposed to be supportive, someone I could trust with the truth. And a therapist might be able to help me without my needing to confide in my mom that I wanted to stop using. I guess I was ready partly because I was exhausted. It had been two weeks since I'd tripped, and I was still having flashbacks every day. I wanted the demons gone.

●

That Thursday, my mom and I sat silently in the therapist's waiting room. We had crappy insurance, so we had to choose one of the therapists who worked in our community mental health center, and I assumed that any therapist who had to work there would be too up to their ears in clients to be able to actually listen and help me. *Of course, we'd be at a shitty place like this*, I thought. *We're this kind of people.*

There were broken toys in the playroom, the paint on the walls was peeling, and people who were probably also poor came in and out of the waiting room. Sinking in my chair, I crossed my arms. I didn't want to do therapy with my mom in the room, and I wasn't sure if I'd have to or if I'd be allowed to go at it alone. Mom hadn't said. But there wasn't a chance in hell I was going to talk about drugs with my mother sitting next to me. I wasn't about to say out loud that in the past month I'd ingested enough booze and drugs to land a football team in the hospital.

Everyone in the waiting room looked up when a woman who appeared to be in her thirties or forties entered the room from a door in a far corner. She had short spiked blonde hair and had to be six feet tall in her black boots with chunky heels. Her big white teeth almost looked fake. She seemed kinda cool.

"Ginelle Testa?" she called.

"Hi, that's us." My mom got up, and I uncrossed my arms and followed.

We walked up a flight of stairs, and the woman said, "My name is Scarlett. It's nice to meet you, Michaela and Ginelle."

"You too," I said. I may have been a brat to my mom, but I was polite to strangers.

Once we arrived in Scarlett's office, I sat on a cushioned chair on one side of the room, and my mom took a seat in a similar chair on the other. Scarlett sat in a comfy-looking wheeled chair and said, "I'll be your new therapist. I'm looking forward to working with you." On her desk was a picture of her riding a motorcycle, dressed head to toe in leather gear. I thought she was a badass, but I wondered what was up with these biker chicks in my grill.

"Michaela, you filled me in a little bit on the phone, but I'd love to hear from both of you. What brings you here today?" she asked.

My mother's arms were crossed tight against her chest. "She won't stop using drugs, and her attitude is out of control. She's been getting in trouble for years, and I cannot fucking deal with her anymore," she spat.

Rolling my eyes, I swirled my tongue around my mouth, aggravated but not surprised.

"Okay, thanks for sharing, Michaela. I'd love to work with both of you, but as we spoke about on the phone, Ginelle and I will primarily be working together, so we're going to meet alone for a bit. Thanks for bringing her today." I breathed a sigh of relief.

"All right, thank you," Mom said. They shook hands, smiling, and my mom grabbed her bag, gave me a forced smile, and left.

"Hi, Ginelle," Scarlett said gently. "It sounds like things are tough. Can you tell me in your words what you think is going on?"

"I dunno," I mumbled. "A lot." I wanted to share but also felt a pit in my stomach, unsure if I could trust her.

"Do you want to share any of it?"

Maybe I can trust her. She is a professional.

"I do . . ."

"Everything you say here is confidential."

I pushed my lips out with a big sigh. "Okay." Tears began streaming down my face as I finally let out everything I'd been holding on to for the past two weeks. I said, "I had an awful acid trip, and I'm afraid it's messed me up for good. I'm still hallucinating." The more I told this stranger my personal business, the larger the pit in my stomach grew, but I could also tell that sharing it all with her was releasing some pressure. It felt good to let all that crap out. I was telling Scarlett things I hadn't told any friends or even Nana.

"This sounds really scary. I'm sorry it's happening to you. Do you want to tell me about these hallucinations?" Scarlett sat tall in her seat.

I'd told myself not to open up about the demon thing because I was terrified she'd send me to the loony bin, but I told her about some of the rest of it. "I'm having a hard time driving. My car closes in on me, and I have to pull over." My eyes rested on the carpet as I clenched and unclenched my fists.

"That sounds scary."

"It is." I didn't look up. My heart thudded like a bass drum.

"Is there anything else bothering you?" I felt Scarlett's eyes on me.

"Other than the fact that my mom is the devil?" I rolled my eyes. Scarlett had no idea my mom had scratched my face, cracked my head open, and told me it was my fault her husband left. I'd probably tell her soon. I'd have to wait and see.

"I'm sorry, that also sounds difficult. Your relationship seems strained."

"Ya think?" I sat back in my chair, feeling exposed, like I'd just shown a stranger my underwear. Would this stranger be able to help me? She actually seemed competent and kind. Maybe I'd judged the place too harshly.

"Well, I hope to be able to help both of you, but especially you. Do you plan to continue using hallucinogens?"

I scoffed. "Absolutely not. I was using drugs pretty heavily, but I have stopped entirely."

"That sounds like a good idea. What does heavy drug use look like for you?"

"I dunno, like using them every weekend."

"What kind of drugs were you using?"

"Whatever I could get my hands on, honestly, weed, coke, ecstasy, opiates . . ."

"Okay, I gotcha. And you think you want to stop?"

"I definitely do. This isn't a good path for me."

"Thanks for opening up to me."

I felt some relief but wondered if I should have shared so much. What if she told Mom the extent of my drug use? What if she told the police? Was she allowed to tell the police? Wait, was she *required* to tell the police?

Despite feeling exposed, I had a clear feeling that maybe I could get better, that maybe, just maybe she could help me stop using drugs for good. As I left the office, I felt hopeful. I made eye contact with my mom as she got up and said, "Ready?"

"Mhm," I muttered. I actually felt a pep in my step. *Should I share it with her?* I wondered. *Would that be weird?*

"So, did it go okay?" Mom asked as we got into the car.

"Yeah, actually. I really like Scarlett."

"Good, 'cause you're gonna keep seeing her." I didn't feel ready to open up to my mom yet, so I left it at that.

I continued to see Scarlett one-on-one weekly. Scarlett brought my mom in only when she wanted to help us talk something out, like when I wouldn't come home for several weeks except to collect clothes. I was "staying overnight at Holly's house" five to seven nights a week, I'd said, but most of the time I was sleeping over at boys' houses, whoever was the flavor of the week.

"Ginelle thinks she can just do whatever she wants." My mom leaned forward in her chair, her elbows propped up on her legs.

"What're you going to do about it?" I huffed. "You don't give a shit." I leaned back in my chair as far as I could go. I didn't think she cared what I did because she didn't do much to stop me or to even get involved. When I was gone for six hours or days at a time, she didn't call me or call Holly's parents. She only reamed me out when I did come home, eventually.

Scarlett took a moment before she said, "It sounds like your mom does care about where you are. And Ginelle, from what we've discussed, you feel happy when you stay at Holly's."

"I do," I nodded, tearing up. Of course, I did, because it meant escaping the shithole of a house I lived in, with its piles of cat vomit on the carpet in the basement and moldy-smelling dishes always overflowing in the sink. And now that Jack was gone, we sometimes didn't even have heat in the dead of winter because my mom couldn't afford to pay the bills.

I was grateful Scarlett didn't tell her that sometimes I wasn't *actually* staying at Holly's, that sometimes Holly and I stayed out partying or I stayed at a guy's house. It made my trust in Scarlett grow.

"She should be home," my mom snarled.

"Ginelle, what if you agree to split your time, four days at home and three days at Holly's? Do you think you could do that?"

"I guess." Scarlett was good at helping us compromise, and I was almost eighteen, so I was close to legally being able to do whatever I wanted. I didn't mind compromising a little knowing soon I'd be moving out and wouldn't have to give in anymore.

A few months after starting therapy, my mom and I joined a dialectical behavior therapy (DBT) group Scarlett led. We met weekly to learn to regulate emotions, practice mindfulness, and have healthy relationships. At this point, we still hadn't learned how to get along, but Scarlett helped me cope. I began talking to her about more than just my mom and drugs. I told her about my body image struggles and messy relationships with boys. Scarlett helped me work through what had happened with Anthony, helping me realize that how he treated me was not okay and that I deserved better. She also helped me through whatever trauma I was dealing with because of whatever boy was the flavor of the week—like Tommy, who talked me into dealing ecstasy, or Ethan, who cheated on me.

She helped me understand that eating a few extra cookies wasn't bingeing, and that when I did feel a bigger eating session coming on, I could use coping tools like holding a frozen orange to bring my anxiety down.

And she helped me cope with my mom's attitude by teaching me to breathe and to use tools like taking a hot shower to calm my nerves when I wanted to scream or fight with Mom. I was still chronically mad at Mom, but we were finding some common ground, like my splitting my time between Holly's and my own home.

My alcohol use continued every weekend, but I vowed to stop doing drugs and so, for a while, I did.

After a few months of seeing Scarlett, I also started to see a psychiatrist because of mood swings and potential depression. He was a balding, heavyset dude with a Russian accent. Our relationship was strictly transactional: I told him what ailed me, he gave me meds, and my insurance paid him. I was always as honest as I could be with him because I'd hoped he could help me, too. I told him when I drank, got arrested for stealing or drinking, or had days when I wanted to crawl out of my skin due to body issues or my hang-ups and insecurities about boys.

One of our meetings was on an afternoon in the spring of my senior year.

"Hi, Ginelle. How are you today?" he asked, sunshine peeping through the window behind him.

"I'm okay, I guess." I still hadn't been sleeping. I had to squint because of the bright light in my eyes.

"What has your mood been like?"

"It's been pretty bad lately." I wondered how much I should tell him. I didn't want to tell anyone about the demons that still haunted me months after I'd taken acid. I could just feel that it would be sharing too much.

"What's bad look like for you?"

"Can't sleep, having a hard time getting out of bed." I stared out his window, afraid the dark cloud over my head was going to hang there forever.

"But you seem to bounce back quickly. Sometimes when I see you, your energy is through the roof. Then you have periods like this when you display signs of depression."

"I guess," I shrugged. *Is this depression?* I thought. *I dunno.*

"It's possible you might have bipolar disorder, perhaps bipolar II, but you're too young to diagnose, so let's start treating your depression and anxiety."

"I may be bipolar?" My whole body tensed, and I squinted my eyes, trying not to cry.

I panicked. *What if I'm like my grandfather, the one who beat a man nearly to death and went to jail? The one who choked Nana against a wall right in front of me? I can't be bipolar.*

"I can't formally diagnose you since you're only seventeen, but it's quite possible. Your impulsive behavior goes beyond what is normal for teenagers. Lighting a street on fire, the drinking, the drugs."

I thought, *God, I've been honest with him. Should I have done that? Did I just screw myself? Am I going to be called bipolar because I told him too much?*

"I'm going to start you on a low dose of Prozac to see how that goes in helping your mood."

"Okay," I gulped. I'd never been on real meds before. What if I started to depend on them like my junkie uncle who was addicted to opiates?

The idea that I might be bipolar sickened me because I'd only ever seen bipolar behavior from my abusive and insufferable paternal grandfather. I wondered if having bipolar disorder would make me a bad person like him.

Later that day, I called Nana to process and share.

"Hi, Nan, it's me."

"Hi, Nell. Good to hear from you. How's it going?"

I breathed in and out, as Scarlett taught me. "To be honest, I'm a little shaken up. My doctor said today that I might be bipolar."

She paused. "Okay, that's information. How do you feel about that? Can he help you?"

My shoulders dropped. I was expecting judgment, even though that'd be out of character for her.

"For now, he's only gonna treat my depression. I started a new med."

"I hope it helps, sweetie. Know that you're okay."

"Thanks, Nan." Was I okay?

We chatted a bit more, and then I hung up the phone, feeling loved by Nana, as usual.

I started taking Prozac, and relatively quickly, it seemed to alleviate some of the depression and boost my mood, which helped me to sleep at night. Instead of dragging through the day with a gloomy outlook, I started to have hope for my life. Rather than struggling to get out of bed in the morning, I had more energy.

The hallucinations lasted a year and then stopped. The final hallucination happened when I tried to watch a horror movie with Holly. We were watching *The Ring*, and I saw an outline of something in the corner of my eye to the right of the TV. When I looked over, I saw a snarling demon baring its teeth. I grabbed a nearby blanket to squeeze and started to hyperventilate. I tried to do it quietly because I was embarrassed. Holly must have just thought I was scared of the movie because she didn't say anything. Eventually, I peeped out from behind the blanket, and the demon was gone. I could feel my heart beating a million miles an hour.

But this girl hadn't had her fill of doing drugs. Oh, no she had not.

CHAPTER 11

My senior year flew by, so prom came quickly.

"Dude, I got some Adderall. Wanna snort it together?" Holly asked as we were getting our hair curled by a friend at Holly's house. We were each other's dates, having chosen to leave the guys we were dating at home. John was in my life, twenty-two, and a dropout from the high school I attended. He and I were dating, but we hadn't put a label on it yet.

I paused. Holly knew I was trying to stay off drugs, and she wasn't exactly embracing the role of supportive friend. She wanted to maximize our fun, and that always meant booze and/ or drugs. But I was becoming more cautious. I really wanted to live a better life. And what about the hallucinations? They'd stopped, and I was afraid they'd start up again. "I don't know," I hesitated.

"Come on, just one night. It'll be fun." Holly lifted her eyebrows up and down.

I guessed it was okay, just this one time. Maybe it wouldn't count as a relapse because it was just once.

After our friend finished doing our hair—mine in a curly half updo and Holly's in another curly style—we went into the bathroom, and Holly took out her debit card. She smashed three pills to crumbs, then handed the card and three pills to me. My hand shook as I smashed my pills, which totaled sixty milligrams of Adderall, about triple the dosage that most people I knew took

in a day. I stared at the pile of crumpled bits. *Here goes nothing*, I thought.

She rolled up a dollar bill and took several snorts to get every bit of the drug up her nose. It was kinda grossing me out. *Agh*, I thought, *this was a terrible idea*. What was I going to tell Scarlett? I knew I could still back out if I wanted, but I thought Holly might think I was a wuss, so I grabbed the dollar from her and re-rolled it.

I guessed that on prom night I'd make a home out of the pills, even though I knew perfectly well that the floors in such a home would have gaping holes, and I'd probably crash right through to some dark cellar below.

"You got this," she nudged.

Placing the dollar on the counter, I began to suck the powder up my nose. It took four snorts to get it all in, and I snorted until the sink was clean.

Holly drove us to prom in her car. The Adderall kicked in quickly, and my energy level shot up, and before long we were both wiggling our arms and bopping around to music.

"This is awesome!" I said, drumming the dashboard as if I was playing a solo from a Lil Wayne song, but even as I was floating, I felt guilty that I was betraying my promise to Scarlett. I'd told her I was done with drugs. I'd said it to her as if I really meant it. What would she say if she could see me right now? I was still drinking, but I *had* sworn off drugs "forever."

"I told you!" Holly squealed. "Aren't you glad we did it?" I figured since there were no hallucinations so far, maybe this was no big deal, just some prom-based fun. Maybe.

Maybe not. I hadn't hallucinated on Adderall before, but I was worried any drug could bring out the demons. I was terrified to have the demons back in my life. But not terrified enough to say no to Holly.

Upon arrival, the principal leaned in to smell each person's breath. Holly and I exchanged sneering glances. No smells on us. Weren't we clever? We made it inside.

As the Adderall started to kick in even more, I thought about Scarlett and felt even more guilt. I really didn't want to let her down, but I was also really hyped, as if I'd chugged several energy drinks, and it felt just great to feel so high. I shoved my thoughts of Scarlett to the side.

Holly and I immediately took to the dance floor despite being two of the earliest to arrive, and we danced like maniacs together.

After about an hour of dancing, Holly and I had had enough of prom. We were ready to party.

We walked out to the parking lot where John was waiting to go to the camp with us. He didn't come to prom with me because he had dropped out of our high school on bad terms. I gave him a smooch, and the three of us got into Holly's car and headed up to another friend's cabin in northern New Hampshire. For two hours, I sat in the passenger's seat as Holly swerved in and out of lanes.

"I wonder if John should drive?" I suggested, turning down the music, suddenly becoming aware that Holly's lousy driving might get us killed.

"Nah, I got it," Holly said, turning the music back up.

We drove for a bit more, and then a giant creature on the edge of the road appeared to be just about to step out in front of us.

"Holy crap, a moose!" shouted John from the back seat as the moose backed out of the light.

Holly laughed as she veered past the moose, almost hitting it.

"That was wild," I gasped, letting all the breath out of my mouth.

After another thirty minutes of swerving, Holly rolled the car onto a dirt road that led to a cabin in the middle of the woods, and there we spent the rest of the night drinking around a fire with a few of my high school friends and our boyfriends and boy toys; John was only the latter to me at the time. The drugs kept us up all night until the next day at 5:00 a.m., when we were starving and craving Dunkin' Donuts coffee and bagels.

"I'll drive," said Kara, a friend who had just gotten her license. She was barely sixteen.

"I dunno," said Holly. "I'm not that messed up." But I knew she was still pretty messed up. She'd just downed a beer.

"Just let her drive," I said to Holly. "It's right down the street." I didn't want a repeat of the night before.

Four of us piled into the car, including a guy another friend of ours was dating. He sat in the front. Our friend started up the engine, and Holly begrudgingly strapped herself in the back seat of her own car. I sat in the back seat, too, but didn't bother to wear my seat belt because we were going only half a mile up the road.

We drove for several minutes through a bumpy, unpaved field.

"I need an iced coffee to wake my ass up," said Holly.

"Ditto," I chimed in.

The car continued on the long trail back to the road, and we eventually hit the pavement. It was light out at this point. At first our sixteen-year-old friend seemed to be doing okay behind the wheel, but when she drove around the first bend in the road, the car hit a patch of loose gravel and veered out of control.

We all screamed, and I tensed my body as the car crashed into a ditch on the right side of the road. There was a loud thud and a crunch of the front bumper. Because I wasn't being held back by a seat belt, the impact of the crash flung me from the back seat

all the way through the car and onto the dashboard, then tossed me into the lap of the guy in the front seat. He screamed garbled words.

Stunned, I peeled myself out of his lap and grasped at the door handle. "Owwww," I grumbled, unsure if I'd broken anything. Managing to get the door open, I flopped out of the car and stood up straight. I leaned over to pat each part of my body, starting with my legs. Nothing seemed injured at all, and looking around, nobody else seemed to be, either. Everyone was out of the car and standing, which was a friggen miracle.

"What the fuck did you do?!" shouted Holly at our friend.

"It was an accident!" Kara yelled.

I wondered if the cops would come, and I had a sudden urge to get John to comfort me.

I looked at the smashed car and my confused-but-okay friends, then made a full-blown panic move and took off running as fast as I could.

Oh my god, I thought. *What the hell just happened?* The voices behind me got quieter the farther I ran until they died out completely.

I booked it toward the cabin, pumping, pumping, pumping my tired legs beyond what I thought I was capable of. I just kept running at a full sprint, and when I couldn't sprint anymore, I ran. I ran until I reached a field of weeds up to my thighs. I was a couple of hundred yards away from John and friends still sleeping when I dropped to my knees in the dirt. I looked up at the early morning sky, bright as an interrogation room, and with my hands to my chest, spoke to a God I didn't believe in. I was desperate. "Please, God. I swear I'll stop getting in trouble. I'll stop doing drugs. Thank you for not letting me die, and please don't let me get in trouble for this." Then I stumbled to my feet and darted the rest of the way to the cabin as if someone was chasing me.

Sobbing the whole way, I whipped opened the screen door to the cabin, ran inside, and climbed up a loft ladder to get to John. I shook him awake. "We . . . got . . . in . . . a . . . car . . . accident."

John wiped his eyes as he raised himself from his slumber. "Slow down. What happened?"

My friend Molly, hearing me screaming from the loft next to us, stumbled into the room and said, "Is everyone okay? Where's everyone else?"

"I don't know," I sobbed. "I . . . just ran."

"You just ran? What do you mean?" John asked. He looked shocked. "Are you okay?"

"I think, I d-don't know, I wasn't wearing a seat belt." I think I was in shock.

"Jesus, Ginelle. Let's go downstairs and make sure you're not hurt," John said. The three of us crept down the steep ladder, and John and Molly checked my legs, arms, and the rest of my body.

"You seem okay. Do you think you have a concussion?"

"I-I-I'm not sure." My mind was racing, wondering if everyone else was okay. How were we going to get the car out? We shouldn't have let her drive. That was my dumb idea. *Shit. Is Holly pissed? What if I have a concussion?*

They sat me down, and John tried calling Holly. No answer.

Within twenty minutes, the others weren't back from the accident, and the cops pulled down the winding driveway. I watched two cops get out of their cars, then they pounded on the door, *boom, boom, boom.*

"We're looking for a Ginelle," one of them demanded as Molly opened the door. I was hiding behind her. Still pouring tears, I walked around her and locked eyes with the cop.

"Do you know it's illegal to flee the scene of an accident?" the cop snapped at me.

"I didn't think," I wailed. "I panicked. I'm sorry."

"We'll need to breathalyze you because you're underage. The others were drunk."

I nodded. I didn't want to get into more trouble, so I cooperated.

I blew into the machine, and he said, "Point zero seven. You're under twenty-one, so you're under arrest for internal possession of alcohol."

"Internal possession?" I asked, scrunching up my face. "That's a thing?"

"Um, yes. It's illegal for you to drink." He read me my Miranda rights, cuffed me, and hustled me into the back of his police truck.

The cuffs were loose on my wrists, so I slipped one hand out and pulled at the door. It was locked, so I lifted my hands over my head and waved my arms around, showing my friends I was uncuffed. A moment of humor was just what I needed in this crappy situation. With his back to me, the cop couldn't see what I was doing. My friend and John, who were standing outside the cabin, burst out laughing. The cop turned around, and I let my arms drop, acting innocent. Then I slipped my hand back into the cuffs, and they drove me to the jail.

As the police escorted me into the jail in handcuffs, I walked by Holly in a cell. She looked at me with her eyes squinted like she was angry and then looked down. Kara was in the cell next to her, and she gave me an awkward grin. I was then put in my own cell, out of their view.

I spent the next few hours in a cell. I had nothing to occupy my time, so my thoughts raced. I knew I was in trouble this time. Damn. At least I wasn't hurt. How did I not get hurt? I should have cracked my head open. *Did* I get hurt? They didn't test me for a concussion. I could have one. Would I die if I fell asleep tonight?

"Miss Testa," the cop interrupted my musings. "Your mom's here." Oh god, my mother. What was my mom going to do to me? What was she going to say?

When I saw her in the waiting room, she had a crinkled and scared face of concern but not anger. She seemed much less angry than in the past when I'd gotten in trouble for drugs or drinking. What was going on here?

"Are you okay?" she asked as we walked out of jail.

"Mhm," I nodded.

"The cops said you got in an accident. Is everyone okay?" She was being strangely kind. What was she up to? Was she saving the explosion until we got home? We got into her car, and I avoided eye contact with my nine-year-old sister, who was in the back seat. Boy, did I feel like a piece of shit with my little sister having to see me bailed out of jail. All of this sucked, but my sister seeing me was the absolute worst. I told myself no more drugs, for real this time. I meant it.

I shut the door. "Yeah, yeah. Everyone's okay. I'm glad I'm not the one with the DUI."

"You got nabbed for internal possession, though? That charge is bullshit." Mom started the car and turned the radio on.

I laughed. I guessed I wasn't in trouble. Maybe she'd begun to loosen up on me as I was nearing eighteen and about to go to college. I wasn't ready to be nice or forgive her for years of trauma, but she was trying. On the drive home, I got a group text.

It was from Holly. *I want nothing to do with you ever again. None of you. You're dead to me.*

What? I suddenly became aware of my labored breathing, and the world started to spin. Did Holly mean it? What did I do that was so bad? She was supposed to be my best friend. What was I going to do without her? I thought maybe she was just mad

and needed space. I didn't know what to say to change her mind, so I didn't answer.

In the aftermath of that car wreck, I got a little lucky. Even though I was eighteen at our hearing, I wasn't yet eighteen when we crashed the car, so I was tried as a minor. My dad accompanied me to court, and on the walk into the courtroom, he said, "You know, you didn't have to blow in the breathalyzer. You weren't driving. They had nothing on you." Classic Dad, focusing on how to evade the cops. I would have been embarrassed if someone else had overheard that conversation. How did he even know that?

"Oh," I murmured. "Well, I didn't know."

While we awaited the hearing, Dad and I sat outside the courtroom. The cop who arrested me strolled over to us and sneered, "We're also considering smacking you with a felony for attempting to escape."

My eyes widened. *What?* My stunt with the cuffs was supposed to be a joke.

"We saw your little show on camera in the back of the truck," the cop said, his face all pinched like a big tough guy. He was about five foot one.

My eyes were bulging, but I was speechless.

"Escape? Get the fuck out of here," my dad said. "She's eighteen, you bully. How about I stuff your midget ass in a trash can?"

"Dad!" I shouted. I grabbed his shoulder as he leaned in toward the cop.

The cop put his hands up, gave a smug look, and walked away. We were lucky we didn't get another charge slapped on for threats. I had experienced my dad being angry, but this was next level. I was so embarrassed.

Someone called my name to go into the courtroom, and we went through the trial. The judge looked over at me, down at her paper, and back at me again.

"The arrest was made at 6:13 a.m. What in the world were you doing?"

"Um, just going to Dunkin's, Your Honor." I wondered if I was supposed to say, "Your Honor."

She went on to ask me how I pleaded, and I pleaded guilty, receiving a $350 fine for internal possession of alcohol, which my father promptly paid upon leaving the hearing. I felt relieved that it wasn't going on my permanent record, and that I wasn't in that much trouble. My dad made it out without arrest, and there were no more run-ins with the five-foot-one cop.

I texted Holly in hopes of reviving the friendship.

Hey, just got off with a fine. I'm sorry things ended the way they did. Hope things went okay with you.

My text went unanswered.

I was devastated to lose the friendship; she was my party buddy and someone who was there for me through breakups and bad drinking nights, not to mention I may have had a low-key crush on her. At the same time, I was also well accustomed to losing friends at this point, as I'd lost Natalia, Jocelyn, and Selena.

I was hurt, but I hoped to make new friends in college. With drugs behind me, I saw hope for my future. I wasn't quite sober because I still drank every weekend, but I'd hoped that was my last arrest and that I'd really put drugs down. With Scarlett's help, I crafted a college essay to help me stand out, which I needed, considering I ended high school with a 2.3 GPA.

My essay about how dialectical behavior therapy (DBT) helped me turn around my life got me into a local Catholic university where I wanted to study psychology so I could help people find their way as Scarlett had helped me. She reached under my teenage skin and helped me change my ways. She helped my mother and me stop hating each other. I stopped using drugs (for real this time). For once in my life, I didn't feel like a total loser.

My mom may not have known how to parent very well, but she was the one who put me in therapy and supported me through that process. She showed up to weekly DBT for months on end. As I began my adult years, I started to realize that maybe she wasn't so terrible after all.

I was starting to learn that, although I had made many mistakes, I was not the bad things I'd done. I was not inherently bad just because I lit the street on fire or stole drugs from my dad. Often when you make a mistake, you think you *are* the mistake. This twisted thinking manifested in my acid trip; I thought I was so fucked up that God wanted me to kill myself. But as I was moving on and about to start college, I realized I was at the start of unraveling the truth: the mistakes I made and the family I came from did not define me. I was in charge of shaping my future.

CHAPTER 12

I t was a warm summer night before my freshman year of college. I was working at the pizza shop when my phone lit up with a Facebook message from Diego, the beautiful Peruvian, the first boy I ever had at my house four years back.

Hey! Long time no talk. What're you up to tonight?

Was he booty-calling me? Diego had ghosted me. Now what did he want?

Clicking on his Facebook profile, I crept on his photos. His first one showed him with a backward baseball cap, flowy hair sticking out the sides, and a pair of hipster black-framed glasses on. Holy shit, he'd gotten even hotter over the years. I was in. John and I weren't official yet. We were just hanging out, but we hadn't talked about exclusivity or being each other's boyfriend/girlfriend, so I was up for some action. I had a twinge of guilt, thinking that John would probably be devastated about me hooking up with someone else, but he also hadn't asked me to be his girlfriend yet. On the other hand, I was pretty sure he wasn't hooking up with anybody else.

I answered Diego anyway. I wanted the attention.

Hey, stranger. How have you been? I'm working till closing but free after.

He replied right away.

Wanna come over to my house and watch a movie?

Sure. A movie. *I'm game. Shoot me your address, and I'll let you know when I leave work.*

As I wrapped up at the pizza shop, I wondered what I was headed into. I didn't feel like having sex because I was kind of still mad at him for ghosting me years back, so I decided we wouldn't. *On my way.*

I wondered, was this going to be awkward? Why was he hitting me up now?

When I pulled up in front of his house, I sprayed myself with some fruity perfume from Victoria's Secret, then popped a piece of mint gum in my mouth. I chewed it a few times, then spit it out. I didn't want to seem overprepared, but I also wanted to smell good. I had to play it cool. I coached myself, though I was nervous. "You got this," I said. "If you don't want to stay, just leave. You guys don't have to have sex. It doesn't have to be a big deal that you don't want to."

I walked over to the house and knocked on the glass door he'd directed me to. It led to the basement of his parents' house. I was a ball of nerves. He opened the door with a big smile on his face, and my first thought at the sight of his big grin was that he probably thought we were gonna have sex. This was a bad idea. Was I leading him on? He waved his hand toward his room, and I stepped in.

He went to college at MIT (smarty pants) but was home for the summer. I thought back to us playing video games as kids when he was the first boy to ever come over to my house. Then he blew me off. I grumbled to myself. Why was I hanging out with him?

He was wearing a sports jersey—probably soccer—of a team unfamiliar to me. Those sexy, thick black glasses rested just right on his sexy face. *Ah right, that's why we're hanging out, because he's hot.*

Exchanging pleasantries, we caught up while standing but quickly settled onto his couch.

"What are we gonna watch?" I asked as he turned on Netflix.

"Let's see," he said as he flipped through and landed on a movie. He slipped his arm around me. I settled next to his warm body, self-conscious that, despite dousing myself with perfume, I might reek of pizza and toppings. I also hoped I didn't smell too strongly of perfume. I didn't want him to think I was trying too hard. I wasn't desperate.

We watched the movie for about fifteen minutes before he leaned in to shove his tongue down my throat. Woah, he was an aggressive kisser. I tried to go with it, and we kissed for a few minutes until he pulled me up and said, "Let's move to the bed." I wasn't sure about this. I still didn't want to have sex. I thought we could just make out and have some fun that way without it going any further. Then I thought I was probably fooling myself. In the midst of all this conflicting thinking, I let Diego lead me to his bed.

We lay down and right away he started tugging at my shirt. I helped him pull it off, then he grabbed his own and yanked it over his head. As he pressed his chest to mine, the skin-to-skin contact shallowed my breathing. It was hot, but I was still feeling hesitant, not only because I was still a bit mad at him, but also because I simply didn't want to have sex. I was still telling myself we could have fun without penis-in-vagina sex. Slipping his hands behind my back while still jabbing his tongue in my mouth, he unhooked my bra. I didn't want my bra taken off, but I didn't want to create an awkward moment. Still, I needed to say something.

I put my hand on his chest and pushed.

"Hey, I don't want to go any further tonight, okay?" I relaxed a bit. It felt good to be honest, but I also feared his response.

"Why not?" he asked, taking his hands off my bra strap.

What the fuck? I thought. "I just, um, don't want to." Pulling my hand away from his chest, I tucked it by my side and grabbed onto my thigh for comfort.

"Can we keep kissing?" he murmured.

Ugh. I knew this game. He'd lure me into a state of trust by appearing to agree that kissing was far enough for him, we'd kiss awhile, then he'd push for more. But still I said, "Sure." I was staying only because it felt awkward to get up and leave, and I was worried he'd think I was a bitch or a tease.

He lay on top of me and pressed his pelvis into mine. Then he slid his hand down to the bottom of my belly and started edging the tops of his fingers down my pants.

"Dude, I said no." I pushed him off me. "I'm leaving. This is ridiculous." I grabbed my clothes, tugging them on while collecting my belongings. Then I stormed out the door.

"Ginelle, I'm s-sorry," he stammered as I slammed the door behind me.

Ugh, I thought as I rushed out to my car. *Why are so many guys like this?* That familiar feeling of my body not being mine washed over me as I thought back to the kid at the party creeping his hands between my legs and the time Ray had sex with me when I was blacked out. As I drove home, I felt like I was floating above my body, disconnected from driving. *What the fuck?* I thought. *Why did that just happen?* I wondered if all guys were this way, then I remembered I had one in my life who wasn't. I shot John a text.

Hey there. Whatcha up to?

I began to sort it out in my mind while driving. John was a much better guy than Diego. Why did I feel the need to see Diego again? Why did I put myself in that situation? I guess being with John was a little uncomfortable, as I'd never been with

a guy so consistently nice to me, a guy who wasn't problematic. He wouldn't violate me or cheat on me or hit me. I didn't quite know what to do with the kindness. I also felt maybe I didn't deserve it.

As I drove, my hands trembled. I needed to eat something, so I pulled into 7-Eleven and grabbed a jar of pickles and a package of chocolate chip cookies. I could feel my face turning red as I brought the food to the counter, avoiding the eyes of the pimpled teenage boy clerk. I thought I was such a cow, and he knew it.

"Have a good night," he said, unfazed.

"Thanks," I mumbled as I grabbed my snacks and hustled out of the store.

Tearing open the blue package of cookies before I even got in the car, I shoved one in my mouth. Once the crumbling goodness hit my lips, it was as though I had taken a drink. My shoulders fell from their scrunched, stressed state, and I took what felt like my first breath in hours. Thank God. I saved the pickles for when I got home. Although I was desperate, I wasn't trying to make a total mess of my vehicle.

Tears welled in my eyes, and I tried to stop myself from crying. I decided I wasn't going to cry over that idiot, even though I was probably crying over the fact that yet another guy had violated me. Still, I refused to let him get the best of me, and I thought crying meant he'd won.

I arrived home, shut off my car, and just sat there in the driveway. I barely remembered the drive. I wondered, would all men do this if they had the chance? Why couldn't any of them fucking behave like decent human beings? Why were they always trying to get laid, no matter who they had to violate to do it? *Maybe I should just make John my boyfriend. Yeah. Maybe that'll be safer than trying to put myself out there like this. After all, he's been nothing but good to me.* I shot off a text.

I know we've been hanging out a while. Any chance you wanna like be my boyfriend?

I took a deep breath and went inside. A few minutes later, his text came in.

Of course, Ginelle. I like you.

I felt relieved reading his words and the same time felt guilty about letting Diego shove his tongue in my mouth. I partially blamed myself for going to Diego's house in the first place, not listening to my gut, but I couldn't have predicted he'd be such a jerk. Meanwhile, John had never done an unkind thing to me in the two years we'd known each other. And I didn't appreciate him. But then, I rarely appreciated or even noticed nice men. I wasn't used to them. I decided at this point I was going to try to change my ways. A nice guy was for me. Not because I thought I deserved it, but because I thought I ought to try something different.

I remember seeing an image online of a little girl holding a small teddy bear. God is kneeling in front of her with a giant teddy bear behind his back, trying to remove the teeny bear from her hands so he can give her the bigger one. The girl says, "But I love it, God." That was me with John. He was a big teddy bear, and I wanted to cling to shitty little bears. But at least now I was trying to stop clutching unworthy things.

CHAPTER 13

On move-in morning, I was in my dorm room dancing around to the new Mumford & Sons song, "Little Lion Man," at Ridgewood College, unpacking and organizing. I was so friggen excited; I couldn't believe I'd actually made it to college. I honestly hadn't been sure I'd live to see eighteen, let alone make it to "adulthood" *and* become a college student. I set up my dusty old fan Nana had given me, draped a pink fake feathered boa over my desk, and smoothed out my bedsheet, then topped it with my brand-new pink-and-green comforter. As I was getting my room settled, my roommate arrived.

"Hey!" I called out to the stuffy-looking person who stood in the doorway. "Nice to meet you. I'm Ginelle."

"Hey, Ginelle, I'm Sadie. My parents are just trying to find a bin for us to bring my stuff up in," she said, dressed in a polo and nice unripped jeans.

Standing there in my standard torn-up shorts, I wondered if she was prim and proper. My parents usually made fun of preppy people because they thought preps were rich. To them, rich meant full of themselves, out of touch, and just totally lame. Rich was something we were not.

Wanting to get to know her anyway, I asked, "Where are you from?" Ridgewood matched us randomly, and this was our first meeting.

"I'm from Vermont, and you?"

"Hudson, New Hampshire, just down the street." I felt a little self-conscious that she'd come from a few hours away, but I'd come because this school was right next door, and it was my last chance. I'd gotten rejected from my other choice. I applied to only two schools because I didn't think I had a chance at any others. Ridgewood had an eighty-five percent acceptance rate and was a pretty expensive private Catholic university. I'd have to take out a ton of loans, but I didn't want to go to a community college. I thought attending a community college would label me a failure because you're "supposed" to go right to college from high school. Or so I thought.

"Nice, well I should go meet my parents. We'll talk soon," she said.

We hadn't had enough time to make much of an impression on each other, but her polo gave me a weird vibe. Was she, like, upper-class? Were we going to get along? What did she think of me? For as long as I could remember, I'd been uncomfortable around people I thought had money because my family never really had much. I thought about our heat getting shut off at my mom's house and my dad scrounging for money by selling drugs. Was this roommate going to be someone I'd hate because she drove a nice car or could afford tuition without loans? Ugh.

Settling alone in my dorm, I opened my laptop. I'd been accepted into the school's psychology program. I looked at my course listings and read through my new class schedule, filled with psychology and general liberal arts classes. My arms flopped to my side, relaxed, as I marveled at the idea of having my shit together for once in my life. *I* was a college student, enrolled in a real four-year college. *Not bad, Ginelle. Try not to fuck it up.*

I thought back to an hour earlier, John and my mom helping me move into my dorm room. She was unpacking my boxes

and said she was proud of me. Were my mom and I actually cool now? She even gave me a hug when she left and told me to visit anytime. Weird. I couldn't remember the last time we'd hugged.

I felt bad for her because just as I was leaving to go to college, my little sister and brother moved in with their father, and she was forced to move into a smaller place on her own with just the dog. My stepdad had the money, the fancy house, and the luxury cars, so I understood why my siblings wanted to move in with him. But I think they forgot that he'd disappear for "bike weeks" and leave my mom to parent alone.

I thought about all the nights he was out drinking and fucking other women. All the years he hid money to make sure my mom got nothing. I was starting to have compassion for her. And I worried my mom would be lonely. I made a promise to myself to call or visit her once a month or so.

John helped me unpack boxes, too, but I had weird feelings about our compatibility. Since he had dropped out of high school and never attended college, the only time he'd ever been in a dorm room would have been for a party. I ground my teeth, feeling a twinge of embarrassment at having a high school dropout for boyfriend. Quickly I told myself it was silly thinking because he was a really nice guy. Then I gulped down shame for having the thought at all.

I decided to try to shake my unattractive thoughts about John by looking at jobs on campus. I was outgrowing my pizza shop job, and I figured it was time I deserved a big-girl college job. I clicked open the Ridgewood jobs pages and searched through them. The first title was "Service Learning Coordinator" for a local nursing home. The job was for a liaison who would help coordinate Ridgewood students who wanted to volunteer there. This would be a great job for me—I could help people like Scarlett had helped me. I typed up an application and sent it.

As I was flying high about college and all the success I was going to have, I got a text. From Ray. *That* Ray. Nail-a-shit-faced-girl-at-a-party-then-let-your-friend-record-and-distribute-it Ray.

Hey, lady. What're you up to?

I felt like someone had just pushed me off a building and I was free-falling with my stomach in my mouth. I hadn't spoken to Ray in two years, not since he, well, assaulted me.

Impulsively, I replied. I reasoned that it would be mean not to.

Hey, not much. Just chillin. You?

As I wrote it, I felt like I'd splattered on the ground. Why was I answering Ray? He was a piece of shit. But wouldn't it be rude just to ignore him? Wasn't it unkind to ignore another human being?

Same. Wanna chill?

No, no, absolutely not. Sweat broke out on my forehead. I put my phone down.

Then I picked it up again.

Then put it back down again.

You're better than that, I thought.

I finally put the phone on my desk and walked away to unpack another box. Ray didn't deserve to ever talk to me again. Whether or not it was rape, I felt gross about the encounter and could finally identify that it was very wrong. I realized I didn't ask for it, I was blacked out, and I was a minor. Just being able to articulate these aspects of the incident told me I was growing in self-awareness and self-respect. That little voice inside, my gut or intuition, was speaking to me, and I was finally beginning to hear it. It was barely a peep and only once in a while, but I could hear it at this moment and it said to get the fuck away from him. Plus, I had John. Though I was already full of doubts about my relationship on this first day of college, he was enough, and I didn't need attention or booze from Ray. Ray was dead to me.

Three days into school, I got an email back from the Service Learning Center with an invitation to interview. I signed up for the earliest slot, the next day. My dad was super supportive of me going for a new job, so he helped me prepare by asking me interview questions like, "What's your greatest strength and what's your greatest weakness?" He helped me work through my responses and listened to my raving hopes about getting this job.

As I dressed up in black slacks and a brown button-down shirt, I felt like I might be able to nail this interview. The clothes made me feel like a true professional, a pretty dramatic contrast from the way I felt wearing the black yoga pants and loose red T-shirt I wore to my pizza job.

As I walked to the interview, my thoughts wandered back to John. I grappled with whether or not I should be dating him anymore. Even though we hadn't been dating for long, I felt we didn't align. I was a college student with a head full of dreams—he was a blue-collar worker who dropped out of high school and had no ambition to do anything further than his factory job. *I shouldn't be with him*, I thought. *I think I'm over him.*

But I was also aware that I'd hardly given him a chance after dragging him along for months, maybe years, before finally becoming his girlfriend. I'd hooked up with his friends multiple times when we'd gone to parties together. I'd chased other boys while he chased me. I didn't see how good of a guy he was.

I was aware only of my desire to be deemed successful.

I followed the directions in the email and walked a few buildings down to the Service Learning Center. The campus was small, and I again felt ashamed that this was the only college I could get into, but then I shifted toward hyping myself up. I'd never actually had an interview, so I didn't know what to expect.

My uncle had gotten me the job at the pizza shop. *You've got this*, I thought. *I hope. But what if I don't got this?* I hunched my shoulders forward and clasped my hands, pushing them out to stretch.

It was showtime, regardless of how I felt.

Opening the door to the building, I poked my head in and said, "Hey, Danny?" to a man sitting with papers all over his desk. He had a massive smile on his face, comforting my frazzled nerves.

"Yes." His smile gleamed. "You must be Ginelle. Take a seat."

Straightening my top, I sat in the comfy chair opposite his desk.

"So, why are you interested in this position?" he asked.

"Well . . ." I hadn't thought about what I'd say other than the truth. I froze for a few seconds, trying to think of a summary. "I'd love to help people. Someone helped me get into Ridgewood, and I feel so thankful."

"Okay, love that," he said. I sighed a breath of relief.

"What's your employment history?"

"I've worked at Pippy's Pizza for two years. I'm a cashier, so I have a lot of experience working with people."

"That'll be helpful with this role. Sounds good."

Sounds good? I thought, *Yay!*

"Yeah, I answer phones and ring in customers."

"Great. I don't anticipate this job being too stressful, but there might be times when volunteers don't show up, or you have a lot of tasks. How do you handle stressful situations?"

Hm, I thought. *I think I've got this.* "At Pippy's, it can get stressful, especially on Friday nights. Orders are stacking up, people are overflowing in line, and pizzas are coming out of the oven. I've had to manage that, and I've done well."

"Sounds promising. Thanks for sharing. Okay, so the role. You'd be a liaison between a local nursing home and Ridgewood,

helping students to volunteer. You'd need to work ten hours a week and get paid $7.25 an hour."

"I'd love to." $7.25 hourly was New Hampshire's minimum wage, so this sounded great to me.

"You're hired." He shuffled some papers in the massive heap on his desk. "I'm just going to need you to sign here."

I signed the papers agreeing to take the job, thanked him, and shuffled out of the room. I wanted to squeal and jump up and down. This was my first real job! Holy crap.

In keeping with the way I'd thought about John on my way to the interview, I now thought about him on my way out. I'd just gotten a respectable job to go along with my respectable college student status. And what did my boyfriend do for his job? His lame factory job with no growth prospects, which I assumed he'd still be doing for years while I was pursuing a degree. Ecstatic from the successful interview, I impulsively decided to break up with him. I called John.

"I can't do this anymore," I said. "It's just feeling like it's not right anymore."

"Ginelle, what? Are-are you breaking up with me?" he stuttered.

"Yes," I said, breaking out in tears. I liked John, but I knew it was time to move on.

"But why? What have I done?"

"Nothing, nothing. I just have a lot going on right now, and I don't know."

"Can we please talk in person?" I knew he deserved better than a breakup by phone call, but I also thought that he was desperate, while I knew what I wanted. What good would an in-person conversation do us?

"No. This is it." I hung up the phone. I was feeling pretty ruthless.

After our call, he sent me a flurry of texts.

Ginelle, please.

Why are you doing this?

Let me see you in person.

I got another call from him, so I opened up his contact and pressed Block. I was done. It was harsh, but I didn't care. His being four years older stopped being sexy. His dead-end job wasn't attractive. Nice as he was, his lack of ambition did nothing for me. I had outgrown him.

I didn't care that breaking up with him was impulsive. I had my eye on being a successful college student, and I didn't see him being part of that. I wanted a boyfriend who was in college, dreaming, and shiny. I wanted new friends who were dreaming and shiny, too. Natalia and Selena, my childhood friends who I drank with and got into trouble with, didn't make it to college, so already I felt I was more successful than them. It was time for new everything.

I decided that with all the changes going on in my life, I should be in therapy, but now eighteen, I could no longer work with Scarlett, who was a therapist only for kids. That made me sad. She was my rock, and I was scared I'd relapse back into drugs without her. But it was time to move ahead, so I went back to my dorm room, found the counseling center on Ridgewood's website, and scheduled an appointment with a new therapist.

●

Sitting in my new college therapist's office the following Monday, I felt good to be in a room with such big windows that let so much light in. I was glad to be in therapy because it had been so helpful in the past. This was a much fancier therapy place than my last, and that one had done the job. This should help, too.

Paula was a skinny woman who looked to be in her forties or fifties. She had gentle blue eyes and grayish-brown hair. I hoped our therapy would go deep. I settled into her massive office with an equally oversized red couch, and Paula sat across from me in her chair.

Paula began, "So, what brings you in? Do you want to tell me about yourself?"

"I'm sad I can't see my old therapist anymore. She was awesome."

"Ah, I'm sorry to hear. I hope that I can help you, too. So, you're a freshman?"

"Yep, just moved into Ridgewood. I have kind of a wild history." I wondered how much I should share so quickly, but decided she was probably safe.

"Wild? How so?"

"I'm kind of a recovering addict. I used to use drugs like crazy, but now I'm done with that." I felt proud to say this. I'd truly put down drugs for good, and it hadn't been easy. I'd done a crap ton of work in therapy and climbed that mountain through sheer willpower.

"That's great. Congrats. Do you still drink?"

"Yeah, but my drinking isn't a problem like drugs were. It's pretty casual." I felt confident about this statement. It was just like once a week, so it was under control. "She also helped me with boy stuff."

"Okay, got it. What does 'casual drinking' mean to you?"

"Drinking on the weekends."

"How much do you drink?"

"I don't know, maybe three beers." I was lying. I didn't want her to judge me.

"And how about the 'boy stuff'?"

"I just broke up with my boyfriend. He was kind of a loser. But I do miss him."

"Why was he a loser?"

"He didn't even graduate high school. I'm trying to move on to bigger and better things."

"Okay. How did he treat you?"

"Actually, better than any guy I'd ever been with." I heard myself say that, and right away wondered if I'd made a mistake, but I quickly told myself I hadn't. "But I'm ready to move on."

"If you say so. It might be good just to examine what's going there, though, if anything. How's your mood been?"

"It's been okay. I've been flying pretty high with college here, but I have my down days."

"What does 'flying high' mean?"

"I dunno, like a lot of energy. It was suggested I had bipolar in the past, but I was never diagnosed."

"I see. Thanks for sharing. Do you have a psychiatrist?"

"Not anymore, I suppose I should get a new one." I made a mental note to make an appointment with a new one, then Paula and I wrapped up our session. I was feeling pretty good about our interaction, maybe this would be good!

When I got back to my room, my roommate was at her desk, so I thought this might be a good time to ask whether or not she partied. Her answer was going to give me a pretty good idea about if we were going to be a good match.

"Hey, Sadie. Do you drink?" I peeked at her from the corner of my eye. I loved to drink and would most definitely be coming back to the room drunk, frequently. If she didn't drink, I couldn't imagine the two of us working out as roommates.

"No, not at all."

Yikes, I thought.

"Oh, okay. Well, I drink once in a while," I lied. I drank most weekends, anywhere from three to six drinks on either Friday or Saturday nights, sometimes both. Occasionally I blacked out, and usually I hooked up with someone. Recently, before breaking up with John, I'd gotten drunk and hooked up with a friend of his. I told him what I'd done, and he didn't break up with me over it.

"I can be around it. I just choose not to drink." Sadie gave what looked like a forced smile and said, "The girls across the hall invited me to go with you all to Davie College next week, so I'll go but not drink."

"Oh! Fun. Would you mind DDing?" I asked so that I could get drunk without a worry.

"I can't. I don't have a license."

"Oh dang. Well, I can DD." I thought it'd score me points with the girls if I volunteered. The plans were also on a Thursday, which seemed like an odd day to drink. I usually drank only on weekends, which I was sure proved I didn't have a problem. I was nervous, though, to be around drinking while I was expected not to drink. I'd never done that because I'd never been anyone's designated driver.

CHAPTER 14

It was the night of the Davie College party, and I had agreed to be the driver of my group. It was also my first time celebrating Thirsty Thursday at school, which was a day close enough to the weekend that college students justified it as a drinking night. It was now a week and a half after move-in, and four girls from my floor packed into my car. Tessa, the girl from across the hall, hopped into the passenger seat—she had a vampire poster in her dorm room, so I was excited to befriend her because I loved vampire shows and books. My roommate, Sadie, jumped in the back with Kira and Allison, two other girls I didn't know yet. Tessa told us the Davie College guys were hot and that there would be a bunch of dudes at the party, so I was in. I wasn't sure what her definition of "hot" was, but hoped it matched mine.

Kesha came on the radio, and we all sang the lyrics to "Tik Tok" and danced in our seats. The song was an absolute jam at the time, a wild pop song about partying, so we all got amped up. While driving, I swayed my head to the girly music and thought about whether I might meet a guy that night—someone to be my new college boyfriend. I hoped he'd be studious but still like to party. Handsome, but not a jock. Fun, but didn't do drugs. Fingers crossed.

Although I'd been single for barely a week, I was already over it. I'd had almost no experience being without a boyfriend, and I found it excruciating. No one to give me attention, no one to do activities with, no one to have sex with. I'd had a boyfriend, fling,

or some male attention since I was thirteen. Now I was eighteen, and I didn't even have anyone on the back burner. I felt I was a pathetic and lonely loser, even in a car full of new friends and fantastic pre-party energy.

"I hope they have enough booze," Allison said.

"Oh, they will," said Tessa.

I felt left out, knowing I wouldn't be drinking, so I cranked the music up. While I thought offering to be DD would gain me points with these girls, I also feared I'd text John if I got too drunk, so right there I had two good reasons not to drink. But already I felt my skin crawling with the urge to get wasted. I missed John but didn't want to get back together or give him hope by sending him some drunken *I miss you* message. So, this was good—my not drinking. This was responsible. A good, adult choice.

When we arrived at the barely lit campus of the all-boys school I'd never been to before, I parked and shut off the car, and we all piled out. Sadie put her arm around me and said, "Thanks for driving us, pal." I grumbled. She wasn't even a drinker! She could have been DD if she had her license, so I felt mad at her. I knew it was an irrational feeling, but this girl's lack of driving ambition was getting in the way of my having the best possible time.

We walked over to the door of a sketchy brick building, and two boys came outside to bring us inside. They both had a lacrosse-bro vibe, wearing what looked like their team uniform: navy-blue tank tops that showed their sculpted arms and knee-length sporty shorts that showed their hairy man legs. I judged them instantly, thinking they probably picked up equally sporty women by strutting around in their uniforms. Sporty bros weren't my type because they usually seemed full of themselves. I also never felt thin, fit, or hot enough for them.

They mumbled their names, and I forgot them instantly. I responded with mine and doubted they cared, either. It felt a little sketchy walking in because I didn't know the place or the people, and the moment we walked up a flight of stairs, I felt resentment that I wasn't supposed to drink. That mixed with the pain of being single made the party seem like one big drag. Not drinking just made it worse because I had to actually feel, and my pissed-off feelings about being single were weighing on me like dumbbells on my chest. My thoughts rattled off: *How will I get through this night without drinking? What if I end up in my bed alone?* I rarely went home without some sort of attention or hookup, but without booze or non-jock guys involved, how was I going to get either? I was also paranoid that everyone thought I was a loser for being single. This was going to be the longest night of my life.

Soon we were in the bros' dark dorm room, where rainbow-colored Christmas lights decorated the walls. The bass of their sound system pounded some techno music, and one of the guys broke out a bottle of raspberry Bacardi rum from his desk drawer. He wasn't wasting any time.

"Come on, shots for everyone!" he shouted over the music as he poured about half a dozen shots into Solo cups. I leaned against the wall, crossing my arms and watching the party from a distance like some snotty non-drinker. But, boy, I craved that feeling of alcohol evaporating my worries, each drop of pain slipping away with each taste of rum. Lacrosse bro startled me from my fantasy.

"Come on, you too," he nudged me.

"I can't. I'm DDing," I replied sourly.

"Come onnnn, just one won't hurt you." He picked it up and thrust it in front of me. I thought I shouldn't, but the idea of being drunk sounded lovely, and maybe someone else would drive my car home.

"All right, fine." It didn't take much convincing. Kira and Sadie looked at me like I had ten heads, but Tessa cheered and held her glass to mine. *Screw it*, I thought. I didn't like to drive drunk and rarely did, so I just thought we'd figure it out later. But I knew I couldn't just have one shot. That first shot was only opening the door.

The rum hit fast and hard. One shot had me feeling woozy and light, and I felt at ease after what seemed like just a few minutes. I smiled and craved more of the feeling of ease, especially with the doom of singledom on my mind.

While most of the room was huddled over a lacrosse bro's laptop, trying to change the techno garbage he was playing, I secretly took a swig of the bottle, as I'd done years ago with the banana schnapps in Natalia's room. I gagged and then began making choking sounds as the liquor burned its way down my esophagus, and everyone turned around.

"Ginelle!" Sadie shrieked.

"What the fuck, you're having another one?" Kira said angrily. "Give me your keys. I haven't been drinking much. I'll drive." She retreated to sit on a bed in the corner of the room with Allison. Even in the dim light of the room, I could see my brownie points floating away.

I shrugged, retrieved my keys from my purse, and threw them her way. Then I stopped focusing on finding a boy and instead, my gaze fell on Kira. She was a butch lesbian who wore baggy jeans, a loose-fitting T-shirt, and an athletic wrap in her hair that she kept in an updo. She dripped confidence, which I thought was really sexy. I wanted to be her and be on her. Maybe I could make a home out of Kira.

I was used to making out with girls at parties, which even back then I understood I was doing for attention, but I realized as I grew older that it was also because I liked girls. I thought

I might be bisexual but wasn't ready to accept that possibility because the idea still made me uncomfortable. Was it bad to be queer? There weren't many queer kids at my high school (that I knew of), so I didn't have many examples of what it was like to be queer and out. Of course, I didn't—I was from a little New Hampshire town. I thought my mom would be cool with it, which comforted me, but would my dad and Nana think I was a weirdo, an embarrassment? I didn't know.

Kira was sitting on the bed with Allison on her lap. Were they a real couple? Just dating? Just flirting? Allison had boring brown hair and a flat chest. The only thing she had over me was that she was thinner.

I was always comparing myself to others in this way. Was I thinner? Bigger? How did my thighs compare to hers? Did I have better hair? Who had nicer makeup or fashion sense? If I added up my assets, subtracted my flaws, and threw in a few more calculations relative to whatever girl I was up against in the moment, I could figure out if I was hotter. Thanks to my tits being bigger, I decided I *was* hotter than Allison, so I figured it would be easy to scoop Kira up at some point that night. Maybe I could get her alone somewhere.

As the second shot found its way into my bloodstream, I got comfortable sitting on the bed opposite Kira and Allison. Tessa handed me another shot, and I tipped it into my mouth, then I held back a gag and gurgled at the nasty taste. The cheap rum was strong, and it tasted like gasoline, but I felt great. My limbs were now lighter. The heavy feeling of worry that had taken over my body, that had gripped my shoulders and hands with tension, was now gone. Booze to the rescue again.

"Let's play flip cup!" One of the bros started to clear his desk. Flip cup was yet another ridiculous drinking game designed to get people shit-faced as fast as possible.

"I'm in," shouted Tessa. Kira and Allison still sat quietly in the corner. Allison was nursing a drink, and Kira had her empty hands wrapped around her apparent girlfriend's waist.

"I'm obviously in, too." I smiled and got up from the bed.

While one lacrosse bro finished shoving his phone charger, beer cans, and books off his desk, the other grabbed the rum and filled the cups in front of each of us.

"We're playing with rum?" I asked. "I thought you only played flip cup with beer."

"I'm not playing around. I'm tryna get drunk tonight!" the bro holding the bottle said.

"All right," I shrugged. At only five foot two, I was already struggling to hold myself up, but I still seemed to think I could drink like a big girl. Three shots of rum were enough to get me drunk, and here I was about to slam back a fourth. And then who knew how many after that?

Tessa helped set up the three cups on each side and poured about two shots into each one.

My turn was first, so I got into position, standing up and hunching over the table. Someone screamed, "GO!" I chugged the rum in my red cup, choking on the cheap liquor as I barely got it down, then tried to flip the cup. During the first try, the cup flopped around. The second time, the cup fell onto the dirty floor. The third time, I successfully flipped the red Solo cup upside down and tapped in the next lacrosse bro next to me. I leaned back against the wall behind me as the room around me spun. Holy crap, I was sloshed. My mouth tasted as if it was full of raspberries sprayed with bathroom cleaner. I reached for a nearby cup, hoping to chase the taste with cranberry juice, which I should have been doing all night. I didn't know whose cup I was drinking from, and I choked again when I realized the cranberry juice was mixed with rum.

Despite being extremely drunk at this point, I felt a mix of concern and calmness. I was still worried that I'd text John—because I did miss him—but I couldn't help but smile because I was in friggen college! Woo! And maybe I wasn't going to be single for much longer. Small as my school was, there must be plenty of guys I could make a home in.

Then, I looked over at Kira, who was talking to a lacrosse bro. Allison was across the room, so I decided to make my move. Still leaning against the wall, I squeezed my heavy eyes shut. After that, I blacked out.

I didn't wake up until the following day.

Sprawled across my bed, I clenched my stomach and ground my teeth, trying not to puke. I had a headache that felt like someone was clapping huge brass cymbals between my ears. I thought about the night before, and my memories were very fuzzy. Lacrosse bros. Rum. DDing, whoops. Flip cup. Kira?

I slowly opened my eyes to see Sadie tidying our dorm room. I wondered how we got home. The nausea in my stomach was physical, but I also had that same sinking mental feeling I'd experienced the night after Ray, the feeling that something really terrible had happened. Then I looked down the length of me and saw that I was still in my dress from the night before.

I rolled to the side of my bed to see Tessa sitting on our rug. "What happened?" I asked her and Sadie. *Please don't let it be anything bad*, I silently pleaded. My stomach felt like it was full of termites on the loose, and I struggled to find my breath as the creatures ate away at my stomach lining. Tessa and Sadie looked at each other with their eyebrows raised and paused.

"You don't remember?" Tessa said, bunching up her eyebrows.

"Not much. I remember some things, but I don't remember how we got home." I sat up, grasping my belly in fear I'd puke.

Sadie sighed and said, "Yeah, because you were *supposed* to be DD. Kira ended up driving us home, and you kept coming on to her even though she said no."

Shit, I thought. *I really fucked up.*

"You tried to stick your hand down her pants while she drove your car."

Oh god, did that happen? The sinking feeling I'd woken up with morphed into a drowning feeling. I couldn't breathe. *I'm such a fucking idiot*, I thought as my breathing sped up. Why did I think I could steal her from her girlfriend? Why did I drink so much? Wasn't I the one who told my therapist I had control over my drinking?

"Can I . . . can I apologize to her?" I stammered.

They shook their heads in unison.

"Kira said she never wants you near her again," mumbled Sadie, sitting on the floor and continuing to avoid eye contact with me. Before today, she'd never avoided eye contact with me. I must have really fucked up. Shit.

"Okay. Um. I've gotta get dressed," I sighed as Tessa nodded and left the room in silence.

"I'm going back to bed," my roommate said, clearly trying to avoid me.

"I'm gonna try to get ready for the day," I said. Today was my first day on the job at the nursing home. My first day, and here I was, about to slink in with the shakes, cloudy-headed, and smelling like rum. Fuck. I had just barely woken up in time, as I'd forgotten to set an alarm.

As I pulled clothes out of my drawer, my brain rattled off thoughts. *I guess it's probably for the best if I don't try to apologize to Kira right away.* Avoiding that meant I wouldn't have to face her, so that sounded good right now. *Oh god, she must hate me*, I thought. I couldn't believe I did something so

weird to another person. And what did her girlfriend think? Oh man.

As I was slipping on my black pants, I noticed my calf muscles ached. I wondered what on earth I'd done with my legs the night before. Had I run around naked? It wouldn't be the first time. Jeez. As I pulled my shirt over my pounding head, I clenched my stomach.

I drove over to Dunkin' Donuts and scarfed down a bagel, hoping it would ease the nausea. It didn't. Then, I drove to the nursing home and parked. There were three minutes to go before my very first shift was to start.

I asked the lady at the front desk for the volunteer service office, and she sent me to the basement. When I walked in, I was greeted by a cheerful fifty-something woman with short dyed-blonde hair who said her name was Nadine.

"You must be Ginelle!" She came around her desk and shook my hand.

"I am, I'm happy to be here." *And I kinda wanna die*, I thought.

"We're so lucky to have you, I think you're gonna be great!" She put her hand on my shoulder. "Let me give you a tour."

If you only knew how not great I am, I thought. The contrast between what had happened last night and how she was treating me was startling.

Her cheerfulness was grating, but I pushed through as she toured me through the massive building. I tried to focus and learn what I needed to know about the place, but my brain kept returning to the night before. *Why did you do that?* I wondered. *You're such a goddamn idiot.*

As we walked through the dining room, Nadine said, "I need to get your paperwork ready. Do you want to join the ladies for Scrabble?"

I nodded, while I also thought my brain was not functioning well enough for word games.

I introduced myself to the three women who had to be at least eighty or ninety. They didn't offer to restart the game, so I just watched. At first, watching them play got my mind off the night before. I laughed with them as they ruthlessly placed high-scoring words against one another. But time crawled as Nadine took about an hour to get back to me.

By the time Nadine returned, my headache and bellyache were beginning to lift. And by the end of my three-hour shift, my mind felt clearer. Like many days that had followed many drunken nights, I pushed away thoughts of my awful behavior the night before. In this case, I pushed away the fact that I may have assaulted someone, and I refused to acknowledge that my drinking may have been the cause. I rationalized that I'd just had a bad night, that my despicable behavior had been an exception.

After a few days, I'd mostly forgotten about the incident. I was reminded only when I was on my way to class one morning and saw Kira walking toward me on campus. I wasn't sure if I should cross the street, avoid eye contact, or say something. As she approached, I held my breath while she walked by. She stayed on the far edge of the sidewalk and walked past me as if she hadn't seen another human being there.

After initially seeing Kira on campus, I felt some pressure release. *Well*, I thought, *I got too drunk. What can ya do?* I figured maybe what I'd done wasn't that big of a deal. But the fact was, I was guilty. I'd been a victim of sexual assault before, and

now I was the perpetrator. Kira had said no, and I'd pushed anyway. The more I thought about this, the more disgusted I became with myself. How did I suddenly become all those men I despised, the creep at the party, Ray, Diego, and others? Even though I had experienced kindness from John, most of my encounters with men involved their taking what they wanted and leaving me to clean up the pieces of myself that felt shattered and dirty. Now I'd done that same thing to someone else, and I felt sick about it.

CHAPTER 15

O n the following Monday, I went to therapy. I'd been in
college for a month now. I didn't trust my therapist,
Paula, yet, but I was bursting with emotions after what
had happened with Kira—shame, guilt, fear, and envy, but also
excitement about beginning to accept that I might like girls. It
was all there.

Horrible behavior aside, I'd been obsessing about Kira and
her girlfriend—as a couple. They were out, bold, and unapologet-
ically themselves—queer. Could I be the same, maybe a bisexual?
I didn't know what to think about my feelings, but I had to tell
Paula some of it. Maybe not about the drunkenness, but the liking
girls thing. It only made sense to start with her because it would
be easier to tell a professional than anyone in my family. If I saw
judgment in Paula's eyes, the stakes would be lower. I couldn't
stop thinking about Kira, so I decided to let the truth out.

I had never called myself the B-word (bisexual) or said I
liked girls. Was Paula going to reject me by scowling or trying to
talk me out of it?

I sat in her office and tugged at a string on my sweatshirt as I
worked to find the courage to say the words out loud.

"So, I think I like girls. Like, I wanna date them." Then I
cringed as I thought about the fact that I was attending a Catho-
lic college. Was Paula a strict Catholic, or did she just work here?

"Okay," she said. There was no hint of judgment in her voice or
on her face. I wondered if that was good because she didn't judge

me or bad because she wasn't smiling. I clenched my stomach muscles. "How long have you been feeling this way?" she asked.

I swallowed hard. I asked myself if I should tell her the truth or whether I should keep the rest of it all inside. What if she told a priest at school and got me kicked out? I knew that wasn't likely, but I wasn't thinking rationally. I blew air into my cheeks and let it all out with a rumbling sound. "Truthfully, as long as I can remember. When I was a kid, I used to get in trouble for trying to kiss my girlfriends. I was told I wasn't allowed to do that. Being with women always seemed off-limits 'til now." I thought I was going to cry, but I held it in. "I see lesbians out being themselves on campus, and it makes me want to be myself."

"That's great, Ginelle. Is there anyone . . . in particular you're interested in?"

"No, but I think I'll online date." I assumed it was better not to tell her about Kira, as it was a mess, and I was still embarrassed about it.

"That's a great idea."

"I'm nervous, though. I have no experience with women other than kissing in the shadows."

"You'll get experience. You've gotta put yourself out there to get that experience, and it sounds like you're willing to do that."

"I am." What a relief it was to just tell someone. I always kissed my friends and thought that's just what friends did. Now I knew I wasn't straight, and that's why I wanted to kiss girls. What would it be like to kiss girls in the daylight?

Paula seemed entirely unfazed. Her expression didn't change once. She wasn't warm, though, just sort of nonchalant. I was glad she didn't exile me, but I didn't feel super welcomed by her, either. I guess it could have gone worse, but it felt good to finally have told someone. And feeling brave because of it, I decided it was time to tell my family.

Or maybe I'd just tell Nana. The idea of that conversation made me so nervous I wanted to puke.

Later that night, I paced in my dorm room. My roommate was off somewhere, so I thought it was a perfect time to call my grandmother. Then I took several minutes to work up the courage to dial Nana's number.

"Hi, Nana." My stomach dropped as I second-guessed myself and the wisdom of making this call.

"Hi, Nell. How are you doing?" she chirped.

"I'm okay. How 'bout you?" I squeaked, feeling tears start to burn in my eyes. And then there they were, dripping down my face.

"I'm doing well," she said. "I miss you. When're ya gonna come to visit?" I guessed she couldn't tell I was crying.

"Miss you, too," I said in a high-pitched voice. "Maybe this weekend."

"That sounds good. How's school going? Is everything okay?" Now I was sure she could hear my crying.

"It's going well, actually. I'm killin' it. But, yeah, um, Nan, I wanted to tell you something important."

"Oh? What is it?"

"It's juhhhsst . . ." I said almost incoherently. I paused to regain my composure and let out all my breath. "I'm . . . I'm bisexual."

There was a pause on the other end. *Oh, jeez,* I thought. *Shit. I shouldn't have told her.*

"Okay, Nell. That's okay."

"Yeah?" I breathed a sigh of relief. "I just wasn't sure, you know, with the whole Catholicism thing," I said. The tears were falling faster now.

"I'll dance at your wedding, whether it's a man or a woman," she said with a laugh. Her laugh was full of love, and her comment made my heart feel like exploding firecrackers.

I chuckled through tears and said, "I love you." It felt so damn good to be validated, especially after all those years of fearing what she would say as a Catholic about my wanting to kiss girls. Turned out Nana didn't really care. She just loved me.

"I love you, too. Don't ever forget it," she said, still laughing.

I came out to Nana first because I had hoped for a reaction like this. It turned out my Nana loved me more than she cared about Catholicism's opinions. She'd never made a negative comment about the LGBTQIA+ community, but Lord knows some Christians or Catholics, in general, had a lot to say about it: shame, bad, sinful, broken, ugly, gross. I'd heard it from right-wing conservative churches my whole life. She wasn't right-wing, though. She was just my Nana.

It felt validating to be emotionally held the way Nana held me, and now I had hope for telling my mom. Dad, not so much, as he'd grown up in a homophobic home that still had its claws in him. He'd talked about "fags" and gay people as if they were dirt on his shoe. I decided not to tell him yet. I decided not to tell Mom, either, until I met someone special.

CHAPTER 16

I hadn't used online dating sites before this because their minimum age for membership was eighteen, and for some reason I didn't defy their age rules as I had when I'd used a fake ID to drink and get a tattoo and piercings. But now I was of age. Shortly after coming out to Paula and Nana, I typed into my new OkCupid profile: *Looking for a serious relationship.* When it asked the gender I wanted to see, I set it to women. I wanted to make a home out of a woman. Maybe the foundations would be stronger than anything I hoped for with a man. I thought it must be easier because women just get each other. I also thought it'd be sweeter because women are more thoughtful. Maybe we'd buy each other flowers regularly. That was a nice thought.

Right away I got a few bites, people who would send one or two messages back and forth, but then they'd drop off. For the most part, though, women didn't answer my messages. I wondered if I was just broken, unable to be in a relationship with someone worth my time, someone who also had dreams. Would no one ever love me? For a while, I felt like crap.

Until I met a girl named Penny.

Penny: *Hey there :) I saw that you just started a new school year! How's it going?*

Someone messaged me first?! This was exciting.

Me: *Hey! School's going great. I'm really loving it. Are you in school?*

Penny: *I am. I go to a local community college. I'm trying to save some money before getting into a 4 year. What do you like to do for fun?*

What do I like to do for fun? I wondered. *Drink, I guess.*

Me: *I like to party and hang out with my friends. I've made some new ones here at Ridgewood. What do you like to do for fun?*

Penny: *That's awesome. Drinking can be fun. I like to work out and I work at a garden center. I love plants. :)*

This girl was too cool for me! I didn't really work out anymore, so I'd gained weight. I looked down at the tire of blubber around my waist and wondered if she'd like me anyway.

We continued to chat for a while, and we'd graduated to texting each other off the site. Three days into our texting, Penny texted me a few hours before we were supposed to meet at the beach.

I'm nervous. :) but excited to meet you.

Are you allowed to say that? I wondered. *That you're nervous?* I raised my eyebrows when I read her text because I was never that open with my feelings. I kinda liked it because being vulnerable meant just being honest, and in my few experiences being honest, I'd felt that saying the truth out loud was like opening a pressure-release valve. The muscles in my jaw loosened as I began to type. I guessed I could be honest, too.

I'm nervous, too. And excited!

The whole drive there, I wanted to jump out of my seat and do a dance. I could feel my smile overtaking my face, and I blasted "Love on Top" by Beyoncé to help keep my mood elevated. I bopped my head as I thought, *I can't wait to meet her.* I hoped she wouldn't be scared away when she found out I was a baby queer. My sexual experiences with women had so far been limited to drunken kissing late at night and then never talking about it again.

Penny and I met at a beach between our hometowns around 4:00 p.m. on a weekday. It was April, not quite warm enough for summer clothes, so I was bundled in a sweatshirt. When I pulled up, I saw Penny in her gold Pontiac already there and just sitting waiting for me. My stomach whirled. We both got out and had giant grins. The spring New England winds whipped around us as we leaned in for a hug. Penny smelled like Old Spice, which I knew was a scent men often wear. I liked it and noted that her appearance matched the men's cologne. She wore an orange tee that hugged her thin frame, showing off her flat stomach and almost flat boobs. Her hair was tied up with athletic wrap, and she wore loose jeans that a guy might wear. I leaned in further, and our hug lasted for a few seconds.

"Wanna walk on the beach?" She gestured toward the ocean.

"Yeah." I smiled, stepped in front of her, and scrunched my face with joy when I knew she couldn't see my expression. Our feet made imprints in the sand while we walked together and started talking.

"You know, it surprised me that you told me you were nervous." I laughed and turned around to face her while walking backward.

"Yeah? Why is that?" she chuckled, her soft green eyes meeting mine.

"Because, I don't know. Aren't we supposed to be playing it cool or something?" I let out a few awkward giggles before she cracked up.

"You don't have to do that with me." She beamed.

"I guess I've always tried to play it cool, but it feels kind of good to just be me," I said. A deep breath came out of my mouth, and I chuckled. How was this happening? Penny nodded and stopped walking.

My laughter settled, and I noticed that without a spot of makeup, she looked perfect. I swallowed hard. Oh my god, this girl was too good to be true.

"Wanna sit down?" She motioned to the sand.

"Yeah." I was still kind of trying to be cool, but I was trembling.

We planted our butts on the ground, and I let the grainy sand run through my fingertips, trying to avoid looking at her because I was nervous. Her shoulder brushed up against mine, and we let our shoulders stay connected.

"This is my first date with a girl," I blurted out. My shoulders tightened. I hoped she wouldn't run away.

There was a pause.

I've done it, I thought. *I've scared Penny away.*

"No worries," she said, smiling. "That doesn't matter to me."

My shoulders dropped, and my breathing steadied. *Well, here goes nothing*, I thought as I leaned my head on her shoulder. Her hand slowly glided over to mine, and she laced her fingers through mine. The softness of her skin made me want to become the ocean with her, waves kissing and flowing into one another.

We chatted for a few hours, getting to know each other, then, smiling gently, she said, "Tell me about what it's been like coming out."

"It's been great for the most part. I haven't told my parents yet, though. I was waiting until I met someone . . ."

"Gotcha." Penny hadn't stopped smiling the whole time we were together. Neither had I. We looked at each other under the moonlight when she leaned in and planted her soft lips on mine. I tried not to freak out, as I was still nervous, so I didn't use my tongue.

"Wow," I said, pulling away for a moment. "It's really nice to do that sober."

"I get it, honestly. I kissed girls while drinking before I realized I was gay."

"No way!" I felt relieved. "When did you come out?"

"Only two years ago, when I was seventeen."

Penny was a year older than me, and I started to relax, knowing she had a similar history. This was miraculous. For the first time ever, I felt hope about being with someone who wasn't a guy. Penny was gentle, soft, sweet, and actually doing something with her life—going to school and working. Plus, she was a girl. A girl!

It felt good to be coming out of the closet, finally. I didn't think that the term "gay" described me because I was also attracted to men, but now I was playing with the term "bisexual," and it felt like a fit.

Although it was only our first date, I already felt that, in Penny, I'd found someone worth telling my parents about.

Penny and I got to know each other fast. We spent most nights having sleepovers in my dorm, and I thought it was a miracle my roommate didn't seem to care. Sadie was always around, so Penny and I didn't do more than kiss for the first month. And in those first weeks, even though I was a big drinker, she and I didn't drink together. But we were always busy doing something fun—like going to bookstores or the mall, hiking, or going to hookah bars together. We were starting to build a beautiful relationship, and I decided I'd tell Mom about it first.

My mom and I had started to get along better when I moved into the dorm, which gave us both more space. We still didn't talk regularly, and I visited home only once a month or so, but things seemed to be on the mend because we weren't fighting. During one of my visits home, my mom and I attended a Red Sox game together. I decided that on the ride there, I'd tell her about my bisexuality. I'd tell her about Penny.

"I'm going to another Red Sox game soon," I said.

"Oh nice, that's fun. Are you going with your dad?" she asked casually.

I took a deep breath. "I'm going with the girl I'm dating." I looked down, fidgeting with my cell phone.

"Oh," she said. "Okay, cool." She looked back at me briefly with a smile, then returned her gaze to the road. I figured she wouldn't freak out because she'd historically been much more open-minded than my dad, but I was still nervous about how she'd react the moment she actually heard that her daughter was queer.

Later in the night, as we sat in the stands behind the dugout, she asked, "So, who's this girl you're dating?"

My cheeks felt hot as I said, "I really like her. She's sweet, and she's nice to me."

"That's good. She sounds good for you. Did you guys meet at school?"

This was extraordinary. Here I was, sitting with the mother I'd battled all through my childhood, the mother who had been so awful to me, and we were talking like two mature friends who really respected each other. And she was showing genuine interest in Penny. Wow.

"We actually met on an app." I smiled. "Her name is Penny."

"Well, I'd love to meet her sometime."

As the game went on, I sat there and thought about my mother. Our relationship was really turning around. I genuinely felt that all our two-way abuse was behind us. We could communicate now, even hang out. Weird. I felt warmth in my heart for her, a feeling I thought I'd never have for my own mother. And I felt appreciation for her. This was a good day.

I'd tell Dad about my sexuality at some point, but for now I was content to have entered a new level of honesty with my mother.

The following week, Penny and I rode to a Red Sox game in her gold Pontiac. The car's upholstery smelled like her lavender air freshener, much girlier than the Old Spice deodorant she used. I thought about how we'd mostly spent time in my dorm room, so aside from the deserted beach, this was my debut in public with a girlfriend.

As we walked toward the stadium, we held hands, and I felt like all eyes were on us—which both exhilarated and terrified me. We were center stage, coming out for the opening act. Penny didn't seem to notice or care, but she'd been out longer than I had. We nuzzled up next to each other in the seats and took a cute couple's picture.

"Would you mind if I put it on Facebook?" I asked hesitantly because I wasn't sure if she'd be cool with it. I wasn't even sure if *I* was cool with it.

"Of course! Tag me." She was like a walking smiley face, just like her messages. I smirked and felt relief and fear at the same time.

For the picture's caption, I put a heart and a smiley face. People would know she was my girlfriend, right? I put my phone away and decided to just focus on the game.

That night we slept at her house, where she had a room in her parents' basement. We'd been having sleepovers at my dorm, but this was our first time without any roommates around. I wondered if this would be when we had sex. The logistics of her anatomy and queer sex were a mystery to me. I'd spent years studying and practicing how to please people with penises but knew little about vaginas, even my own. I'd only started to use a vibrator for the first time a few months before, so my own anatomy wasn't very clear to me. This left me feeling like a child who didn't know how to tie her shoes.

I slipped off my sports tee and bra, getting ready to put on a sleep shirt, when Penny softly caressed my arm and gently tugged me toward the bed. She had a fire of desire in her eyes as she tugged off her own shirt, revealing a neon-pink sports bra. *Yup, I* thought, *it's going to happen.*

She laid me down, pressing her skin against me, and gliding her tongue into my mouth. I thought about how flat and firm her stomach was compared with how squishy mine was. But she didn't seem to care as she pushed her body against mine. Although I was worried about my performance, I wasn't worrying about whether I'd want sex. I was all in.

She pulled away from me for a moment, then began planting gentle kisses on my shoulder, moving her way down my arm. As I continued worrying about my belly fat, she planted smooches on it and laid wet kisses against the inseam of my pants.

"Is it okay if I take these off?" she asked. No one had ever asked me that, not even John. It confused me, but it also comforted me and made me feel safe, a feeling I rarely felt when it came to sex.

"Yeah. Yeah, totally." This was really happening! I helped her slip off my pants as jitters filled my body.

"Can I take these off, too?" she asked, pointing at the red lace undies I'd worn just for her.

"Mhm." I bit my lip with a big grin.

"You're cool with this, right?" She slipped my panties off, and I was both a nervous wreck and ravenous with desire.

"I am." Would she just do it already? What was all this asking? I wondered. I wasn't used to so much talk.

Lowering her body to the bed, she placed her head between my legs, and her hands slid under my thighs. I panted hot and heavy as she slid her tongue inside of me and then maneuvered around like she was spelling the alphabet. I closed my eyes, dug

my fingers into the sheets, and laid my head back, moaning. It felt like I'd snorted ecstasy; I could feel pleasure coursing throughout my entire body. I could count on one hand how many guys had gone down on me, and I'd never really enjoyed it because I couldn't get comfortable. I'd always felt unsafe with them because of my history of being assaulted.

I became lightheaded, like I'd had a perfect drink that left me with no worries or thoughts in my head—just warm and fuzzies.

"Just . . . so . . . you . . . know," I said between pants, "I probably won't finish. I never have with anyone."

"All right, no worries." She looked up at me with a big wet grin. "Do you want me to stop?"

I nodded, eager to pleasure her but feeling like a child attempting to play an adult.

"Your turn," I said as I tugged her up toward me. She lay down next to me and I forced a smile, but really, I was freaking out. I thought, *What if I suck at this? What if I don't know what to do? I* won't *know what to do. I've never friggen done this before. Oh my god.* I wanted to learn Penny's skills to please her. I wanted to spell the alphabet on her vagina, but I'd never done anything like it, and in that moment, I felt like a complete imposter, someone only pretending to be sexually attracted to girls.

Her hair was beaded with sweat, and her forehead was pink. Was she wiped out from working on me, or was she really aroused and ready? This was so much pressure.

I made my way down between her legs and helped her tug her pants off. Soon she was lying back wearing nothing but her black men's boxer briefs. God, she was so hot.

I wondered if I should just call it off before I embarrassed myself. I wanted to be with her, but I didn't want to deal with the total awkwardness of being new at something.

"Here," she said, as she slipped her boxers off her perfectly bony body. I looked her up and down and thought she had the body of Paris Hilton. Instead of wanting to be her, I wanted to be on her and in her.

All right, I thought, *here goes nothing.*

I lay on the bed and directed my head between her legs, bracing myself. Pressing my tongue up against her clit, it tasted pretty neutral. I didn't know what I was expecting. I swirled my tongue around as best I could, all while overthinking like crazy: *Is this right? Should I put my fingers in? Which direction do I move my tongue?* I wasn't hearing much of a reaction from her.

"Ugh." I pulled away and crossed my arms, pouting. "I don't know what I'm doing," I grumbled.

"You're fine, babe. It feels good. It's your first time, right? It's okay."

"I feel stupid. I know what to do with a penis. I don't know what to do with your . . . parts," I griped.

"Relax, come on," she said, tugging at me. "Let's just go to sleep."

"Okay." I gave in and snuggled up naked as a little spoon next to her. As we were falling asleep, I felt like I'd ruined something.

I had really prided myself on my sexual capabilities with a penis, so feeling lost in this new situation deflated my confidence and left me not wanting to have sex with Penny at all. Ugh, the idea of starting the learning all over again. I hated being new at something. Who doesn't?

The day after the failed oral sex attempt, I texted Penny.

Ugh, I'm slammed with school and work! Can we hang out next on Thursday?

It was a Sunday night and we'd been seeing each other almost every day. I feared she'd read my avoidance to mean something was up. She would have been right—something was up. I was having my doubts about being with a woman. I was thinking I might have gotten this queer thing wrong. Maybe I did need to go back to dating cis guys. At least I knew what to do with their parts.

After a few days of keeping my distance from Penny, I figured I couldn't avoid her anymore without her thinking something was wrong between us, so we made plans to get together that weekend. In my dorm room, we tossed back shots of vodka and giggled as we felt more and more buzzed. We'd been together for two months, and this was our first time drinking together. I was surprised it had taken so long, but I was enjoying Penny so much that I felt like I didn't really need the booze with her.

There was a foam party happening on my campus, and I grabbed Penny's hand, then dragged her down to the bounce house. I was excited to be out there with my girlfriend, but even with a little booze on the brain, I was still plagued by thoughts of being a fraud relative to Penny. I was suffering from imposter syndrome about being queer. I wondered, *What if I'm just not queer enough?* I worried that people who would see me dancing

with my girlfriend would know I was faking it, just trying to be cool.

Forcing the thoughts out of my mind, I scooped up some foam with both hands and blew it at Penny. She was giddy from the alcohol and seemed drunk in love. Her adoration made me feel guilty because I wasn't sure I felt the same. I felt not good enough, not gay enough, maybe even not affectionate enough.

Dancing like a goofball, I wrapped my arms around Penny's narrow hips. She plopped a wet kiss on my lips, foamy and juicy. I could feel the alcohol dulling my worries, and I suddenly wanted desperately to be sexual with her.

"Can we go back to my room?" I shouted over the music.

She nodded, beaming at me.

As we floundered back into the room, I was full of courage and suggested, "Do you want to take a shower?"

Penny's smile was a beam of sunlight when she wrapped her arms around me. "Yeah, babe. Let's do it."

We giggled as we scampered down the hall and burst into the bathroom filled with drunken women stumbling and chitchatting by the mirrors.

The two of us slipped into one of the showers, and I locked the door behind us. A couple of queers were about to have sex in a Catholic school community shower! *Don't mind if I do*, I thought.

Helping Penny pull off her soaked clothes, I gazed into her eyes, kissed her chest, and hugged her with our almost-naked bodies pressed against each other. As we both peeled off our bras and underwear, I turned the water on.

The water ran like ice at first, and we tried not to squeal, but then the hot droplets hit our skin. I stood on the tips of my toes as we pushed our lips together, the warm water sliding down our faces and arms and backs. I stuck my tongue in her mouth, and

she pushed hers into mine. I wasn't overthinking it for once and was fully there with her as opposed to being trapped in my worried head.

I got down on my knees on the hard tile and gently pulled her legs apart. Water beating down on my head, I went down on her. I just went at it, licking her clit and slipping my fingers inside her. Penny panted and moaned, and I wasn't worried about what anyone outside thought.

My confidence was sky-high as the booze buried my worries. I went down on her for what felt like forever before she pulled me up and began kissing me again. We were passionate for once, without worry. When we were done, we wrapped ourselves in towels and headed back to my room, giggling once again.

As we curled up in my bed, the nagging feeling came back. *Is something missing?* I wondered. *Am I genuinely bi? Or am I faking it?*

We ended up falling asleep in my dorm-room bed all curled up in one another, yet the thoughts continued. *I've gotta get outta this.*

The following week, Penny and I were doing homework together at my school library. I typed a paper on my laptop as she sat across from me, reading from a textbook. Penny leaned forward and rested her hand over mine. I looked up to see she was grinning. I forced a smile in return. Oh shit. I definitely wasn't feeling what I thought I should be feeling at this point. I wasn't feeling what Penny was clearly feeling. Lately, I'd begun to feel more and more disconnected from her and from my queerness. I'm not sure if she noticed or felt something was off. But how could she not know? Was it time I said something about it? Ugh.

My head was spinning. *Do I break up with her? She's so sweet, good to me, and adores me. Plus, damn she's hot. But what about me? Am I happy?* I wondered what I should do next.

Penny asked, "Do you want to hang out with my family this weekend? I think we're having a board-game night."

I paused and tried to think of an ambiguous answer, fast. "I don't know, school is super busy. I have that sociology test on Tuesday. I might be able to. What day?" I felt weird meeting her family at this time.

"Aw, okay. Well, it's Sunday night. I hope you can make it." She squeezed my hand.

"I'll try, babe." I forced a cheerful voice.

I continued to come up with excuses to avoid her and skipped out on the board-game night. I had a trip coming up soon, and I thought I could sort out my feelings there.

●

I'd planned a trip to go away for three weeks to Uganda to teach kids basic English at an orphanage with Haley, a friend from college. We were both studying psychology and wanted to see a third-world country as well as volunteer there. Haley and I fundraised for months and eventually earned enough money to take the trip. I was eager to see how an international non-profit operated and wanted to teach English to the orphanage the non-profit funded.

Penny drove me to the airport, and there was an awkward quietness between us. The only sound was NPR playing in the background. I wondered if she could feel my distance, or if she was just worried about missing me.

I couldn't take the tension anymore and said, "I'll be sure to Skype you at night when I can!"

She looked at me, then back at the road, and said in a pouty way, "I'll miss you so much, you know?"

"I'll miss you, too! What will you do when I'm gone?"

"Probably catch up with friends, do homework, work. Nothing too special."

"Gotcha, gotcha. Gosh, I can't wait to go. I'm nervous."

She didn't respond.

We pulled up to Logan Airport, and she helped me with my bag. "Hope you have a good birthday while you're there." In a week, I would turn nineteen.

"Thanks," I said. "I'll be sad I'm not celebrating with you." I wondered why I was lying. I was actually thrilled that I'd be ringing in a new birthday in a foreign land away from almost everyone I knew. Why couldn't I just tell her how weird I felt about our relationship? I guess I just didn't want to upset her and decided space was the best solution. Maybe going thousands of miles away would let me work through my feelings and figure out what to do.

●

When I arrived, Uganda shocked me more than I could have ever imagined. Dirt roads, people carrying buckets of water on their heads, poverty . . . everywhere. Everywhere I looked there were children without shoes, run-down shacks, and boda boda motorcycles zooming down the road piled with people, bags, and boxes. I'd never seen anything like it—such poverty, such a swarming frenzy of activity.

In Uganda, being gay was punishable by prison or, in some cases, death, so I kept my mouth shut about Penny. Their extreme aversion to homosexuality made me question even further my romantic relationship with a girl. Was Penny right for me? Was I even queer? I was stuck on the idea that if I couldn't properly go down on a girl while sober, I must not be bisexual enough. Shouldn't that part be easy?

About a week into the trip, Penny and I had a video call on my birthday. The time difference was eight hours, I was pretty busy, and I was still avoiding her. We got onto the call, and she had a "Happy Birthday" balloon behind her. Gosh, she was so sweet. Why was I such a jerk?

"Happy birthday, dear!" she beamed when we got on the call.

I couldn't help but smile. "Thank you, thank you. That's really sweet."

"So, how is it? Tell me everything!"

"It's amazing. There's this one little girl, Daisy. I wish I could adopt her, she's such a peach. She's HIV positive, and she doesn't have parents. It's pretty devastating here."

"Damn, well you're doing a good thing."

I looked at Penny, all fresh-faced on the screen, and felt a knot in my chest. The week apart had left me thinking I should probably end things, but seeing her face and hearing her sweet voice had me doubting myself again.

"Well," I said, "it's late, so I should get going to bed."

"Okay, enjoy the rest of your time there!" She smiled.

Nausea rolled through me as I said, "Bye, dear!"

●

In Uganda, I talked only with Haley about my relationship with Penny, and the subject was pretty easy to avoid with everyone else—except for Akiki, the woman who cooked our meals. It was during breakfast that the topic came up.

"Ginelle," Akiki said in her Ugandan accent, with a French accentuation on the *G*, like *Genevieve*. "Do you have a boyfriend back at home?" Haley and I looked at each other with bug eyes.

"Nope, no boyfriend." I shoveled food into my mouth and looked at just about anything but Akiki's face.

"Why not? Surprising. You're such a beautiful girl."

I simply smiled, shrugged, and continued to shovel food into my mouth.

●

No one found me out during the three weeks I was there, but the time away gave me plenty of time to think about what I wanted. After returning to the States, I changed my major to sociology and my minor to social work. I was committed to a helping path. The experience in Uganda made me want to be as useful as possible, and also made me want to do the right thing in my relationship. I made up my mind: no more dating Penny. I'd made time for only that one video call, so I assumed she knew what was coming.

But I took the coward's way out and just did a slow fade. I stopped having sex with her. We still spent all our time together, but I just wanted us to drift into something platonic—to me, that would be easier than breaking her heart with honesty. I think she just kind of got the message, although I'm sure that came after a lot of confusion and doubt, and I know what a jerk I was for not being a better communicator.

We weren't dating any longer but still managed to stay great friends, and we even cuddled together most nights during our many sleepovers. Not long after my Uganda trip, I started to see other people. She knew but didn't pursue other people herself. There was a ton of unspoken business between us, and neither of us was willing to address it head-on.

CHAPTER 18

I t was the summer before my sophomore year of college. I'd been a serial monogamist since age thirteen, and I didn't see any reason to give up what felt like a good thing. Penny had been staying over my place a lot—more or less platonically—for a few months, and I'd been trying to find a new target, dating around but having no sticky luck. For two months, I dated a guy named Jack. Two months after we began dating, and only days after declaring ourselves exclusive, I caught Jack sexting his "friend" after I went through his phone because I had a suspicion. Penny had warned me about him, saying she didn't trust him, and I'd dismissed her warnings as jealousy. Turned out she'd been right.

Within a day, I was back on the hunt. While I sat on my bed, swiping through dating sites, my phone buzzed. It was a text from an unfamiliar number. Was it an ex?

Hey Ginelle, it's Diego. I know it's been a while. How have you been?

Diego? What the heck? We hadn't talked in several years, not since that awful night he'd violated me in his bedroom. I thought he was a disrespectful douche, but I had a bad habit of giving second and even third chances to people who probably didn't deserve them.

On Facebook, I had recently posted a cute selfie with my lips puckered. In the picture, I looked pretty hot and wondered if

that had dragged him in. Men often popped up "randomly" not long after I'd post a thirst trap.

I wrote back. *Hey stranger. I've been good. Long time no talk!*

I felt weird about messaging him back, but I told myself people could change.

I know, I'm glad you're doing well. What're you up to this weekend?

I was having a party that weekend. For about two seconds I debated inviting him, then shot off a text.

I'm having a party at my place Saturday, wanna come?

What was I doing?

Diego wrote back, *Thanks. I'm so down.*

I sent him the address and time and then started reminding myself that people can change. Maybe there was a home to be made out of Diego.

Saturday rolled around, and Penny and I were setting up for the party. She was twenty-one, so she'd bought the beer. We were setting out cups for people to play beer pong when she said, "Do you really think it's a good idea to invite Diego?"

I shrugged. "He's probably grown up a lot since the last time I saw him."

"It's just, the story you told me about him. He sounds like bad news."

Since Penny and I had "broken up," she seemed to have opinions on everyone I dated.

"Like I said, it's been years. People deserve second chances."

"Not everyone," she mumbled.

Penny hadn't dated anyone since she and I had broken up, which I loved, because the thought of her dating or sleeping with other people made me want to punch a wall. At the time, I didn't give that raging emotion any thought. It seemed completely normal that I wanted her all to myself but didn't want to be her

girlfriend. Anyway, she seemed happy spending most of her time with me and never talked about getting back together. Of course, I didn't worry much about what my sleeping with men was doing to her feelings. I had a cuddling buddy and men when I wanted them. Life was good.

The evening rolled around, and people started to filter into my apartment, including Diego. Wow, he had gotten even sexier over the last two years. How was that possible? His tawny-brown skin looked delicious, laced with dark-brown, nicely groomed scruff, and it was impossible not to smile inside at the sight of his swoopy dark hair and charming grin. At five foot ten, he strutted in wearing tight jeans and a black Bruins shirt that hugged his fit body. Oh yeah, we were going to hook up.

Right away I could tell I felt different than I had that night at his house when I'd told him no. I'd told him not to put his hands down my pants. Tonight, I wanted those hands down my pants.

"Wanna be my beer pong partner?" I smiled at Diego.

"I do!" He nodded excitedly.

"Are you any good at this?" he asked, laughing and missing a cup as the game started.

"Usually quite good!" I bragged, also missing a cup. "Whoops." I looked at him and our eyes locked. *God, he's hot.*

"So, what's new? How's college?" he asked. *Look*, I thought, *he's asking about me. He's genuinely curious.*

"Ridgewood is good. And you? MIT?" *Smarty pants*, I thought. I sunk a ball in a cup, and the opponents sank three of our cups, which meant Diego and I each had three more sips ahead of us. We were losing.

"We're not very good at this!" He grinned and elbowed me. The contact made me bite my lip. "School's great. I love the engineering program. It's hard, but I'm managing." He didn't talk about MIT with arrogance. That was hot. As he sunk his next

cup, his shoulder brushed against mine, sending chills through my body. I wanted him.

Then, as if I had an angel and a devil perched on each shoulder, I heard a voice inside my head. "Um, what about that time he violated you? Remember that?" I didn't want to hear the angel, so I drowned it out, even though it continued to emit little peeps. The devil on the other side was much louder. "You've put all that nonsense in the past, and it wasn't that bad anyway. Live in the present! This dashing MIT guy came all this way for you! Give him a chance!"

As I was taking a huge gulp of beer, the opposing team sunk their ball in the last of our cups. We lost. We gulped down more beer.

I turned to Diego. "Do you want to go outside?" I asked, doubting that being alone with him was the best idea.

His eyes lit up. "I do!"

Despite it being my party, I didn't say anything to anyone and just walked out the door, Irish good-bye style. I thought, *Will people come looking for me? What if he hurts me?* Then I cut myself off—*Gosh, stop being so dramatic. He won't.*

Diego and I went outside into the warm summer night. The air was thick, and I could hear crickets chirping in a massive chorus in the distance of the New Hampshire woods. We walked to a lawn in my apartment complex and plopped onto damp grass, which wet my jean shorts, but I didn't care.

"So, do you party a lot at MIT?" I asked, glad he didn't know that my last visit to his school involved a battle with snarling demons and leaving campus in an ambulance.

"I'm in a frat, so, for sure. We party most nights."

Awesome, I thought.

"What about you, big parties at Ridgewood?"

"Not so much. It's kinda lame. But since I have an off-campus apartment, I can throw my own, as you can see," I laughed. He laughed, too, then we both paused. I turned toward him, and he had that hungry look in his eyes. *Oh man*, I thought. *We're going to kiss.*

He leaned in to kiss me and his tongue was slow, less jabby than before. His kiss was more intentional and calculated, less frantic. It felt good as I kissed him back, matching his energy. Then the kissing intensified and sped up. I felt my body tense up. *What if he hurts me?* But as he worked his tongue gently around my mouth, I thought my way out of it. I told myself he might have grown up. Maybe he respected women now. He ran his hand across my stomach and up to my chest, in full view of people driving by, people walking by, but I didn't care. The booze in my system helped me feel sexy and at ease.

I lay back on the grass, and he climbed on top of me. We were both fully clothed, and I wrapped my knees around his sides. Then suddenly I pictured Penny at the party. I wondered what she was doing. Why was I thinking of Penny in this moment? *It's nothing*, I thought. *She's probably worried about me. I'm just being thoughtful, that's all.*

"You're a lot of fun, do you know that?" he said, his words snapping me from my Penny thoughts. He kissed my neck and I giggled and closed my eyes, taking in the feeling of his body pressed against mine. The scruff of his face rubbed against me, and the wetness of his lips made me want to tear his clothes off.

But I missed Penny.

Wait, I missed *Penny*?

We kissed for a bit longer before I said, "Ready to go back inside?"

"Uh, I guess," he said, pulling away.

"It's just, it's my party. I don't wanna be gone for too long." We untangled ourselves from each other and started to get up.

"I gotcha," he said, brushing himself off and standing up.

We walked back to my apartment, and when we stepped inside, Penny was sitting on the couch with a few of my friends, and her eyebrows were bunched together with a concerned look. She looked like she was ready to kill Diego. I returned with an exaggerated toothy smile to let her know all was good.

As the night went on, I drank three more beers, totaling about five or six. I'd intentionally stayed off the hard alcohol to avoid blacking out. People started to leave the party until it was just Penny, Diego, and me. Penny was planning to sleep over, so I kissed Diego on the cheek and said, "So I'll see you soon?"

"Oh," he said, his face bunched up, clearly disappointed. "Okay."

I kissed him again on the lips, then he left.

"Sooo?" Penny asked as we got dressed for bed. "What was he like? I didn't really get a chance to talk to him."

"He was nice. Respectful," I said as I tucked myself into bed, Penny crawling in after me.

"Mmm," she said. "I don't trust him."

"Well," I replied, sliding my arm around her and nuzzling into her chest, "I do."

I got a text from Diego that said, *I had so much fun with you. Can we hang out again soon?*

I didn't reply and fell asleep cuddling Penny.

The following weekend, I visited Diego at his frat house. We went into his room, a really yucky mess of bongs, a hookah pipe, and beer bottles and cans. There was a visible layer of dirt on the ground, and the room smelled of weed and dirty gym socks. *Gross*, I thought.

"How are you?" he asked.

"I'm good, glad it's the weekend. How are you?" I wasn't sure where to put my purse, so I just clutched it.

"Me too! What do you wanna do? We can go for a walk, watch Netflix, light up the hookah, whatever you want."

This visit already felt different than the time he just wanted to Netflix and chill immediately. At least this time he was offering me options. I had choices. "Hm," I said. "Maybe let's walk for a bit?"

"Sure thing. Can I get you water or anything?"

Gosh, I thought, *he really does seem like he changed.*

"I'm okay, thanks. What's living in a frat like? I know you said you party most nights." I was getting ahead of myself, but I wondered if he'd cheat if we dated, if there were many ladies around.

"It's a little wild, but we're really close friends and there for each other in a special way."

Aw, that's cute, I thought.

He gave me a tour of his campus, and as we were walking, a girl with long, beautiful curly brown hair, wearing some sort of sorority shirt, said, "Hi, Diego!"

We stopped, then he gave her a hug and said, "This is Ginelle."

"Hi, Ginelle, I'm Brina." She shook my hand excitedly, and right away I wondered if they hooked up. I was jealous, and he wasn't even my boyfriend. "Well, I'll leave you guys to it," she said with a smile. No, I decided, they probably didn't hook up. Or did they? Did he hook up with a lot of girls?

We continued to walk around the campus, then got back to his room. I said, "Wanna watch Netflix now?" Now I was ready to hook up.

"We can watch it on the couch or in my bed." He grabbed his laptop from his desk. I looked at the filthy couches, and his bed looked clean.

"Let's watch it in your bed," I said. He nodded, we settled ourselves on the bottom bunk, and he pulled the curtain shut around us.

He pulled out his laptop and asked, "What should we watch?"

"I dunno, something light," I laughed, as I figured we'd hook up pretty fast, and I was excited.

"*Great British Bake Off*?" He grinned.

"Perfect."

Diego wrapped his arm around me, and I snuggled in close. It was only a few minutes before I turned to kiss him. We locked eyes, then I planted a kiss on his lips. As our tongues made homes in each other's mouths, he pushed his laptop aside and we pressed our bodies against one another, thrusting our hips. He paused to tug his shirt off, and I took mine off.

As he began to tug at my pants, he asked, "Is this okay?" I couldn't believe he was asking for my consent. Penny had taught me about consent—that people can and do ask for it. Was this evidence that Diego had also learned its importance?

"Yeah," I nodded as he pulled my pants and leopard underwear off both legs.

He leaned over to the side to awkwardly take his pants and underwear off. We didn't have much space. I wondered if I should bring up what happened a couple of years ago. I decided against it.

"Are your roommates gonna care if they come in?" I asked.

"Ginelle," he laughed, "no one cares."

He stuck his hand in the pocket of his pants that he'd just taken off and slipped a condom out of his wallet while he lay next to me. "You good?" he asked.

I smiled and said, "I'm good." I was, for a change. My body felt calm like it did with Penny. My thoughts weren't racing for once.

He slipped the condom on and stuck his penis inside me, pressing his body against mine. I pulled his head closer and planted my lips on his. Our tongues played again, and our hips glided in synchronicity. I moaned, only slightly concerned someone would walk in, but I was having fun. And I felt cared for, something I hadn't been sure could ever be possible with Diego. As our kissing grew more passionate and intense, so did the movement of our hips, thrusting into one another. We kissed and grinded until I heard him groan and felt his body stiffen. Then he rolled over to the side of me, and that was it. I didn't expect anything more.

I didn't want him to go down on me because that made me feel I wasn't in control, so I was glad he didn't offer. The sex was good, better than I'd expected. And I felt more confident with him than I ever had with Penny—I knew how to have sex with someone with a penis, which made me feel like I was good at sex. I derived worth from that. If I was bad at sex, I was a shit person. I needed to be good in bed to be lovable.

We hung out for a few more hours, watching Netflix and laughing, then I went home.

Diego and I continued to hang out, and on the nights I wasn't with him, Penny and I continued with our sleepovers. One night, Penny and I lay in my bed, and our legs were twisted around each other's. The softness of Penny made me want to melt into her and live there forever. Diego was hairy and not so smooth.

"How was your day?" she asked.

"My day was okay, work and school . . . it was a lot. But making dinner with you was a highlight," I smirked as I faced the ceiling. We often made dinner together, or I cooked for her. "How was *your* day?" I turned toward her and poked her chest with my finger.

"Good, I submitted my AmeriCorps application today," she said, facing me. Penny had been feeling directionless when it

came to school and life. She wasn't sure what to study or pursue, so she decided to try to apply for a service year with AmeriCorps. They'd place her at a school in New Hampshire, and she'd serve kids or teens. She hoped to find purpose there.

"You'll def get it!" Our faces were inches apart, and both of them were plastered with smiles. As a friend, Penny felt like home in a way that she didn't as a girlfriend. There was no pressure to perform sexually or be "queer enough." I could just enjoy her company. But I knew the home wasn't mine. It was like I was renting, and I knew that one day she'd find someone else to live there. I knew the day would come eventually, but I hoped it wasn't anytime soon.

"Yeah, wanna get an apartment in Manchester together if I do get the job?"

I didn't hesitate to respond, "Of course." What could go wrong, just two ex-girlfriends signing a lease together post-breakup? To our friends and parents, we asserted that we were just friends, while they all thought we were still dating. Except for Diego. If he thought it was weird that Penny, my ex-girlfriend, lived with me, he never voiced it.

A few months into our new relationship, Diego and I were in his shared room at the frat house, hanging out on the filthy couches. He and his frat brothers had mixed shisha and pot for a killer high, and Diego coughed while blowing out a puff of weed smoke from the hookah pipe he was holding. I sat back, not participating. That acid trip had fucked me up with drugs, so I wasn't interested in doing anything other than drinking.

As I sat back and watched Diego get high, I wondered why he had to smoke so much weed. It was constant, and it pissed me off. Because he was a brilliant engineering student, I thought he should know better than to smoke three times a day. I felt he should be different than his frat brothers; he was gifted. He had intellect. He had a big future ahead, so he shouldn't waste his time or brain smoking weed. More and more I was turning against drugs, not just because of my own dramatic drug mishaps but because my father had been a drug dealer. I wanted to stay as far away from all that as possible.

I was getting nauseated from the skunky smell, so I went to the common area to do homework. All I could think about was how I wanted to advance my life and not be like my dad or even my boyfriend, so I put pen to paper. There seemed to be two Ginelles: party-on-weekends Ginelle and study-all-week Ginelle. Weekday Ginelle had a 3.8 in college and cared deeply about her

future. Weekend Ginelle drank like a raging alcoholic. I could compartmentalize the parts of me to suit whatever was present.

Diego came into the room and kissed me on the top of my head. "You good, babe?" I nodded. I wasn't really good, but I liked him. So I made the excuse that being with him was worth the stoner vibes. Our communication wasn't great; I didn't often tell him how I was truly feeling and wasn't sure if he did the same.

Diego and I lived an hour apart, so we saw each other only on weekends. One weekend we were hanging out, playing Monopoly with his little sister on the floor of his parents' living room.

"What do I do with this card?" his sister asked. She was only seven and was having a hard time understanding the game.

Diego leaned forward and took the card from his little sister's hand. "Here, that's a Chance card. Let's see what it says." Watching how sweet and patient he was with her made me adore him even more.

It was a party night with his family, and they were big drinkers. They were all in the kitchen, and he and I were nursing Coronas in the other room. An hour into the game, his grandma came into the living room and handed me a shot. I had no idea what it was, and that must have been evident on my face. Diego just said to his grandmother, "*Gracias.*" Then to me, "*Tequila, mi amor.*"

I knew "*mi amor*" meant "my love," and I bit my lip. He was so sweet. I wanted to tell him I loved him right there, because I did. For once, I'd actually gotten something right relative to a guy. Diego was totally different than the person he'd been before. He was mature, thoughtful, and really friggen smart.

Later that night as we lay in his bed side by side, with my head resting on his arm around me, I mustered the courage to tell him how I really felt.

"Can I tell you something?" I asked nervously.

"Of course, sweetheart, what's up?"

"Well . . ." I paused. Not sure how he'd react but pretty sure he'd return the sentiment, I said, "I just, I'm in love with you."

"Aww," he said as he kissed me on the forehead. "I'm in love with you, too, Ginelle."

Relief flooded my system, as I felt like I might have finally found my person. The weed smoking wasn't a big deal, right?

Penny and I decided to sign that lease together and move into the apartment. About nine months had passed since Penny and I had broken up, and she still hadn't gone out on as much as one date.

Then that changed.

She came home after a night out and said, "I met someone. We had a threesome at a party. It was pretty weird. But she's cool. We're going out again, just her and me."

"Oh," I squeaked. "How nice." Inside, I wanted to die. Penny, dating? *What?* I couldn't fathom her being with anyone but me. I didn't want her anymore, but I didn't want anyone else to have her. I didn't even feel bad or selfish about this brand of possessiveness. All I knew was that it sickened me to think of Penny with anyone else.

For the following two days, I couldn't sleep. I couldn't eat. I couldn't pay attention in school because I spent all my time imagining coming home to find Penny and the new chick cuddling or having sex. I was flooded with panic over the idea of losing my best friend, my cuddle partner, my warm blanket. Was she going to build something real with this girl? Would that mean there was no more room left for me? What was I going to do without Penny? What would she do without me? Why was everything changing so fast?

Three days after she told me about the new girl, Penny came home one evening and asked, "Did you feed Felix?" We both took care of her cat.

"Yup," I said as I shuffled things around the kitchen. I was full of things to say and felt like I couldn't say any of them to her, Diego, or anyone else. This made me feel cranky and like a loose cannon, like anything would set me off.

"How was your day?" she asked.

With my back to her, I could feel her eyes on me. "Fine, yours?"

"It was good. Can we talk?" Penny stepped next to me and touched my shoulder, but I didn't react. I was fuming with jealousy. The idea of her with someone other than me was making me crazy. It didn't matter to me that my being in a relationship with Diego made this thinking completely unfair and irrational.

I snapped, "I just can't fucking do this anymore, okay?" I slammed the cabinet door and stormed into my room, then jumped into my bed, grabbing a blanket for comfort.

She burst into my room. "I'm not leaving until we work this out."

"Us living together isn't working. It's not going to work." I gritted my teeth and squeezed the blanket.

"Ginelle," she whimpered. My light was off, but I could see her tear-streaked face in the glow of my night-light.

"You need to leave!" I screamed.

"Ginelle, please, let's talk about this," she pleaded through her tears.

The heat was boiling in my ears. I crawled to the edge of my bed, stood up, unclenched my fists, and pushed her. "Enough! I've had enough," I said.

Stunned, she took a few steps back before turning around and quietly closing the door behind her. I hadn't cried yet, but

once I heard the click of the door, I burst into tears. It hit me how desperately sad I was, and I started punching my pillows. *What the fuck*, I thought. What was going on with me? Why was I so friggen upset?

I got a text from Penny the next day.

I'm finding a new roommate for you and I'm moving in with Ashley.

I didn't respond. Within three days, she followed up on that promise. I was going to have a new roommate. I walked around acting angry, but deep down, I was devastated. She was my best friend, and I'd hurt both of us because I couldn't handle the idea of her moving on, of having her own life without me, of having real love. I was so scared of losing her that I'd pushed her away, pushed her literally. My fear became a self-fulfilling prophecy. And she moved in with that stupid girl after knowing her for a week. Penny and I never spoke again.

●

My relationship with Diego continued, and I leaned on him via text to help nurse my broken heart. *Penny and I aren't friends anymore and she's moving out. I'm getting a new roommate.*

I'm sorry, babe, I know she was really important to you.

Yeah . . .

You okay?

I wasn't okay, but I lied because I didn't want him to know how hurt I was. I was embarrassed about it.

I'm okay.

Good ☺ You excited to hang out this weekend?

Yep!

He didn't pry, which was pretty common. While we had fun when we were together, our communication was terrible. We

told each other we loved each other a lot, but I rarely told him what was going on with my mental health or my inner thoughts about the relationship or even school or other aspects of my life. He was surface level with me, too, so I never knew if he was struggling, either.

That weekend I drove to Rhode Island to see him, and when I arrived, I could tell he'd been drinking and smoking for much of the day. His room reeked of freshly smoked weed, and he greeted me with a completely stoned sounding, "Heyyy." He and his roommate were watching a soccer game, beers in hand. I kissed Diego on the head, grabbed a beer for myself, then plopped down on the couch and started texting Jay, a guy I had a crush on. He was a new friend, someone who lived near me in New Hampshire. Maybe he'd be a good replacement for Penny. Maybe he'd give me lots of attention.

He wrote, *You just look the cutest in your new Facebook profile pic.*

Daaw thanks :) Whatcha up to?

Diego wasn't paying attention. He and his roommate were shouting at the TV.

Jay replied, *I dunno, maybe fishing today. Are you around?*

I'm not, I'm in Providence, but bored af.

Ah, I see.

I had a big fat crush on Jay, and we were really flirtatious by text. We hadn't done anything physical, but that was probably only because we hadn't actually met yet. We met virtually because he'd randomly added me on Facebook. He said he'd "thought I was someone else." I knew it was bullshit, but he was cute in a dorky boy-next-door kind of way. He had short brown hair and faint facial hair and usually wore shirts with pictures of fish, trucks, or American flags. He was a raging conservative, and I was a flaming liberal, but I wasn't in it to date him anyway, so I

wasn't too worried. I was just looking for attention and to maybe eventually screw around.

I also had a crush on Nate, a soccer player I'd seen around school and who I'd helped volunteer at the nursing home where I worked. We hadn't flirted or anything, but I wanted to come on to him.

Despite all these feelings of wanting other people because I'd grown weary of all the pot smoking in my relationship, having Diego in my life was too comfortable to let go of. He and I had fun drinking, playing video games, going on trips, and hanging out with his family. But I was beginning to accept that our relationship lacked a very important element of depth.

That night at Diego's, after I grew tired of texting other guys, Diego, his roommate, and I played *The Settlers of Catan* as a drinking game until I threw up. That was usually what we did on the weekends we were together: we drank and then we drank some more.

While I was building my relationship with Diego, I was hired to be a resident assistant (RA) at Ridgewood for what would be my senior year, which involved watching over fifty girls on my dorm floor. Ironically, I was going to be the RA on the floor where I'd wreaked havoc during my freshman year. But now, as a junior, I was ready to be a leader. How far I'd come since my high school days.

Before applying for the RA position, I'd made a name for myself at Ridgewood with excellent grades; my volunteer work-study job, which consisted of helping students volunteer at the nursing home; and extracurriculars, like starting an LGBTQIA+ Alliance club. For the director of housing, I was an easy hire. I was proud of my progress. I wasn't about to give up drinking, but I didn't think my drinking pretty much only on weekends would be a problem. In my eyes, I had my shit together. It wasn't hurting my academics or work life, so who cared that I binged on Fridays and Saturdays (and occasional Thursdays)?

I called Diego. "Baby, I'm so excited—I got the RA job!"

"I knew you would, I wasn't even concerned. You're gonna be great." He sounded high. I rolled my eyes, then tried to convince myself it didn't matter.

"Thanks, what're you up to?"

"Just hanging with the boys." I had grown to trust him, trust that he wouldn't cheat even if there were girls around.

"Nice . . ." I trailed off, losing excitement about my job accomplishment because I was pissed off that he was high.

"Well, I'm super proud of you. Let's celebrate this weekend."

"Thanks." I forced a smile, and we hung up.

Six months into our relationship, Diego graduated from college and moved to Providence, Rhode Island, to take an engineering job. I was thinking about going to grad school for public affairs to continue on the helping path at the policy level. Around this time, the idea of going to Brown came into my mind. I thought if I got into Brown, I could prove to everyone that I was good and smart. The "Loser Ginelle" stigma from high school still hung over me. I hadn't gotten out from the shadow of the girl who'd graduated with a 2.3 GPA and had barely gotten into college. Intellectually, I knew I was now a different person, but I didn't yet feel it in my bones.

●

About a year into our relationship, Diego and I were at Newport Beach, Rhode Island, for the weekend when I let out the truth. "So, I've been thinking," I said, picking at my nails as my stomach churned.

"Oh?" Diego said, sitting back on his beach chair, looking straight ahead at the Atlantic Ocean.

"I was thinking we could open our relationship up. I kinda wanna sleep with someone at school." I wanted to sleep with Nate *and* Jay, but I figured I'd start with one.

"Who?" Diego looked up for a moment. Did this make him jealous? I perked up. I wanted him to feel jealous, which would make me feel like he really loved me. I still thought jealousy meant love, like I did way back with Anthony. I pulled up Nate's

Facebook and showed it to Diego. He was an Italian who also happened to be a babe of a soccer player.

"He's cute. You should go for it." Diego grinned.

That's it? I thought. *I should go for it? Fucking weed, man, it makes him not care about anything.* "Really?" I said.

"Really. Why not? I think we're mature enough to open our relationship. Plus, I love you and want you to be happy." He rested his hand on my arm, and I felt incredible excitement and guilt. Wouldn't a good girlfriend want only her boyfriend? And what about him? The thought of him with someone else made me want to puke. I told myself the pain of that would be worth it, though, if I could get my squirmy ass into someone else's pants.

"I love you, too," I said, laying my hand on his.

"Are there any rules?" His big brown eyes met mine.

"Just don't tell me if you hook up with anyone. I don't wanna know. And of course, we have to be safe." I looked away.

"Okay, yes, of course we'll be safe. And I won't tell you if I do anything. But I'd like you to ask me before you hook up with someone. Just so I'm in the know," he said, squeezing my hand.

"Deal." I smiled and looked back at him.

Then, seeming completely unaffected by the significance of what we'd just said to each other, he said, "All right, dear. Wanna go in the water?"

I shook my head and wondered what was going on inside his. Was he so numbed out he didn't realize that his girlfriend just requested permission to get naked with other people? Where was his outrage, his possessiveness? There wasn't even a sign of hurt in his eyes. I couldn't figure it out, and our communication wasn't good enough for me to ask or share my thoughts. Most of our attempts at serious conversations ended pretty quickly with a laugh and a nod.

The more I thought about it, the more I came to realize that one reason I wanted to be with other people was that Diego was so lackadaisical about our relationship. I wanted to poke the bear, to see if he cared. But he didn't seem to care. What kind of guy doesn't care if his girlfriend has sex with other men? Maybe my proposition had been a test. Well, he'd failed. Now all I wanted to do was stop caring, to be more like Diego and at the same time punish him for his indifference by sleeping with other guys.

I messaged Nate on Facebook.

Just so you know I think you're really attractive.

As Diego waded out into the water, Nate messaged back.

Oh yeah? What're you up to tomorrow?

I bit my smiling lip as I texted back.

I'll be in my dorm. Come by tomorrow night?

We have a soccer game. I can come by around 2 p.m. before the game?

Being back in time to see Nate meant I'd have to cut our weekend beach trip short. Would Diego be okay with that? And I couldn't really justify drinking in my dorm when I waited for Nate because I thought it'd be weird to drink at two o'clock on a Sunday, which meant I'd have to see Nate sober. Boo. I had weird rules about my drinking, like no hard liquor, no drinking Sunday through Wednesday, and no mixing beer and wine. Creating even these somewhat random rules and sticking to them kept me believing I wasn't an alcoholic. So, I'd have to face Nate with a clear head and no liquid courage. Ugh.

The next day, I told Diego I had homework and Nate to do, and he let me go. He seemed chill, per usual.

Two o'clock Sunday afternoon rolled around, and there was a *tap tap tap* on my door. Nate Savellini had a chiseled face covered in a dark beard. His body was slim and packed with muscle, and

he wore his blue Ridgewood soccer uniform. This hookup was a good idea, I thought.

He immediately made himself at home on my bed. We made small talk for about two minutes before he leaned over and began kissing me. Then he climbed on top of me, and we began to pull our clothes off. *This is happening*, I thought. *Oh my god*. I hadn't touched another guy in over a year, yet I fantasized about it all the time. Digging my fingers into his back felt glorious. We stripped down quickly to nothing. He put on a condom, stuck his penis inside me, then began thrusting with force. Before long he flipped me over, entered me again, and grunted like a porn star, saying, "Your boyfriend doesn't fuck you like this, huh?" He was inside me from behind, so he couldn't see my face, which I felt reddening. I didn't answer him. It felt shit that while *inside my body* he felt the need to actually mention my boyfriend—whom he would have known about thanks to my Facebook status—and turn sex into a competition. What the hell did this hookup have to do with what my boyfriend could or couldn't do?

The sex didn't last long, and I couldn't enjoy the experience because he treated it like a porno and said weird shit. I wondered why I had thought this was a good idea. After he came, he lay on my bed for a few seconds, then shot up and started gathering his clothes. Despite the permission slip, I felt steeped in guilt. Girlfriends weren't supposed to sleep with people who weren't their boyfriends. And I wondered what Nate thought of me with a boyfriend. Ugh. He left after a quick head nod.

●

Although the agreement specified that Diego wasn't to tell me about who he hooked up with, a few weeks into our agreement, I decided I wanted to know. One day we were sitting on the couch

in his apartment, drinking some beers, and I felt bold enough to ask, "So, have you hooked up with anyone?"

"Ginelle." Diego glared at me. "You said not to tell you."

"I changed my mind. Well?" I crossed my arms.

"Are you sure?" He raised his eyebrows and chugged some of his beer.

"Positive." I gritted my teeth.

"I don't want you to get mad. I kissed a girl at a bar once. It didn't even feel good."

"You *what*?" Part of me honestly believed he wasn't going to touch anyone else. I'd banked on it, and I knew I couldn't handle it if he did. His touching someone else would mean he didn't love me, that I wasn't enough for him, and that our relationship was broken. Clearly, I had no idea how to do this polyamory thing in a healthy way.

"It was just for a few minutes. And like I said, I didn't like it."

"Whatever." I took my beer into his bedroom and slammed the door. Diego didn't come after me.

Nate wasn't the last of my "permission slip" hookups—there was Jay, the close friend I hooked up with several times despite the fact that Diego had given me permission to sleep with him only once. There was Fred, an ex's best friend, who I met at a bar. I saw it as the perfect opportunity to get back at an ex for cheating on me, so I brought him back to my dorm room. We didn't have sex, but we had a passionate make-out sesh.

At my next therapy session, I told Paula everything.

"Fred slept over, but I didn't tell Diego that part, just that we kissed at the bar."

Paula said, "That doesn't sound very safe. You didn't know this man."

"I knew he was a friend of my ex."

"And that was why you brought him home?"

"He was also quite hot," I laughed, not taking any of this conversation seriously.

Paula wasn't laughing. "You've been sharing a lot of stories like this lately."

"I guess," I said. I felt I was just going through a slut phase, no biggie. "Doesn't everyone sleep around in college?"

"Possibly. But you've expressed several occasions of needing to go outside of your relationship for sex and attention and not being totally honest with Diego about what happened. First there was Nate, then Jay, and now Fred."

"So? We have an agreement."

"But you're not telling Diego the whole truth. You didn't tell him Fred slept over. Why do you think you omitted that?"

Ugh, I felt sick to my stomach. She was right. I was leaving things out. Why was I leaving things out? I was afraid of losing the permission slip, and I couldn't go back to being with only Diego. I'd lose my mind. I was restless, irritable, and discontented, but for some reason I couldn't break up with him. I thought a poly lifestyle with him was the only way to save us.

I responded, "I don't know. I don't know why." I really didn't have enough self-awareness to know what was going on inside me.

"Have you ever heard of the twelve-step program Sex Addicts Anonymous?"

Where was she headed with this? "No . . ."

"I think you should check it out. It's for people who are sexually overactive and who struggle in relationships."

"Really?" I scrunched up my face. "You think I need that?"

"It couldn't hurt to try, right? There's a meeting list online. Hopefully, you can find one nearby soon."

"I guess I could try it."

I looked up a meeting later that night and found one for the following Friday.

On Friday night, I approached the back door of a sketchy church and wondered what I was doing there. I found my way down a dark hallway, lighting my way with my cell phone. The website said the SAA meeting was in the church basement, and I finally found a room with a light on.

I entered the room and saw three older men, probably in their fifties. They looked like regular old dads in New Balance shoes, T-shirts, and jeans. They seemed nice enough, but really, how much would we have in common? They welcomed me awkwardly with half-smiles and waves, and I wondered what their problems were. Were they pedophiles? And where were the other women?

One of the three men started the meeting with the Serenity Prayer, which I remembered right away because Nana had taught it to me years earlier. The connection to her made me feel warm, then I remembered where I was. I decided I would just listen but wouldn't say anything about what my therapist thought were my own sex and dating struggles because it didn't feel like they'd understand. I felt like maybe their problems were different than mine. Plus, I was just checking the meeting out. I listened as the guy in the Red Sox shirt spoke.

"Hi, I'm Dean, and I'm a sex addict," he shared. "I'm here because I struggle with masturbation, porn, and having sex with hookers."

I gripped my seat and tensed most of my muscles. *Hookers? I don't like to use that word*, I thought.

He continued, "I keep cheating on my wife. I can't stop hiring hookers." I cringed again at that word. "I'm addicted to them and don't know how to cope without them." He kept talking,

but already question marks were dancing around in my head about what the fuck I'd just gotten into, so I wasn't fully paying attention.

One of the other guys shared when he was done, "Hi, I'm Paul, and I'm a sex and love addict. I'm still on probation. I know I fucked up real bad." *Oh my god*, I thought, *what in the world did he do?* "As most of you guys know, I got caught looking at porn at work." I thought, *Jesus Christ, I am nothing like these men!*

I don't even remember what the third said, but I'm sure he also talked about "hookers" and masturbation. I couldn't help but feel disgusted and angry with them. They were offensive and gross. I bolted out after the second Serenity Prayer and vowed never to return.

I pushed the idea of SAA out of my head and told Paula it was a dud, and she said I didn't have to go back if I didn't want to.

I didn't tell Diego about the meeting. No surprise there. Telling him about it would have been adult communication, going beneath the surface. Never going too deep meant not talking about a lot of things, which also meant I didn't consider omissions to be lies. We omitted so much so often that conveniently leaving out information about my lovers didn't feel wrong.

Soon after this, I met a girl named Skyler in our Alliance club (an LGBTQIA+ social and resource group I started) who was a Ridgewood basketball player. She had rich brown skin, an afro, and the gentlest brown eyes I'd ever seen. We texted a lot about school, the club, and our interests and hung out occasionally. One day, midweek, when I hadn't seen Diego for a few days and wasn't going to see him until the following weekend, I texted Skyler. I wanted to hook up even though I knew she didn't want to because I had a boyfriend.

Good luck at your bball game cutie :)

She responded back within ten minutes.

Thanks, G. Whatcha up to tonight?

Working for a bit, wanna hang out after your game?

It gets out late. As much as I'd love to, I don't think that's a good idea.

She was willing to flirt with me mildly over texting and occasionally in person but drew a boundary at us doing anything but hug. Ugh. I wanted her so badly.

At the time, I was reading a book called *The Ethical Slut*. It was about communicative and safe nonmonogamy, something I was awful at. That is, I was terrible at the ethical part. But at this point, I felt only a little bad about it. Might as well keep the peace, I thought, and continue to be allowed to do whatever I want. What I was getting out of the book was that it was okay to be a slut—to sleep with who you wanted and not to worry about the consequences, and I don't quite think that's what the author intended.

wanted to apply to Brown for grad school because Diego lived in an apartment that happened to be on the Brown campus, and I thought a degree from an Ivy League school would give me some kind of pedigree, make me worthwhile. I spent six months preparing my application: gathering recommendations, meeting with Brown staff and faculty, and writing a kick-ass personal statement. Daytime Ginelle was rife with productivity and passion for life. Nighttime Ginelle, not so much; drinking was still my favorite hobby.

While I waited to hear back from Brown, Diego offered to pay for both of us to take a ten-day cruise to three different islands: Dominican Republic, Puerto Rico, and the Virgin Islands. I'd hoped it would rekindle something between us, and I was excited for the vacation.

In the Spinnaker Lounge of our ship, he and I clinked our glasses together as we sipped mint mojitos. The lounge was decorated with obnoxious ocean-blue carpets and retro circular chairs, and there was a giant dance floor in the center. Windows lined the walls, and we sat together, peering out to sea.

"I'm so glad we're doing this," he said with a smile.

"Me too. Thanks so much again, baby, for all of this." A pang of guilt crept through my forced smile, knowing I didn't want to have sex with him. We hadn't had sex in months, perhaps because I was constantly thinking about other people. But I figured if

I kept drinking, I might be able to get myself inspired. At this point, Diego and I had been together for eighteen months, and I stayed because I appreciated his companionship. It was comfortable. Our relationship was like a well-worn sweater with holes and stains—a garment you don't necessarily want to be seen in but also don't want to throw out.

There I was, sipping cocktails on a beautiful ship in the Caribbean with my handsome, generous boyfriend, and I wanted to text Skyler. I hadn't been sexually involved with a female in ages, and I felt my bisexuality slipping away, which I didn't like. I didn't yet realize I could be queer no matter who I was dating at the moment—man, woman, or anyone else. And I still felt I wasn't queer enough to be with women because of my failed attempt with Penny. But there was no doubt that I had a legitimate crush on Skyler. She was a hook back into the LGBTQIA+ community, a place where I was beginning to think I wanted to live.

I had no cell service in the middle of the ocean, but I excused myself to "the bathroom" and stumbled to the top of the ship to try to text Skyler.

When I reached the upper deck, I tapped, *Hey sunshine, hope you're doing well. I'm psyched to go to the islands. What're you up to?*

I held the phone above my head and waved it around, trying to find a spot with service. It was useless. I grumbled, tucked my phone in my clutch, and stumbled back to the lounge.

"Hey, babe," Diego said when I returned. "Want another drink?"

"Mhm," I nodded as I sat down and let him put his arm around me. I tried to lean into it, hoping to start feeling more lovey-dovey than I did. I was faking it, trying to feel it. We were sitting with a few people we'd started chatting up at the bar.

"How long have you two been together?" asked our new friend. She was a thicker girl than me, with curly hair, traveling with her sister.

"Year and a half," I slurred.

"Oh wow. Okay, you're cute together." She nudged her arm into mine.

Smiling, I nuzzled into Diego, feeling warmth in my chest for him at that moment. He was a good boyfriend. Why was I an asshole? He knew about the girl I was texting; he just didn't know the severity of the crush. I continued to leave out details, like how I'd sleep with her in a second if she gave me a chance. All this time I'd been trying to make a home in Diego, there had been bad foundations, weak support beams, and leaks in the ceiling.

During our ten days away, we drank about seven hundred dollars' worth of wine, beer, and hard drinks and had fun dancing, making friends, and watching cruise-ship performers until we passed out every night.

Late one night, we were in our private room getting undressed, and the tension of unspoken issues was palpable. Should we have sex? I felt I owed him because he'd paid for the trip. Was he wondering the same thing? I looked over at him, and he paused before taking his shirt off, perhaps waiting for me to make a move. Then I quickly changed out of my dress and into a loose T-shirt and shorts. He did the same, and we went to bed without having sex. I'd lost interest in sex and even attention from Diego because I was making sure I got it from every Billy, Bob, and Sally who crossed my path. I felt a little bad about how I was treating him, but I shoved the feelings down and forced myself to bed.

Two days before Christmas, our boat docked in New York, and my phone sprang to life. Ding after ding after ding, texts and voicemails came in.

From my mom: *Call me back right when you get this. It's an emergency.*

From my cousin: *Ginelle, you need to call your mom ASAP. We need you to come home. Please.*

From an auntie: *Where are you? Ginelle, you need to get back to us.*

My heart dropped. Tightness spread from my chest to my fingertips, then out into the rest of my body. Who died?

Diego heard the wave of dings and peeked his head into the bathroom, where I was standing by the mirror.

"What's wrong?" He looked concerned and reached out his hand.

I pushed away his hand as my head swam. "Hold on," I said.

Fumbling with the numbers and with tears stinging my eyes as I feared the worst, I dialed my mom.

It barely had the chance to ring, but the second felt like an eternity.

She answered after the first ring.

"Ginelle. Where have you been? We've been trying to reach you." She sounded fraught.

"Was in the middle of the ocean. Just got your messages. What's happening?" I gripped the sink as I waited for her answer. Everyone knew I was on a trip, did they forget or what?

"Don't freak out," she said. My heart seemed to stop beating while I awaited her words. "Nana had a stroke. She's in the hospital. They're not sure she'll make it." My stomach twisted into itself. It was like I'd been stabbed in the belly with a knife, fallen overboard, and started to drown. Nana was my second mother, my confidant, my best friend. And she was only sixty-seven. I'd just talked to her a few days before my trip, when she told me to have fun and bring back some sunshine for her.

"W-what do you mean?" I said as hot tears welled in my eyes.

Auntie, my mom's sister, must have grabbed my mother's phone. "Ginelle?" she sobbed. "She might be okay. We're hoping she's okay." My shoulders dropped several inches as I took what felt like my first breath in minutes. There was a pause.

Then my mom spoke again. "It doesn't look good."

"I'll be home as soon as I can," I sobbed.

Diego came into the bathroom and wrapped me in a big hug. I cried and cried in his arms. He and I booked the first plane to Boston. On the taxi ride over to the airport, I texted Skyler.

I think my Nana's gonna die. I'm heartbroken.

She responded when Diego and I were checking into our flight at the airport. I quickly picked up my buzzing phone.

Oh, Ginelle, I'm so sorry. Can I do anything?

I'd love to see you when I get home.

I thought maybe seeing her would cheer me up. And maybe she'd actually hook up with me if I was grieving. My mind was definitely not in the right place.

As much as I wish I could do that, I still just don't think it's a good idea. We need to just be friends. But I'm here for you, as a friend.

I tossed my phone into my purse and boarded the plane.

●

When I arrived at the hospital in Boston, I locked eyes with Auntie, who burst into tears as I did the same.

"Don't freak out, but she's hooked up to a lot of machines. It looks bad." She grabbed my hand.

"Okay." I let out a deep breath and walked toward Nana's room with Auntie holding my hand. When I entered the room, I

pulled my hand away from hers to clap it over my mouth. Across Nana's face was a mask with a big tube; she was hooked up to an IV, and had a wired finger clamp. All around her were terrifying machines beeping and flashing.

This is it, I thought. *She's going to die. Nana's going to die.* I'd never been in a serious hospital setting like this before, and it scared the crap out of me.

I watched Nana's chest rise and fall as I sat in a stiff chair by her bedside, then grabbed her hand. The doctor said her brain function was gone, and she couldn't hear me. But every few seconds, she squeezed my hand, and although the doctor said it was an involuntary reflex, to me it was an embrace. With each squeeze of the hand, I felt she was still with me. For now.

"I'll love you always," I told her.

I felt cold and alone on that dark, silent Christmas Eve. I stayed until almost midnight, and then with my mom, Auntie, and the rest of the family, I went home, figuring Nana still had a few days to live.

She died alone on Christmas morning.

●

A few days later, I sat in the front pew of a church with the rest of my immediate family, puffy-eyed and drenched in tears. The priest droned on about Jesus for a while, and I tuned out. Then, he called me up to the podium. I was the writer of the family and probably her favorite grandkid, so the eulogy was up to me. I was the one who had to stand up there and talk about Nana. My heart thundered as I looked at the crowd for a moment and began reading.

Strangely, I had written the eulogy a few months prior in a public speaking class that had encouraged us to write one about

someone we cared deeply about. It was mostly about me, which most things were, I suppose. I talked about my grandmother, but only in relation to how she helped me grow. It was a bit selfish, which was the feedback I got from my aunt later.

When I folded the paper and headed back to my seat, all I could think about was how much I wanted to go out and get messed up.

CHAPTER 22

For the next three weeks, I binged alcohol every moment I could. I sat in my dorm room on Martin Luther King Jr. Day with the day off from school and work, just lounging, when my phone lit up with a text from my ex, Anthony. I hadn't heard from him in five years.

Hey, Ginelle. It's been a while. What're you up to tonight?

My childhood sweetheart. The one I threw a computer monitor at. The one who choked me with a seat belt while my friend in the car watched in horror. Our relationship had been codependent to the point of "I'll die without you."

We hadn't talked in years. What did Anthony want from me? I shot a text back.

Hey there. I'm off school today, not up to anything.

You're 21 now, right? We should get a drink at Penuche's tonight.

Penuche's was a local bar in Nashua, New Hampshire. I thought about joining him and then wondered if I'd end up dead behind that bar. One of the last times we talked, he'd threatened to kill me and bury my body. *Nah*, I thought. *He's probably grown up a lot since then.*

Okay, I'm down.

What about Diego? I figured nothing would happen between Anthony and me, and Diego wouldn't care anyway. Mostly, I wanted to get out of my head. My grief was an ongoing ache, so I was happy to jump on another chance to drink and drown out

my thoughts about Nana. Skyler had totally friend-zoned me, so I was happy to grab a chance for some attention.

Anthony wrote, *All right, I'll pick you up at eight. Just send me your address.*

I sent him my address and wondered if I was making the right choice. Why was I so quick to open the door to lousy guys from my past the minute they sent me a text? Then again, Diego had certainly changed over the years.

Diego's face popped into my mind. Diego and Anthony had been friends in high school, so I texted Diego.

Hey, babe. Tonight I'm going to Penuche's with Anthony. He wants to celebrate my 21st.

My twenty-first birthday had been six months earlier. A bit of a stretch, but it was my excuse.

Diego wrote, *Okay. Have fun.*

Ugh. Did he care about me at all? I still became furious that no matter who I hooked up with during our relationship, Diego barely blinked. But I didn't recognize the care he gave in the form of showing up for me when my Nana died, putting up with all of my bullshit, and cheering me on when I'd achieved something.

Anthony texted that he'd arrived, so I made my way outside.

When I opened the door of Anthony's car, the woodsy scent of his cologne excited me, but then the chemical stench of old, burned cigarettes wafted into my nose. He shoved most of the junk off his seat and threw it in the back, but there were still three empty water bottles on the floor where I was to put my feet. I sat down, leaned over, and we both shifted in different directions before we hugged, my arm awkwardly draped across his center console.

The lines of his jaw showed in between flashes of the street-lights above, and I thought it was hot. I saw his shaggy brown hair resting around his collar and wondered what it would feel

like between my fingers. A blue-and-white flannel shirt hugged his body, particularly the curve of his soft dad belly, much squishier than before and quite cute. After a good look, I turned to face forward before he caught me peeking.

"I've applied for grad school at Brown," I said. "I can't even believe it. Remember when I barely graduated high school?" I sat up in my seat and looked over at him.

"Damn, good for you," he said with a nod. "I've been managing a restaurant. Things have been going pretty well for me."

"That's great. I'm happy for you. I plan to move in with Diego and live with him on campus at Brown. He already has an apartment there." He already knew we were dating from Facebook. Brown was going to make me worthy—finally. I was sure of it, and when I told people my plan, I perked up, waiting for them to be impressed.

"Oh, nice. So, you're twenty-one. That's weird, huh?" He hadn't even acknowledged what I said. I scrunched my hands into fists out of tension.

"If by weird you mean awesome, then yeah." I stared out the window and rolled my eyes.

We got to the bar, and I let out a sigh of relief. Alcohol always made awkward situations easier. I guess part of me hoped to rekindle something with my abusive ex, though I wasn't ready to admit that.

I flagged down the bartender and ordered a Long Island iced tea. He ordered the same. We slid into a booth, drinks in hand, and as the chilled glass hit my lips, I could feel the tension drop from my shoulders.

"Okay, Long Island iced tea. Not a sissy drink. I'm impressed," he smirked.

"Oh, shut up. What even is a 'sissy'?" I held my fingers up in air quotes. "I try not to drink hard liquor much because I tend

to make an ass of myself, but here goes nothin.'" We clinked glasses.

"If not hard liquor, what do you usually drink?"

"I try to stick to beer because then I don't get too drunk." I wasn't following my own rules that night. Occasionally, I did break the rule, and I was making an exception to see an "old friend." It didn't make any sense.

Before long I'd downed a second, third, and fourth Long Island iced tea. My face resting on my hand, propped up on the table, laughing loud at his jokes, I stared at him. I was coming in and out of a blackout at this point. I remember some of it, like eventually finding myself on his side of the booth, unsure of how I got there.

"So, Miss Non-Sissy Drink . . ."

"I told you, the word 'sissy' is offensive," I laughed. It wasn't funny, but I wanted to keep things relatively light.

"Whatever, are you still a pickle freak? I considered bringing you a jar." I pushed him and laughed.

"Aw, that's sweet," I said. How thoughtful. When he turned back toward me, our faces were close. I leaned in and planted a kiss on his lips. He kissed me back, this time with his tongue. He tasted of stale cigarettes and alcohol. I ran my hand through his unwashed hair.

I had one more drink, and then everything went black.

I woke up the next morning in a stall in my dorm's community shower, surprisingly dry, wrapped in my striped comforter, my pounding head resting on the cold tile. My bare butt was on the floor. *Where the hell are my clothes?* I wondered. There were chunks of vomit spread across the comforter and a sharp pain between my ears.

I laid my hand on the ground and lifted my heavy head off of the tile with all my might. Wrapping the puke-stained comforter

around me, I prayed that no one else was awake. My thoughts rattled off: *I'm the floor's RA! Did someone see me naked? Or drunk? Or both? Oh, man.*

Trembling, I lifted myself from the ground. The tiny stall spun around me. I peeked through the crack to check for movement. Not a soul to be seen. My head continued to throb as I made my way toward the door leading to the hallway. Leaning against the door, I held my breath. Opening it a crack, I peered down the hallway. Empty.

I lifted the blanket over my head and struggled to step one foot in front of the other until I got to my room. I slammed the door behind me and dropped to the floor. What had I done the night before?

I forced myself up to put some clothes on and then stuffed the vomit-soiled comforter into the laundry basket. Then I lay down on the stripped bed and pressed my palms firmly into each temple. Within minutes, I felt vomit charging up from my stomach and I ran to the trash can, then leaned over it, dry heaving and wondering, *Ugh, can I be dead already, please?* Picking up my phone, I read the time: 8:30 a.m. Below the time were missed texts and calls from both Diego and Anthony. What the hell did I do? Not just the booze, but what did I do with Anthony?

Anthony wrote, *Are you okay? You were friggen drunk last night.*

Then Diego: *Did you get home okay last night?*

Bits of the night peeked through my clouded brain. I remembered making out with Anthony in our booth. *Shit. What else did I do?*

I couldn't think about this right now. I had to be at my job at the nursing home at nine. I stumbled around my room to gather clothes. It was time to set aside Nighttime Ginelle and pretend to be Daytime Ginelle. I pulled on a pair of comfy pants that

passed as non-pajamas and threw on a T-shirt that said, "Love Is the Movement." As I was a student worker, the dress code was lax. Right when I arrived at work, my boss sent me home, telling me I may have the flu.

As I walked with shame through our campus, a disappointed voice whispered, "You cannot keep living like this." It sounded like Nana's voice, and the tone wasn't angry. More sad than anything. *Nana?* I thought. I stopped walking and looked around, sure I'd gone nuts. Suddenly, I had an overwhelming feeling that she could see what I was doing. All the drinking. All the cheating. All the hangovers at work. All the cold-tile-floor wake-ups. Everything.

"Nana's" words stuck with me throughout the day. What *was* I doing? Cheating on Diego, regularly drinking to the point of blackout, and getting involved with Anthony again. What if Nana could see all of that? She'd think I was a hot mess express. And she would not be happy about it.

I tried to nap away the thoughts and the hangover for a few hours before my 2:00 p.m. appointment with Paula, but I still couldn't shake Nana's voice: "You cannot keep living like this."

I dragged myself to the appointment, still wondering what paranormal shit was going on. Paula's face dropped when she saw me. I must have looked awful.

"What's happening?" she asked as I settled on the couch. I decided not to tell her about the voice, fearing she'd send me to a loony bin. I exhaled deeply.

"I fucked up last night." This was new for me—acknowledging that what I did to Diego was wrong. "I feel terrible. I cheated on Diego again." Calling it cheating was also new for me. I was tired of my own shit.

"What happened?"

"I went out drinking with my ex-boyfriend, Anthony. I naively thought nothing would happen, but we made out at the bar and did God knows what else. I blacked out. It was a mess." Hot tears welled up in my eyes and streamed down my face. I reached for a tissue. For once, I was actually scared of myself. Why did I keep blacking out? This couldn't be normal.

"Have you been doing things like this a lot? You used the word 'again.'"

I didn't want to look at her. I hadn't been honest with Paula about my drinking. I didn't tell her how often or how much. I didn't tell her about the blackouts.

I closed my eyes. *Ugh, this is so hard. Why do I keep doing this? What did I do now?* I slumped into the chair and covered my face with my hands. Snot came rushing out of my nose as sobs tumbled out of me.

"I just . . . I don't understand why I keep cheating on Diego." I glanced up at her, then back at the floor.

"Is this mostly happening when you're drunk?" Paula asked.

I nodded again and swallowed hard.

Paula continued, "You know, I didn't think about it until now, but it seems that while you don't get in trouble every time you've been drinking, every time you've been in trouble, you've been drinking."

"Hm, I guess so." I sniffed and wiped my leaky eyes.

"If your drinking is causing you so much trouble, it might be helpful to go to the twelve-step group Alcoholics Anonymous. There are a bunch of meetings here in Nashua."

My shoulders tensed, and my fingers gripped the couch. "Uhhhh, what?" AA? Seriously? AA was for lifelong boozers who'd lost everything. AA was for drunks who live under bridges. AA was for old people. "Are you sure? I'm only twenty-one."

"Age doesn't matter if you're getting yourself into messes. It might help."

"Like SAA helped?" I grumbled.

"It shouldn't be like that."

"But you think I *should* go to AA?"

"It can't hurt to try it." She was smiling.

"Ugh, fine," I agreed, letting out a sigh. I was out of ideas at this point and was willing to try anything. I'd go. I'd find a local meeting and go. But what if the people were as weird as they were in Sex Addicts Anonymous?

strode toward the entrance of the Church of the Good Shepherd, which was just a few streets away from Ridgewood. An AA meeting was scheduled for 7:00 p.m. on Wednesday, the day after my appointment with Paula, so I decided to try it. I found it on a New Hampshire Alcoholics Anonymous website. *Here we go*, I thought. I let out a loud puff of air, then stood and stared at the church's front door. Ugh, why me? Why did I have to go through this kind of thing? I reached for the door handle and pulled. Terrified to face the people inside this place, I pulled the door as if it weighed three thousand pounds. What if I found myself stuck in the middle of a bunch of gross old guys talking about hookers again? Or good god, what kinds of drunken mess stories was I in for? It would have been so easy to turn right around and walk out, but then I remembered that my life was falling apart.

This meeting was in a dusty side room on the church's ground floor. When I arrived, everyone was chatting and laughing like old friends. They were bundled around a table with a coffee pot and three boxes of cheap knock-off Oreos. The median age in the room must have been about fifty. What the hell was I doing in a meeting for old drunks?

I walked over to the padded chair closest to the door in the back in case I needed to make a run for it. With only a minute left before the meeting started, no one had said anything to me. So far, so good. I'd arrived late and made sure not to look anyone

in the eye for fear they'd talk to me and I'd have to tell them why I was there. I was embarrassed that I was making a mess of my life and had already landed myself in AA at the age of twenty-one. What a loser.

I coached myself. *Breathe. You're okay. If you end up being a weird alcoholic like them, you'll be okay.*

What would happen if I became one of them anyway? Would all the fun be gone? No more parties. No more bars. Would my friends ever talk to me again? I really didn't know.

A gray-haired man who seemed like the group leader said it was time to start. Everyone found their seats. He said his name and then, "We're going to start this meeting with a moment of silence followed by the Serenity Prayer." I scanned the room. Many people shut their eyes, and others looked seriously down at the floor. I gripped my worn, cushy seat. Then everyone started saying the Serenity Prayer. *Nana*, I thought, as my stomach lurched. God, I missed her. I caught the end of the prayer and said it with them—*wisdom to know the difference.*

Then the leader read a long passage from a sheet of paper, something about no cross talk and rules for the church. Nothing he read struck me until, "The only requirement for membership is a desire to stop drinking." Those words made my stomach lurch worse, because I was pretty sure I had the desire to stop, and that scared me. What would I be without booze? A boring, stripped-naked weirdo with no friends, probably. It was a social lubricant, an escape, a pal. A pal that had been by my side for *eight years*. My longest relationship, for sure.

Suddenly, I realized we were going around the room and introducing ourselves by our first names. Everyone was saying their name, then "I'm an alcoholic." I felt my breathing speed up as my turn got closer and closer. I wasn't an alcoholic; I just blacked out now and then and had a pattern of doing idiotic,

unethical, and dangerous things when I drank. But I figured that *not* saying I was an alcoholic would only draw attention to me.

When it was my turn, I said, "Hi, I'm Ginelle. I'm an alcoholic." As I spoke the words, I could feel my toes trying to dig into the floor through my shoes. I told myself I was only saying it to blend in. It wasn't real. Was it?

Everyone in the room chimed back at me, "Hi, Ginelle!" and I forced a smile.

Once everyone in the room identified themselves, a woman who looked to be in her fifties with dark-brown hair, a tired face, and an oversized tie-dye T-shirt told her story about her alcoholism. When she talked about her out of control drinking as a teenager, I remembered the time I drank so much I ended up blacking out and getting assaulted by Ray. Then I remembered being in the car accident after prom. Hmmm. I had drinking stories, too.

Maybe I could fit in here, I thought. Maybe.

As she talked about the "wreckage of the past," I thought about some times I'd lied and cheated in my relationships. My drinking had certainly caused plenty of "wreckage," as they called it. I thought back to my little sister seeing me get bailed out of jail, my showing up to work hungover, and all the puking.

After the woman finished sharing, everyone clapped. Then the leader said, "The meeting is open. Again, no cross talk." I wasn't sure what that meant, but it seemed anyone in the room could say something about themselves or how they identified with the speaker. Folks raised their hands and shared stories of driving drunk with kids in the car and being unfaithful to their wives.

Holy crap, I thought. *Are these people talking about these things out loud?* I'd never heard people be so damned honest about their drinking experiences and their bad behavior. I never told anyone

but Paula about the shameful things I'd done, yet here they all were, blabbing their issues to a room full of strangers.

After about thirty minutes and four stories, I realized I could identify with almost every story I was hearing. I related to the feelings of fear, hopelessness, and sadness that drinking always seemed to leave in its wake. After an hour, the meeting began to wrap up, and we all stood. The two people on either side of me grabbed my hands, and I felt both comforted and nervous. We formed a big circle and again said the Serenity Prayer. A warmth radiated through my chest as I was once again reminded of Nana. But fear overrode my warm and fuzzies, and after the meeting ended, I slipped out as fast as I could. Huge contrasting feelings were battling in my chest and my stomach. The idea of being one of those people was comforting but also kind of made me want to throw up. If I gave myself over to this group and everything they appeared to practice, it meant I'd have to give up drinking. What would that life look like? Then again, what would my life look like if I *didn't* stop drinking?

I thought about Paula. She'd been so subtle in the way she encouraged me to try AA. But I knew she wanted me to commit. Of course, she did. And she'd been smart not to push me but instead to tell me it couldn't hurt, that it might be worth a try. It had been worth a try. The meeting had felt like a therapy home-work assignment, but it had turned out to be good. Surprisingly good. It had made me think back to all the shit I'd done: the blackouts, the cheating, the assaults from both ends with Ray and Kira, the waking up on bathroom floors.

Later that week, I went to another meeting in a church, this one also on the ground floor. I'd only heard of twelve-step meetings in basements, so this one literally felt like a step up. We met in a massive room with cafeteria-style tables. The meeting probably held fifty alcoholics, chatting and drinking coffee. I'd

arrived late again to avoid having to talk to people, and I sat on a fold-out metal chair near the door. Once again, I was in a room surrounded by people over fifty, which made me wonder if I might be the youngest known alcoholic in New Hampshire. Where were the other twenty-one-year-old alcoholics?

I sat through the meeting and listened to the old people talk about how drinking had caused them to lose their jobs, houses, and families. I hadn't lost any of those things, so once again, I thought I might be in decent shape. But they also talked of "spiritual loss of values," which they said was about the alcoholic doing something that goes against their value system. *Ding ding!* Cheating fell under that category. I felt like shit about cheating on Diego, and I was starting to realize I didn't want to be the kind of person who cheated on their partner or who lied about what she'd done, even if *just* by omission. I wanted to be a person defined by dignity and grace, which these people said AA helped them to be.

I thought I should raise my hand to share, to let people know who I was, so I sheepishly inched my hand up, kind of hoping not to be called on. Then about halfway through the meeting, the leader pointed at me.

"Um, hi," I mumbled. "I'm Ginelle." *Do I say the other part?* I wondered. "And I'm an alcoholic." I looked down at the floor, and already my eyes were flooded with tears.

"Hi, Ginelle!" the room chimed back with what sounded like one big welcoming roar. I was feeling so quiet and vulnerable that their big "Hi, Ginelle!" was grating to my ears.

I took a deep breath and began. "This is my second AA meeting, and I'm only twenty-one. I'm not sure I'm supposed to be here, but I'm willing to try it." I was ugly crying at this point because even as I spoke, I could feel myself accepting that I belonged there, even though I wished it wasn't true. "My life

has been"—more snotty tears—"pretty messy due to drinking, and I'm hoping to stop. Thanks." Short but sweet. I didn't want to keep crying in front of a bunch of strangers. I wiped my nose with my sleeve, and the older woman next to me handed me a tissue. She had gray hair and sat hunched over, a cane by her side. She had a warm smile and patted me on the back, reminding me of my Nana, which made me feel like it was a sign from the universe that I was in the right place.

The meeting continued, and I sat and listened to more tales of sadness, anger, despair, and regret. Then the meeting ended, and about five women surrounded me, gushing things like, "Aw, sweetie," as if I was some kind of vulnerable lump, which I suppose I was. The older woman who'd handed me a tissue got through to me first.

"Young lady, keep coming back to meetings," she said authoritatively. "There's a young people's meeting here in Nashua on Saturday night. It might be good for you to be around people your age."

A young people's meeting? Cool!

"Wow. Thanks," I sniffled as one woman after another hugged me and told me to keep coming. Some handed me their numbers on scraps of paper. I was overwhelmed by the attention, feeling comforted and scared that I'd dived right in. *Dang,* I thought, *these people are nice.* Despite struggling to relate completely, I intuitively felt I was just where I belonged. Maybe it was the kindness, the ability to relate to other people's horror stories, the fact that I thought Nana might be watching. Or maybe it was just that I was tired of my bullshit and ready to learn from these people who had already fallen down the same wells and had climbed back out. Whatever it was, I was in.

Maybe it was time to make a home out of AA. The foundations surely seemed more solid than any other place or person I'd tried before.

Now it was time to tell Diego. I hadn't told him about the first meeting because I wasn't sure it would stick, but after the second, I decided to really give AA a chance. We were hanging out the next day and it took me hours to get the courage to bring it up. I worried he'd think I was a weirdo.

"Hey, babe, can I talk to you about something?" I said as we lay on the bed in my dorm room.

"Yeah, of course. What's up?" He paused the movie we were watching and looked over.

"Well, you know, my drinking has kinda been messy lately. So my therapist suggested I go to AA." I paused and looked at him.

"Interesting. Are you gonna go?" His face was curious but not judgmental.

"I actually already went, um . . . yeah. I went twice."

"Oh, you didn't tell me." He seemed hurt. "How was it?"

"I actually really liked it. I'm gonna go back. And I'm gonna quit drinking." I felt nervous saying this, and I avoided his eye contact.

"I support you. Whatever you need." That was a surprising response. I thought I might get some questions like, "Why?" "What will you do when everybody else is buzzed?" and "Does this mean you're not gonna be fun anymore?"

"Thanks." I smiled, wondering how long we'd stay together once his drinking and smoking habits started clashing with my new sober life. "Would you wanna come with me to a meeting tonight? I was told it was a young people's meeting." I had learned the difference between a "closed" meeting and an "open" meeting on the website. The latter meant nonalcoholic loved ones were welcome. Tonight's meeting was open.

"Sure, I can definitely support you."

Five days after my initial meeting, I went to the "young people's" Saturday night meeting with Diego. About fifteen people stood around outside the community mental health building smoking cigarettes and laughing, and I immediately felt intimidated because they all seemed cool—they seemed like a comfortable high school clique who knew each other and knew how cool they were. I was triggered by that kind of thing in high school, and here I was at twenty-one, still feeling like a teenager.

As Diego and I made our way over to the young smokers, they smiled big at me and said hello. Maybe they weren't cliquey. Maybe they were just nice people who happened to be friends.

We went inside to the basement and sat in the fold-out chairs. Right away I noted the cuties in the room—one in particular in a red flannel shirt with short black hair and piercing blue eyes—and I regretted bringing Diego. I guess I wasn't free of my wandering eye yet.

The people around us looked to range in age from eighteen through their thirties, making me feel like I belonged there. Who knew? One girl with purple in her hair sat in front of me and turned around to smile and wave.

The meeting started quickly after, and the speaker, named Elena, was a brunette woman who looked to be in her early thirties with sparkling green eyes and a shirt that said, "[Tr]eat Your Girl Right." *What a badass*, I thought. She also mentioned she was a Buddhist PhD student getting her degree in psychology, which I thought was the coolest thing ever. She began to speak from a chair in the front of the room. "So my drinking and using looked a lot like blacking out, snorting cocaine off dirty countertops, and having the messiest relationships with men."

Holy crap, I thought. Was she talking about me? Although I'd done coke only once, on many nights I'd crushed up something and snorted it in a bathroom at a party. I'd also had more than my

share of troubled experiences with men *and* women. Listening to Elena, I had the feeling wash over me that damn, maybe I'd made it to the right place because if she could do it, so could I.

At the end of her share, Elena offered to help people with the twelve steps of AA if anyone was looking for help. I didn't know what this meant but decided she might be a resource to help me since we had so much important stuff in common, like drinking, drugs, and sex troubles.

After the meeting, I told Diego I'd be right back, then I walked up to Elena and said, "Hi, I'm Ginelle. I was wondering if you could tell me about the twelve steps?" I looked down at the ground, a little embarrassed still that I needed to be here, then up at her again.

"I can certainly tell you about the twelve steps," she said seriously but smiling warmly.

Why is everyone at these things so nice? I wondered.

"Do you have a big book?" she asked.

"A big book?" I pictured a massive book where the pages were the same size as me and took all my might to flip. Maybe it was in a room behind a glass case.

"It's our basic text. The steps are in it. Here, let's get you one." She stepped behind a desk and grabbed a book from a bin. "How do you feel about driving to Boston?"

Driving to Boston? This woman was confusing me. "What do you mean?"

"Well, if I'm going to be your sponsor, you'll need to come to my house." She handed me the blue soft-cover book—just normal book sized.

"A sponsor?" What was I getting myself into here? "What's that?"

"A person who takes you through the steps as they're laid out in the big book of Alcoholics Anonymous."

There was a lot of commotion around us as people put away chairs, hugged each other, and made conversation. I was trying to focus on what Elena was saying. I didn't realize I'd asked for a sponsor, but here I was, talking through how to be able to come south so I could work with mine. "My dad and grandparents live in Boston, so I come there quite often, probably once or twice a month." *Wait*, I thought. "Well, my Papa lives there. My Nana just died." I felt nauseated and immediately regretted oversharing.

"I'm really sorry to hear that. Was she important to you?" Elena's eyes softened, and she tilted her head.

"The most important. Actually, kinda one of the reasons I'm here." I swallowed hard to hold back tears.

"Wow, that's big. Good for you, Ginelle. I'm glad you're here."

"Thanks," I mumbled. "Me too."

We both paused for a moment.

"If I'm going to sponsor you, you'll need to meet with me weekly. Are you willing to do that?" she asked.

Um, I thought. *I guess.* "Sure, I can do that." It was about an hour-long drive, which I didn't mind.

We exchanged numbers, and I wondered what kind of cultish oddity I'd just gotten myself into. Sponsorship? Wow, that really felt like a commitment. I'd sworn off drinking before, but if I actually joined AA and signed on for a sponsor, I'd *really* have to stop. The thought both frightened and excited me. Elena was pretty damn cool, and if she had the same wild past I had, maybe she could help me.

Cutie in the flannel came up to me while Diego was still sitting in a chair, texting, oblivious.

"Hey there, I'm Aaron," Mr. Flannel said. "Are you new? We all go out to IHOP after the meeting for fellowship. Do you wanna join?"

Um, hell yes, I thought, though I was unsure what "fellowship" meant. I looked over at Diego and wished he'd just float away. He wasn't paying any attention. It was wrong to treat him this way, but I hadn't mastered the art of leaving a relationship when it was time or leaving one with grace.

"Yeah, thanks for the invite!" I said. "Could I get a ride from someone? I don't have my car," I asked, careful not to say my boyfriend drove me.

"Of course," he said. "You can get a ride with me, or I'm sure anyone would give you one. Hey, I have a question. Have you ever heard of nis-kee-paa?"

"Nis-kee . . . what?"

"Ha. New Hampshire State Conference of Young People in AA." He was smiling big. I gulped hard and thought about wanting to snuggle him. "It's amazing," he said. "There's actually one in a few weeks if you want to go." I felt like I could just die right there. Go? With him? Sign me up.

"I'd love to learn more about it."

"Okay, we'll talk at dinner! Ready to go?"

"Yeah! Hold on one second."

I walked over to Diego. "Hey, babe, I think I'm gonna join everyone for 'fellowship,'" I said while doing air quotes with my hands, still unsure what that meant but guessing it meant hanging out. "I'll get a ride to your house after?"

"Sounds good! Good luck. You're sure you don't want a ride later?" he said as he kissed me on the cheek.

"I'm sure I can snag one. Thanks." Diego nodded and found his way out.

I looked around the room and felt strangely like I'd arrived home.

Before I took the trip with Aaron, I met with my sponsor. I drove to her house, and then together we drove to a twelve-step Buddhist recovery meeting at a meditation center in Brookline. On our way, I picked at my nails and ground my teeth. I had no idea how to meditate. I'd never done it.

During our drive, she asked if I was okay.

"I'm nervous about meditating. And I've been thinking, what if Diego and I don't last?"

"I think you'll find the meditation okay once you get into it. And I hate to say it, but many people don't end up with the people they came into sobriety with. I'm not saying you'll definitely break up, but just know that if you do, you'll be okay."

I'd thought about breaking up with Diego because I was interested in others like Aaron, but on the other hand, I thought that because Diego and I had been dating for eighteen long months already—by far my longest relationship with a lover ever—it would be silly to break up. He was my person, right?

At the meditation, kind people greeted us, then we both grabbed a cup of tea and made small talk with some of the others who stood milling around. Eventually, they rang a bell for us, and my breathing sped up as everyone casually walked toward the meditation hall. My eyes darted around the room when we entered. I wasn't so worried about meeting people but more about how I was going to sit still for thirty minutes. I was still in my first couple weeks of sobriety, and my brain was like a tennis ball machine firing tennis balls every two seconds.

We settled into the room. There was a shrine up front with a photo of a man who appeared to be the head of the center and a throne-looking thing covered in a gold-and-white blanket.

There were offerings of cookies and water at the shrine. About thirty people sat on cushions arranged in a circle.

Meditation began, and I took a deep breath, attempting to settle into my pose with a strong back, crossed legs, and my hands resting in my lap. The tennis balls began blasting immediately. *Should I go to Brown? Is it my destiny? How will I ever stay single if Diego and I break up? Maybe I won't. I've never been single in eight friggen years. Oh dear. I'm doomed. How can I survive sobriety? I can't.*

Breathing became more difficult.

My breaths were strained.

I coached myself. *You got this, Ginelle. You'll be fine.*

The rest of the meditation went on like this—endless streams of thought with a few short moments of pause. Eventually, I found a sense of peace. It wasn't perfect, but I actually think I felt moments of that serenity people were talking about.

CHAPTER 24

Now that I was sober, I found it especially difficult to be my floor's RA. It was my last semester of college, and everybody around me was partying. One Thirsty Thursday, another RA and I were doing rounds when a sophomore came tripping out of a suite holding a Bud Light can.

Damn, I thought. *Do we have to bust her?* I didn't want to go in there knowing there would be more beer cans where that came from. Biggie Smalls boomed from the room, and I could hear what sounded like a small crowd of people shouting over the music. I wanted to let it go but knew my hard-ass fellow RA wouldn't go for it.

"Let's do this," he demanded, then walked over to the suite door and bashed on it like a police officer. The music went silent, and I couldn't hear anything except for a few whispers. *Oh god*, I thought. *Do we have to do this?* A guy opened the door a crack and popped his head out.

"Hi," he said.

"We're coming in!" hard-ass shouted as he pushed himself inside. I timidly followed. *I'm fucked*, I thought, as the smell of Bud Light wafted into my nose the second we opened the door. My mouth salivated and triggered a craving to grab the nearest cold beer and chug.

Hard-ass was writing up names of people and pointed me to the other side of the room to take down more names, breaking my trance. *Ugh*, I thought, *who cares. They're in college; let them party.*

But I flipped open my notepad and began taking down names because I didn't feel I had a choice. I might be reprimanded by my boss if I refused.

After we finished writing a bunch of students up, we walked out of the room. I instantly pulled my cell out of my pocket and shot off a text to Elena.

Around booze tonight for work & not happy about it.

She texted me back immediately.

We just don't drink one day at a time. You got this.

I guess she's right, I thought. I could try to not drink just for tonight. But I continued to think about those frosty beers when we returned to the RA office. Maybe I could get one after my shift? I could go to the bar. Then I remembered I had AA the next night. I'd been going three days a week, and I didn't want to disappoint my fellow alcoholics by earning the white chip that people who relapse pick up. I decided not to drink.

I went to bed sober after my shift ended at midnight.

A week later, at three weeks sober, I received a letter from the Master of Public Affairs program at the Taubman Center at Brown.

This is it.

This is the moment I've been waiting for.

What if I don't get accepted?

But what if I do?

I took a deep breath, then ripped open the letter.

"Dear Ginelle, we want to congratulate you on your acceptance..."

Holy crap!!! I thought. *I did it. I did it!!!*

I wanted to call Nana at that moment, but then I remembered she was dead. I went from elated to feeling like grief was tearing my heart in half. All the muscles in my body seemed to clench as the smile slipped from my face. God, I missed her.

What would she think of me now? What would she have to say
about my twenty whole days of sobriety and about my getting
into Brown? *Brown!* She'd be so happy.

I picked up the phone and called Dad instead.

"Hey, Nell," he said.

"Hey, Dad. Guess what?" I walked out of the mailroom into
the cold New England February air.

"What?"

"I heard back from Brown!"

"Oh my god, what'd they say?"

"I *got in*!!" I waved my arms around with my cell phone
clamped between my shoulder and ear, then looked around to
make sure no one saw me.

We both screamed and cheered, and I felt the love.

"Holy crap! We've got to celebrate. This is a *huge* accom-
plishment, Ginelle." In my family, huge accomplishments or
anything else to celebrate usually meant booze. So now I felt
like that stripped-naked person I feared becoming. AA calls it
the "hole in the donut"—the idea that you fear becoming a drag,
a boring person—you become nothing, the hole. I hoped that
this wouldn't always be true and that eventually I'd find my sober
groove and feel more self-assured.

We made plans to celebrate that weekend.

My dad's support meant the world to me. He was especially
excited about my prospects of being able to make money after
graduating from such a respected school, but I also knew he was
genuinely proud of me. I wasn't excited to tell Mom because I
thought her reaction wouldn't be as big as Dad's. I was right.
When I texted her, her response was: *Congrats!* That was all.

I shouldn't have been surprised; even though our relationship
was stronger these days, she was still rarely outwardly supportive.
It upset me, but regardless of anyone's reactions, I felt valiant. I

couldn't believe *I* had gotten into Brown. Even through all the years of drinking, I'd managed to be high functioning enough to get a 3.8 and stuff my résumé with extracurriculars. I thought about how much I had achieved despite boozing and drugging like a rock star and wondered if I really needed to be sober.

Quickly shaking away that thought, I reminded myself life was already better sober. I felt mentally clear in a way I'd never felt before, as if my decisions were calculated and my judgment was better. I felt that I valued myself and was on the right track, with hopes for my future. I was much less messy, too, no more blackouts or floor wake-ups. I remembered Nana, and thinking of what she thought of me made me swallow hard. She'd want sobriety for me. I wanted sobriety for me, too.

Diego was the third person I was going to tell, and I felt anxious about it. I thought he'd definitely expect me to move in with him, but I wasn't sure that was what I wanted anymore.

On my way to see Dad in Boston, I hit a young people's AA meeting downtown. I parked on Newbury Street and found my way to First Church. Another meeting in a basement.

I found myself a seat in a cold fold-out chair in the front. I was growing more comfortable with AA in that I wasn't afraid of what people thought of me anymore. I wasn't scared of being an alcoholic. I wanted to get to know people and for people to know me. In only a month, I'd come a long way from being the girl who showed up late and scurried out early.

A few young people who looked to be in their twenties said hi to me, and I made small talk with them before the meeting started. Then we chanted the Serenity Prayer, during which I now closed my eyes and prayed like the folks had in my first meeting. The God idea was growing on me, not because I was a Catholic but because I'd felt the presence of Nana so strongly on my last day of drinking, walking around Ridgewood. I'd been

deeply moved in that moment, hearing her say, "You cannot keep living like this." Because of that, I believed there must be some force in the universe greater than myself that had my best interest in mind, even if I didn't yet know what exactly that looked like.

But despite my growing spirituality and thinking that Nana may be watching me, I still had a constantly wandering eye, and knew I was likely to cheat if given a chance. I couldn't believe there were even *more* cuties here in the Boston group than in my young people AA group at home. And my relationship with Diego was getting staler than ever. The constant weed smoking was bothering me like crazy, and we hadn't had sex in probably six months, with neither of us trying to initiate. I was nearing wanting to break up with him, but I still held on because I was scared of experiencing more grief, and Diego was still that comfy well-worn sweater.

I raised my hand to share halfway through the meeting, and the chair called on me.

"Hi, I'm Ginelle, and I'm an alcoholic." A month and ten meetings into my AA life, saying those words already felt smooth as butter. I was an alcoholic.

"Hi, Ginelle," the room echoed.

"I'm visiting from New Hampshire."

"Welcome," sounded everyone.

"I'm visiting my dad in Boston to celebrate that I just got into grad school in Rhode Island." I was careful not to sound too snobby saying Brown, even though I really wanted to. "I'm planning on moving there when I'm done with school in May, but I'm nervous. Grad school is kind of a lot for someone newly sober. So I'm not sure." I shared about how difficult it was to be a sober RA and then listened for the rest of the meeting. At the end of the meeting, a young guy came up to me and shook my hand.

"Hey, I know someone who lives in Rhode Island. Want me to connect you to her? I'm Noah, by the way." He was damned cute. He had spiky black hair, hipster glasses, and stood about my height.

I thought it was sketchy that he was just asking for my number. Was he hitting on me? He was hitting on me.

"All right, sure. My name's Ginelle." I gave him my number, which I knew was a bad idea because I was trying not to cheat on Diego, but I couldn't help myself.

"So, you're visiting your dad in Boston?"

"Yeah, I'm from New Hampshire."

"I heard your share. You're all over the map, huh?"

"Who knows? It's not a guarantee I'm moving to Rhode Island. If it doesn't work out, I'll be moving to Boston." In other words, if Diego and I didn't work out, I wouldn't move to Rhode Island because without him, I wouldn't be able to afford to live there. The plan was to move in with him and not pay for anything. That was me, not giving a thought to what was best for Diego.

Noah raised his eyebrows. "Ohhh."

I noted his excitement about my potential move to Boston.

"How long have you been sober?" he asked.

"Almost a month," I said, beaming—twenty-five freaking days of not drinking. I was damn proud of that. "How about you?"

"Two months," he said.

"Dang, that seems a world away from me right now," I said, and I meant it.

We parted ways, and I went to Dad's to celebrate.

The following weekend, I went to NHSCYPAA with Aaron, the flannel-wearing blue-eyed cutie from my first young people's meeting. I made sure to pack the cutest clothes I owned, including pajamas, since we were sharing a room.

"Cheers." Aaron and I tapped our sugar-free Red Bulls in a hotel room at the young people's AA convention. He was a babe in a tight black tee, showing off his arms that were all muscley from rock climbing. I was one month sober, and he was six months. We booked a room together—with one bed. He said he booked the one-bed as an accident. Hmmm. Sounded like something I'd have done on purpose.

The conference was packed like a clown car. Dozens of rooms were filled with alcoholics, mostly in their teens, twenties, and early thirties. Energy drinks were flowing, and all around there was a contagious, palpable, happy energy in the air. I alternated between hiding in my room because I was overwhelmed and anxious, and talking to as many people as I could muster the courage to talk to because I wanted to make new friends.

As Aaron and I took a break in our room, my phone buzzed in my pocket. Noah had sent me a shirtless ab picture. *Gross*, I thought. *And kinda hot.* Noah and I had been texting, but this was the first picture either of us had sent. I rolled my eyes because it was pretty weird and typed back.

Dude, I have a boyfriend.

I didn't actually care that I had a boyfriend, but it seemed like the right thing to say. Somehow, I'd failed to mention that little fact to Noah before now.

Aaron saw my eyes roll back and asked, "What's up?"

"This guy I met at an AA meeting just sent me a shirtless pic. He's here, too."

"What a tool." He furrowed his brow. "Why are you talking to him?"

"I dunno, he's kinda cute."

"Gotcha." There was a hint of jealousy in his tone, which made me excited.

Later that night, I attended my first sober dance as three sugar-free Red Bulls pumped through my veins. Trying to dance casually and in a friendly way with Aaron, I bopped around but was hyper-aware of everyone around me, especially Aaron. Doing this kind of thing sober was excruciating. Without alcohol in my bloodstream to loosen me up, I felt like everyone was staring at me. I thought back to all the times I'd swayed on a dance floor, drunk, without a care in the world. *God*, I thought, *a drink would be so nice right now.*

I stayed for a few songs, then dragged Aaron back to our room, changing into something comfy—and conveniently sexy—a pair of skintight yoga pants and a tank top that perfectly cupped my chest. We lay down in the same bed. He was quiet. Still hyped up, I rolled onto my side, then onto my back, then onto my side again in the dark. The silence was deafening. I estimated about six inches between us and could feel his body heat.

I want him was the only thought rushing through my head.

I couldn't take it anymore. "I'm attracted to you," I blurted out to Aaron.

"Ginelle, I'm attracted to you, too, but anything happening between us would be bad for many reasons." The bathroom light shed light on him as he gripped his head.

He was attracted to me. That was all I heard.

Pouting, I said, "I guess."

"One, you have a boyfriend. And two, you're brand-new. It's predatorial to go after newcomers in the program. I'm not going to be guilty of thirteenth stepping."

In the twelve-step program, the thirteenth step is acting like a predator. Great, I was shacked up with the morality police.

"I'm breaking up with my boyfriend soon anyway."

"Doesn't change the fact that you're brand-new, Ginelle."

Ugh, I thought. I'd never had a guy turn me down for sex. *What the actual fuck?*

"Okay." Flopping over, I faced the wall and whipped out my cell phone. I had a text.

It was from Noah. *You coming to the dance?*

Not responding right away, I opened my text thread with Diego. It was time.

This isn't working for me anymore.

I put the phone down and stared at it, scared, sad, and frustrated. Was I really ending an eighteen-month relationship over text? Yikes. The communication had gotten that bad. I crossed my arms. I still couldn't believe that Aaron wouldn't have sex with me. What kind of guy says no?

My phone buzzed within a few minutes. *I figured this was coming. I get it. We've both met new people lately and you're on a new journey.*

Wait, *what*? We both met new people? Excuse me? Who had he met? And why didn't he break up with me if he "figured this was coming"? I slammed my phone on the bedside table and left it there for a few seconds, started to cry, then picked it up again.

"Are-are you okay?" Aaron asked.

"Mhm," I said coolly without even looking at him. I had nothing more to say to him. Just like that, I was over Aaron because he wouldn't give me what I wanted.

My fingers moving faster than I could even think, I texted Noah. *I just broke up with my boyfriend.*

He texted right back. *Oh? We should hang out after the convention.*

His text quickly turned my frown into a grin. I didn't even give myself a chance to grieve Diego. Nothing like trying to make a home in a new guy the second I'd lost the previous one, just like I'd always done. I tapped, *Yup. I'm in.*

CHAPTER 25

The following weekend, Noah and I met up in Boston.

I had first-date nerves and no alcohol to quiet them. My previous dates had been at parties or bars, so meeting someone in broad daylight, sober as a judge, was new and wildly uncomfortable.

I parked my car and walked to meet Noah at the entrance of the Boston Aquarium, shaking with nerves. I saw him, in all his spiky-haired cuteness, and made my way over to him. He pressed his whole body against mine when he greeted me. "Hi," he said. It was quite a hug.

"Hi." I smiled. *Oh my gosh*, I thought. *I'm going to burst.* The photo of his abs flashed through my mind as I appreciated the black fleece jacket that hugged his thin stature. "What's the plan?"

"I'm gonna show you around the aquarium." He nudged his shoulder against mine. The prolonged contact sent chills throughout my body. We waited in line.

"So, how's it going?" he asked.

"Oh, ya know, it's going. Still hitting meetings."

"Good, good. Have you decided on grad school?"

I felt a pit in my stomach. Of course, I'd thought about it, but no matter how I flipped the details around, it was looking less and less possible. The prospect of moving to Rhode Island not knowing a single soul, having no money to do it, and uprooting my sober life seemed out of the question.

"Probably not," I pouted. "I don't know yet."

"Ah, gotcha."

There was an awkward silence. *Oh my god*, I thought, *what if we have nothing to talk about?* It'd been almost two years since I'd been on a first date and certainly never without the lubrication of booze.

We got inside and he pointed at the fish and said, "Haha, it looks like they're fucking."

I forced myself to laugh even though it wasn't funny at all. *Oh dear*, I thought, *what have I gotten myself into?* I started to think that maybe Noah was a tool like Aaron had said, but Noah was a *hot* tool. Maybe we could just hook up. Our shoulders pressed against one another's, and I wanted to tear his clothes off.

After awkward jokes and small talk at the aquarium, we sat together on a patch of grass near Boston Harbor. There'd been sexual tension between us for hours, so when he leaned in and planted a kiss on me, it was like the tension bubble burst and released a flurry of energy. Quickly, we began making out in the grass like two lust-filled teenagers. I wondered what people walking by were thinking. He squeezed the sides of my arms and pressed his chest into mine. I wanted to have sex with him right there.

Noah lived in a halfway house, so we couldn't go back to his place. I thought it was cool that he was so serious about his sobriety, but the rules were lame. There was nowhere for us to go and hook up in private, and I felt like a big whore because there I was, sober and rolling around on public grass with a relative stranger, so I suggested we stop and call it a day. Before going our separate ways, we made plans for the following weekend to go to dinner then watch a movie at my place. I figured it'd be a no-brainer that we'd have sex in my dorm.

After our second date, dinner downtown in Nashua, Noah slept over in my dorm. It certainly wasn't the first time I'd violated

my Catholic university's rules about male guests overnight. As an RA, I took my responsibilities seriously, but clearly that didn't apply to adhering to rules that might get in the way of my good time, like the rule about guys not being allowed in girls' rooms past 11:00 p.m. Whoops. It was my last semester of college, and I'd run out of fucks to give.

We took off our shoes, and I motioned awkwardly up to my lofted single bed.

"This is it," I said with a laugh.

"Cool, you wanna go first?" He smiled.

I nodded and climbed up the ladder, hoping my butt looked good from down there, and settled on the bed. He climbed up after me and settled in on the other side. He wrapped his arm around my shoulders, and I cozied up to him.

As he lay beside me, I ran my fingers through his hair, then leaned in to kiss him. Slowly at first, then we began to move in sync, our bodies pressed together and tongues moving rapidly inside each other's mouths. Although we didn't have much to talk about, our chemistry was wild.

It was easier for me to go down on someone than to have someone go down on me because I liked being in control of the other person's pleasure (that is, if they had a penis). It was a power trip that I loved to be on, so I pulled down Noah's pants and went down on him.

He was breathing heavily and moaning. After I was at it for just a few minutes, I said, "Wanna have sex?" Thinking, *Duh, do I even need to ask?*

Noah surprised the hell out of me with his answer. "No, there's no rush. We like each other. Let's learn more about each other."

What the actual fuck? I'd gone my entire life not being turned down for sex, and now I'd been rejected twice in one

month. What was up with these sober guys? And I didn't even like this one that much. This one was the douche who sent the shirtless pic.

"Uh, what?"

"Let me go down on you," he said.

I swallowed hard.

I let him go down on me briefly, and I tensed my entire body. Soon after he started, I pulled him up.

"I just want to snuggle," I said. Most of the guys I had been with up to that point hadn't even offered to go down on me, never mind made a big deal of it.

"I want to make sure you're taken care of," he said. This made me mad because to me, being taken care of would mean we'd have sex, and he wasn't allowing it.

"I'm good. Though I wish we were having sex," I pouted.

"All in time, my dear." He smiled and grabbed my chin, planting a kiss on my lips.

The following day, he left really early. Later that day, he sent me a text.

I'm sorry, Ginelle. I think we aren't the right people for each other and should focus on our own recoveries.

My stomach dropped, but I knew he was right that I should actually be focusing on my recovery, regardless of whether or not we were right for each other. The rejection still stung, though. I called my sponsor, Elena.

"Noah ended things with me," I whined. I had told her we were dating, even though we really weren't because I didn't understand at the time that it takes more than two dates to be "dating" someone. Elena had advised against me seeing him, but I hadn't listened.

"This may be a gift. Sometimes God does for us what we can't do for ourselves."

"I guess," I mumbled, picking at my nails. The God idea *was* still growing on me, but I didn't like the idea of a man in the sky pulling strings about my sex life—or any other aspect of my life, for that matter. I wanted a Buddhist God, as Elena had. She believed in some force in the universe that had her best intentions in mind. She believed that she wasn't the biggest thing on earth, that there had to be a spirit greater than her. Her spirituality was simple and easy to wrap my head around, so I started to adopt it.

"I think you mistook physical attraction for compatibility, my dear," she said. "Maybe while you're doing the steps, it's time to truly take a break from dating."

Take a break from dating? I hadn't been without male attention or the pursuit of it for a damn second since I turned thirteen. And I sure didn't think it made sense to stop dating while I was a case of raw nerves. I didn't think I could survive the world as a single person. Diego was completely out of my life, so I didn't even have a security blanket, and there was no one on the back burner. Still, I was ready to listen to my sponsor because I was a people pleaser. More importantly, I wanted to commit to my sobriety, with all that entailed.

After being rejected by both Aaron and Noah within weeks of each other, I accepted that my old ways of interacting with males were no longer serving me. I was ready to try something new.

The program spoke of powerlessness, not just with alcohol but with many things in our life, such as assholes when we're driving, how our parents treated us as kids, and how our love interests will react to us. That's why we recited the Serenity Prayer at each meeting: *God, grant me the serenity to accept the things I cannot change, the courage to change the things I can, and the wisdom to know the difference.*

I was starting to look at what I couldn't change. I realized maybe that meant I was powerless over my desire to make homes out of boys and sometimes girls. This one flash of awareness gave me the strength to make a change: for the foreseeable future, I wouldn't go near anything even resembling a date, a hookup, or a flirtation.

CHAPTER 26

decided not to attend Brown. A few months sober, poor, fresh out of a breakup, and without any friends in Providence, I decided that the timing was just no good. I had put my absolute all into that application for about a year. But still I wasn't going to have that pedigree that I was so starved for, and I was devastated. I beat myself up and called myself a loser, but I didn't drink. I didn't even really want to, actually.

People say in AA that there's a good chance that if you do the work, your effort and your faith in a Higher Power will lift the desire to drink from you. The change, they say, comes through the steps. I was only early on, but the desire to drink had disappeared. I couldn't necessarily believe that "God" had lifted it from me, but I could believe that a combination of me doing the work and some sort of magic in the universe had made it go away. I was grateful that I wasn't suffering like some others I'd met in the program who had daily and sometimes hourly cravings. I was free.

Instead of going to Brown, I applied to AmeriCorps, and I knew that if I got the job helping Boston teens and kids find volunteer opportunities, that meant for a year I'd be working for very little pay. But it was a path aligned closely with the helping journey I had committed to, having graduated with a sociology degree with a social work minor. The idea of focusing on other people for a long, hard year actually sounded pretty good.

While I waited to hear back from AmeriCorps, I set off to Chelsea, just outside of Boston, where my Papa (grandfather, Nana's husband) lived. I was going to move in with him. I'd always been closer to Nana than Papa, so I was excited for the chance to get to know him. I pulled my car up to his house and rang the doorbell.

Papa greeted me at the door with a warm smile and a hug. He was a short man in his old age, about five foot four. He had brownish-gray patchy hair on the sides of his head and thin tufts of hair on top. He was wearing his worn-in Tweety Bird slippers and a Disney "Grampa" shirt that one of us grandkids had given him. Stepping into the kitchen instantly made me miss Nana and wonder if I was going to be able to live in this house without grief wrecking me.

"Let me help you get your bags," Papa said. I didn't fight him because even at seventy, he was fiercely independent and active. "You can have Nana's room or the guest room, whatever you prefer."

As he stepped outside to grab the rest of my bags from my car, I looked around the house. It was clean but not as spotless as Nana had always kept it. There was dust collecting on the floor, and the normally spotless countertops were cluttered. I hoped Papa wasn't depressed after Nana died. I guess I'd soon find out. I made my way to Nana's bedroom and dropped my bags, then noticed the cross hanging above her bed. *I'll be taking that right down*, I thought. I settled into the room, and for a while, grief seemed to be trying to tell me I'd never feel okay again. But it had been six months since her death, so I knew better. Even though in that moment grief was telling me it'd swallow me whole, I knew that even with grief present I could continue to live my life.

I found community through yoga classes and AA meetings. And I didn't date anyone, which was proving to press my patience, but I was doing it. People in the program talked of "white knuckling it" when not drinking, which meant feeling it was challenging the whole time, that none of it came easy, and I felt like I was white knuckling not dating. Instead of dating, I focused all my attention on my step work for AA, like my sponsor had suggested. This meant a ton of writing about my past, which made me want to reach out to exes or get involved with someone new, but I stayed strong. I stayed single.

Meanwhile, I was building up my AA program in Boston by going to meetings almost every day and getting phone numbers. I found co-ed meetings to be quite distracting, so I switched to an all-women's meeting in Davis Square in Somerville, a suburb of Boston. The idea of an all-women's meeting intimidated me because I was more comfortable flirting with men at mixed meetings, but I forced myself to get out of my car and walk up to the door of the women's meeting. The door felt heavy. Not quite three thousand pounds, but maybe a couple hundred. In the room, a few women were scattered across a three-person couch and others on several large, comfy-looking chairs. The fact that we weren't sitting in cold fold-out chairs made the setting much more intimate than the AA meetings I'd been used to.

The women were coloring, sewing patches onto jackets, and knitting scarves and blankets. *This is awesome*, I thought. It was unique, much different than any New Hampshire AA meetings I'd ever seen. I was quite crafty myself, so I felt comfortable with these women.

The first woman to speak had curly black hair and wore a shin-length flowered dress, a string of big pearls, leather loafers,

and a square-patched sweater that looked hand-crocheted. Her outfit made her look eighty years old even though she couldn't have been older than thirty. "Hi, welcome," she said. "Feel free to grab a coloring book. We'll get started soon."

"Hi, I'm Felicity," the girl sitting beside me said enthusiastically. She was also dressed oddly, like a chaotic young Iris Apfel. She had massive granny glasses that rested on her small round face, and she was wearing mismatched patterns: purple striped pants with a bright-green-and-yellow polka-dotted sweatshirt. Her necklace was made of large black and neon pink geometric squares and triangles.

"Hi, Felicity, I'm Ginelle." I felt intimidated by these women who held themselves so gracefully while they dressed so differently than me. They were cool, and I felt like the odd one out in my plain old red-and-black flannel and jeans. I usually wore flannels because they hid my belly. I wondered if I should start developing more style? I didn't know how. I shook away the thoughts of not fitting in and joined in on the crafting by grabbing a coloring book and some pencils. The meeting got started.

A girl I hadn't yet interacted with started off the sharing portion. "My mental health has been pretty crappy lately. I'm trying so hard to practice self-care, but capitalism sucks, you know?" Many of the girls nodded and smiled, one laughing out loud. She continued, "My mood can be so off and on, and I don't understand it. I guess it's probably partially my bipolar, but also that I'm a raging alcoholic. I don't know. I'm just doing the best that I can. That's all, thanks."

After the girl finished talking, everyone chirped, "Thanks, Marina," and I was amazed by how much this woman spoke about mental health. Given how little it was spoken about in New Hampshire, I'd assumed it was an off-limits topic. But here

I was in a room full of women dressed like artists and talking openly about bipolar disorder? And capitalism? Sign me up.

I was too nervous to say anything at the meeting, so I just listened in awe as woman after powerful woman spoke of struggles and triumphs as a sober person. At the end of the meeting, the gal dressed like an eighty-year-old came up to me. "Are you new?" she asked.

"Yes, I'm not super new to AA—I've been around for six months—but I'm new to the area."

"Well, welcome." She was soft-spoken and didn't make much eye contact, but I felt her warmth. "Can I give you my number? My name is Lucia," she said.

"Yes, please!"

Felicity came out of nowhere and hugged Lucia, then said, "Me too! Take down mine, too!" She had a bright smile showing lots of teeth. She and Lucia seemed to be opposites, but I liked them both, as they made me feel welcome and far less intimidated. Maybe I could make a home in Boston.

CHAPTER 27

My sponsor, Elena, and I continued to meet for a few hours every week. One afternoon when I was about seven months into sobriety, we sat on the couch in her apartment, with her fluffy white Persian cat sitting with us. "Can we look at some of your writing to make sure you're doing it right?" she asked.

I was working the fourth step. I'd been writing about resentments, which was part of our moral inventory during which we looked at our part in our anger. I was required to assess incidents of anger from my past and ask myself what role I had to play.

"Sure, one of them is that I'm resentful at myself for stealing from my best friend, Selena, when I was a teenager."

"Okay, and where were you selfish?"

"I wanted to get away with it without consequences. I wanted to show her."

"Show her what exactly?"

"Show her I wasn't going to deal with her gossip or whatever she did at the time, I don't even remember now."

"When we get to amends, you'll be able to make them to her."

"Actually . . ." I paused, unable to say the words easily. "Selena died last summer. Of an overdose. I'll never be able to make amends." I sat quietly as tears began to well in my eyes. I felt sick to my stomach whenever I thought about the fact that Selena was no longer alive on this earth. I'd found out about her

death on Facebook. Her mother had reached out to me about a memorial service, but I didn't go because I felt too shameful about what I'd done to Selena and her family. I hadn't spoken to my friend in six years, since my sophomore year of high school. I had no idea she was still using.

"Wow, I'm terribly sorry," said Elena. "Okay, well, you can still write her a letter. In my experience, this provides a ton of relief, getting the words onto paper and reading them out loud. We'll get there when we get there. Again, I'm sorry that happened."

"Thanks," I said as I looked down at the resentment on my paper. Man, this was tough stuff.

As I got ready to move on, I let out a sigh. "Okay, here's one I don't know what to do with. My grandfather pulled a gun on my dad in front of me. How could I have been selfish or dishonest in that one? I was just a kid."

While identifying my responsibility in troubled situations from my past was the core of the fourth step, the whole process changed when I got to trauma work.

Elena said, "In twelve step, we often use the phrasing 'to find your part' in your resentments, but we're actually going to approach these trauma resentments differently. We'll look at *what you're carrying around* that's no longer yours, such as your guilt, shame, and negative self-talk. Do you want to share with me what happened?"

These resentments had to do with something horrible that happened to me as a kid or as an adult. We started with childhood. I was to look at the anger I had toward people who had genuinely harmed me as a child, scenarios in which I didn't harm them.

I flashed back to when I was seven. My memory of the situation was fuzzy, thanks to trauma and time, but I remember cooking lunch in the kitchen with my Nana, my dad's mother.

It was a crisp fall day, and the sun was shining on us through the open kitchen window.

I stood on a stool as I watched our hot dogs boil. The air was heavy with a beefy smell I had grown to associate with this Nana. She always cooked the classic large Kayem franks.

The dogs had just finished cooking, and we were plopping them on red plastic plates. I liked to eat them plain, without buns or condiments. I smiled up at my Nana. A warmness filled my chest as we turned toward the table.

Then suddenly my Italian grandfather barked from the living room, "Make me a hot dog!"

"They're already done, Grandpa. We only cooked two," I hollered.

"So? Cook more. I want one!" he shouted. I looked up at my Nana.

My Nana had her shoulders bunched up to her ears, and her eyes were moving down toward the beat-up hardwood floor that was covered in dog hair. She said quietly, "Um, we're going to eat first."

Suddenly, Grandpa muttered, "Ginelle, you're just as useless as your grandmother." I reached out and grabbed my Nana's hand, terrified of what might come next.

My dad was sitting on the couch next to my grandfather, and my dad slowly turned his head, leaned forward, and clenched his fists. "Don't fucking talk to either of them like that."

"It's true," Grandpa spat, lying back on the couch.

My dad sat up in his seat. "*You're* useless. She's a child. What the fuck is wrong with you?"

"Fuck you. This is my house. Don't like it, then get out."

My dad slammed his fist into the wall, just past my grandfather. I felt terror at the sight of my father punching a hole into the wall of a building. My grandfather leapt off the couch and

ran into the other room, then came back with a gun. Pointing it about three feet away at my father's head, he screamed, "Speak to me like that again."

Nana Testa let out a scream, and I covered my mouth with my hand. I clung to her arm as my vision blurred with tears, and I thought my dad might die.

"Jeff!" she yelled. Both my grandfather and dad were named Jeff. I didn't know who she was talking to.

"Go ahead. Fucking coward," my dad spat. There was fire in my grandfather's eyes.

"I'm calling the police!" my Nana shouted. She was bluffing and I knew it. She'd never once stood up to my grandfather, even the time he pinned her up against the fridge, his hand choking her throat.

I stood frozen, powerless.

"Just leave!" my Nana screamed.

Rolling his eyes, my dad walked around my grandfather and headed for the front door. My grandfather lowered the gun. I heard the door slam, and the German shepherds began to bark. Although the fight seemed to be over, I was glued to the floor. I just stood there, frozen. What had been a lovely cooking experience with my grandmother, the two of us preparing hot dogs together, erupted into a scene that shattered my sense of safety for my father, my grandmother, and me.

Shoving the gun into his back pocket, my grandfather stormed off to his room. My Nana hugged me tightly and then grabbed me by the hand and hurried me outside to where my father was waiting in his truck. The cool fall air hit my face as we hustled outside. My dad's running truck hummed as I scurried over to it.

"You need to leave. Now," Nana said to my dad as she wiped her tears with the hem of her ratty sweatshirt. It was only the

second time I'd ever seen her cry. The first was that time my grandfather pinned her against the fridge by her throat. She walked me over to the passenger's side of the truck and hurried me in.

We were off before I knew it, Nana waving her wide slow wave as she always did when I left, but this time with tears rolling down her face. As we drove away, I saw her stop waving and wrap her arms around herself, rocking back and forth.

During the drive back to New Hampshire from Leominster, we sat in silence. I kept glancing at my dad and fiddling with the radio. Finally, in a quiet voice, my dad said, "I'm sorry you had to see that." I wasn't used to hearing my father speak in a quiet voice.

Fortunately, no one had been hurt, but I didn't realize until writing it out in my fourth step that I felt some blame for what had happened. I thought I had somehow spurred the fight. I internalized the word "useless," and it became a part of my self-talk that I would come to know intimately. I don't know that I'm remembering the scene correctly, as is what happens with trauma and time. I feel silly about that now. Still, this is what my memory says happened. On this day with my sponsor, the situation still weighed heavily.

After I told Elena this story, she said, "Ginelle, that's awful. I hope you know this situation wasn't your fault, and actually, despite the twelve-step methods of looking at your part in things, you didn't have a part in it. You didn't harm anyone, so I want to make sure you know it wasn't your fault." I teared up, nodding, understanding perhaps for the first time that so many years earlier during that awful, explosive scene in my grandparents' house, I hadn't done anything wrong. Not a thing.

But after that exercise, I began to see how some particularly vivid words from my youth made their way into my teen years and my adulthood. As I grew, I became so caught up in calling myself "useless," "unlovable," and "broken" that I was incapable of developing a healthy self-image, and that rendered a healthy dating and sex life impossible. But that didn't stop me from obsessing.

Still in my first year of sobriety, I was doing a day of service with my AmeriCorps crew and found myself focused on yet another object of attraction. These AmeriCorps service days were usually on weekends, and we'd spend the day doing something good for some segment of our community. This time we were building beds for kids transitioning out of homelessness.

In the group, there was a man about my age dressed like a punk boy: Vans, black jeans, a black sweatshirt, and an emo haircut. I was drawn to him immediately, and I spent the whole day—just about every minute that I was supposed to be focused on giving back—aware of where he was out of the corner of my eye and feeling magnets anytime we were near each other. I didn't talk to him once; I was terrified of putting myself out there. But I got a thrill from just obsessing about him, daydreaming about him, fantasizing about the beautiful home I might build there.

This was a lot of what my new single life looked like, the life I'd been living since I'd broken up with Diego and stopped messing around with random AA guys. I was no longer acting out but was entirely imprisoned in my mind. I wish I could say I was feeling like a strong, independent woman, that I was calm and actually enjoying the new path I'd paved for myself, but my yearning nearly ate me alive.

CHAPTER 28

O nce during my no dating, no sex period, I fell off the wagon. I had met the guy on the Boston train I was taking to work. He'd commented on my thigh tattoo, as I was wearing a red dress that rested mid-thigh, and he asked for my number. So I met up with him with the intention of hooking up. I rationalized that having sex with this guy wouldn't violate my "no romance while healing" policy because I wasn't going to date him.

Even while driving to his apartment, I knew it was a terrible idea, but kept driving anyway. As I arrived, I noticed the apartments were bougie. They were sleek lofted luxury apartments with big windows that I imagined let a lot of light in during the day. I remembered from his business card when he was giving me his number on it that he was some kind of fancy business consultant.

Those feelings of this being a bad idea dissolved when he met me at the door. He was wearing a nice pair of blue pants that weren't jeans and a button-up collared shirt. His touch was gentle when he greeted me with a hand on my shoulder and pulled me inside.

I bit my bottom lip to suppress the smile as I walked behind him. I shook out my hands. I was eager to have sex, but there was also that voice in the back of my mind that chirped, *What the hell are you doing?* My teeth clenched. We entered his apartment.

"Wanna watch something?" he asked as he sat on his couch, patting the seat next to him.

"Yeah!" I said, knowing what that meant. I sat down, still feeling nervous about what I was doing here. As I sat down, he suavely slipped his arm around me and pulled me close. The touch felt nice. I hadn't felt anything like it in a while. He put on some action movie and within a few minutes leaned in to kiss me. Our tongues moved in and out of each other's mouths with ease. He was a good kisser and I felt glad that I thought I still was, too.

Pretty quickly, he grabbed my hand and pulled me into his bedroom. The floor in his room had no dust or mess. The abstract art on the walls hung perfectly. As we lay down in his bed, his comforter smelled like it had just been washed and dried with lilac dryer sheets. He was cleaner than many men I had been with.

Our lips immediately found each other's. Our tongues explored one another's. He ran his lips up my neck, kissing every inch of it as I thought, *Yup, this is what I'm here for.*

We pressed our full bodies against each other. Worry about what I was doing temporarily slipped out of my mind as I felt my legs wrap around him while he was on top of me. He tugged at my shirt, silently suggesting I remove it. I pulled away from under him for a moment to slip off my shirt, then unhook my hot-pink bra. He was pulling his shirt off his back as well to reveal a sexy physique.

I thought about my sponsor momentarily and wondered if I was doing the wrong thing. My people pleaser side, looking to please my sponsor, was fighting with my addict side, who was looking to get laid.

We kissed some more, the skin-to-skin contact exhilarating me, filling me with enough endorphins to act as jet fuel sending a ship to space. I felt each inch of us rub against one another.

I closed my eyes, and they rolled back as his hands and mouth explored my chest.

He paused for a moment to grab a condom from his drawer, and I knew I was going to have sex with him. The experience of sex in the past had ruined me emotionally. I was left with a tidal wave of emotions and thoughts when it was done, and usually left to deal with them alone. This wasn't going to be any different, I thought, but I carried on.

He slipped his penis inside me. It stung at first, but I didn't tell him. I just let him start pumping while I gritted my teeth. I wanted to be the "cool girl" who didn't make a fuss about anything.

He was on top, missionary style. The pain started to ease, and my breathing began to flow. I had my arms wrapped around his sides, feeling some sweat start to appear. We were about ten minutes into it. My brain ricocheted between guilt and enjoyment, thinking it was fun, then thinking of how much of an idiot I was.

My thought process was interrupted when he stuck a finger in my butt. My body went into shock mode with all of my muscles tensing up. I didn't say anything. I pretended to like it by forcing myself to unclench my muscles, even though I was deeply uncomfortable. It wasn't the first time I'd experienced anal, but the surprise element got me. I was bothered by the fact that he didn't ask. I didn't know what to do. It only lasted a few seconds until he pulled it out, grunted, and rolled over, having finished.

I lay there in shock while he scooped up his phone to put on some music, Foster the People's "Pumped Up Kicks." We lay in bed for about twenty minutes, and my heart beat out of my chest. It felt louder than the music. I was thinking, *Why does this hookup feel so awful?* I couldn't put my finger on it. It was time to go home. I rolled out of the bed and began putting my clothes back on.

I smiled at him. "Thanks for the good time, I think I'm going to head out."

He got up and slipped on his boxers. "Hold on, I'll walk you to the door." I waited for him to get dressed and I put my clothes on, then fumbled with the laces of my beat-up black Chucks.

We walked down the hallway in silence. When we got in the elevator, he asked me, "What do you have planned for tomorrow?"

"Not sure yet," I shrugged, hoping he wouldn't ask me to hang. He didn't.

He kissed me at the door, and I walked over to my car. I shut the door behind me and gripped my cold steering wheel. My stomach churned and I felt as though I was going to be sick. I lay my head against the steering wheel and thought, *What. The. Fuck.*

I analyzed this hookup further as I sat in my new therapist's office at Massachusetts General Hospital. Her name was Giovanna, and I'd been seeing her since I'd moved to Boston. She was in her sixties and had gorgeous long gray hair. Giovanna often nodded and said "mhm" a lot but didn't give much advice. Sometimes she probed.

"I'm sorry this happened," she said. "It sounds like he violated your consent." The word "consent" rang in my ears. It was a strong word, and I hadn't thought of the situation that way. I picked at my cuticles and felt nauseated.

"I guess I just can't help but feel it was my fault because I got myself into the situation." I looked up at her, and we made eye contact.

"You've shared that you've felt the same way about the webcamming, even though you were a victim."

A victim? I thought. No. I mentally replayed images of the ways I'd manipulated men, their coins raising my money count.

"A victim? But I actively participated."

"Thirteen-year-olds can't give consent." Her words hit me like an explosive. I was having trouble swallowing.

"Uh, oh. Wow. I guess you're right." I'd never thought about it like that. I'd always thought I was bad for webcamming at such a young age. For showing myself to random men who were probably old and creepy. I felt dirty, even. Now the idea that I hadn't been and wasn't bad or dirty started to take shape in my mind, and I balled my fists and gritted my teeth. I started to consider that maybe I wasn't bad or dirty for turning to online sex work as a way to cope with my troubled family life. I thought, *What if I'm just a flawed human being doing my best and doing better every day?*

My mind was blown at these realizations that exploded in therapy and continued to rumble in my mind as I went about my daily life. They helped me start to change the way I viewed myself. They made me realize I wasn't all that bad a person. As a result, I wanted to get myself out there again; I wanted to date again because I felt I deserved it, finally—deserved a really good person in my life.

After almost a year of writing my moral inventory and reading parts of it to my sponsor, I had finished my fourth step. I felt excitement, relief, and anticipation for what was to come. People in AA say that the fourth step gets all the junk out of your conscience and onto the page. It helps you become accountable for what you've done and helps you let go of things that were done to you, like trauma inflicted by someone you cared about. I was ready for the freedom people spoke of that came as a result of the fourth step. I'd heard in meetings that in active addiction, you're driving a van and you keep throwing junk in the back, hoping it'll work itself out. But when you get sober, you slam on the brakes and all the junk comes flying onto your

lap. The fourth step was a chance to work through this junk so that I could be free.

The fifth step was next, and that involved reading the results of all the fourth-step writing to a sponsor and a "Higher Power," meaning a God of my understanding. I was required to read every word I had written over the past nine months. Every. Single. Word. This included the secrets I had buried deep inside me that I had never told anyone. I was fucking terrified.

But ten months sober, I pulled up to Elena's apartment armed with one of my four five-subject notebooks littered with writing. For about ten minutes, I just sat in my car looking at her building and wondered how I was going to survive airing all of those stories, sitting next to another person as she listened to all my dark, terrible, embarrassing tales.

Elena greeted me with a hug and a glass of water. I trusted her; her presence calmed my nerves, but I still knew I was about to have an experience that would leave me feeling more vulnerable than I had in all my life. I was about to read all my dirty little secrets out loud, some of them stories I'd never told another soul. AA taught that I needed to do this to stay sober, so I swore to myself I'd see it through.

My stomach was whirling with nerves.

"How are you?" she said.

"Oh, you know, fine. Nervous." I avoided eye contact.

"Understandable. This is a big undertaking. We're going to do it together." She sat on her bed, holding and petting her fluffy white Persian cat. I sat at her desk and opened my notebook. Then I took a deep breath and fought the burning urge to run for the door.

"Do I just start reading?" I asked.

She nodded. "Yup."

All right, here we go. I clenched the muscles in my hands and legs.

"I'm resentful at myself for gaining weight. I'm selfish because I want others to like and approve of me. I want to be extraordinary, better than. I want to attract the perfect partner. I'm dishonest because I tell myself that my weight is correlated with my worth."

I looked over at Elena, and she nodded for me to continue.

Then I began to read the section in which I took all the lies I told myself and turned them into something positive and true. "The truth is that I am lovable and worthy because I'm a child of the universe, just because I exist. My weight doesn't determine that."

I couldn't believe, after all those years of hating my body and my relationship with food, that I was finding peace through this twelve-step process. I was healing.

As I continued to read, I could feel my muscles releasing some of the tension they'd been holding. I read for two hours, all the inventory I'd been instructed to write, person by person. I came first, then my family, then early friends, and so on.

When I came to the story of Kira, the woman I assaulted as a freshman in college, I held my breath. I hadn't talked about this to anyone in such straightforward terms, and it was a subject of great regret for me, great shame. But now I was ready to just come out and say it—I assaulted someone. I read Elena the ugly tale of that night I'd drunk to blackout, failed my friends by drinking when I was supposed to be the safe, sober driver of the night, and assaulted another human being. Elena just sat and listened. When I looked up, I saw no reaction on her face, only the expression of an interested listener.

"I'm resentful at Kira for still not talking to me into senior year," I continued.

Elena sat quietly as I let myself cry.

I cried and breathed and cried and breathed.

When I pulled myself together again, I read, "I was selfish because I assaulted her and then blamed *her* for not talking to

me. I was dishonest when I told myself that what I'd done to her wasn't a big deal." Getting choked up, I continued, "In truth, I'm not a bad person for what I did, but I do have to take ownership of it."

"Thank you for sharing that, Ginelle," Elena reassured. "I understand this one intimately. I had similar resentments for myself because I assaulted some guys, though I never called it that. Good on you for owning your part."

It was as though a massive brick had been lifted from my chest after I finally said it out loud. I had finally owned up to it. I told another soul. Holy crap. Not only that, but my sponsor had been similarly abusive to another innocent person, which made me feel I wasn't alone in my colossal fuckup. If she could recover from that kind of infraction, maybe I could, too.

In that moment, I remembered that AA taught us we weren't bad people getting good, just sick people getting well.

I closed my notebook and wiped my eyes. It was time to wrap up for the day.

My sponsor said, "You're doing it! The steps aren't easy, but they're worth it."

"I hope so," I said. I believed that she believed, and that had to be enough for now.

I packed up my bag and went home.

●

I began to see the work of the twelve steps—all the writing, meeting attendance, talking to my sponsor—having an effect on my life. I was at an AA meeting in downtown Boston, and someone was gossiping about another AA fellow who wasn't at the meeting yet.

"Have you seen Rachel?" the girl said. "She's a hot mess. I heard she's sleeping with Steve."

I had an overwhelming feeling that she was out of line for gossiping. But then I did a reality check and thought, *Wait, I do that, too. Holy crap.* Soon I began to feel uncomfortable whenever I heard myself gossiping, so I worked to eliminate gossip from my life, and I could feel the change. In the past, I had gossiped to connect with others, to feel like part of the group, but now I was connecting with people through positive means, like talking about hopes and dreams. The steps were working.

I was slowly healing emotionally and not just refraining from drinking. In AA, they talk about abstinence vs. emotional sobriety. Abstinence is just not drinking, but emotional sobriety is healing yourself as a whole person by letting go of character defects like gossip, self-righteous anger, and self-pity. I'd figured I'd never be able to completely let go of these things, but I was on my way to more emotional healing.

As I continued my fifth step—reading all the writings of the fourth step to my sponsor—I reminded myself twice a week of how AA defines step five: *Step five is that we admitted to God, to oneself, and to another human being the exact nature of our wrongs.* Step five went on for twelve weeks, and some sessions were tough. At the end of each reading, both Elena and I seemed to need a nap. But the more I read, the more I recognized my part in things.

A couple of weeks into my fifth step, I revisited robbing Selena's house. I was the one at fault there. What prompted it, whether gossip or disloyalty, didn't matter. I did that crime. I made the conscious choice to break into the home of a dear friend and steal from her family. As I thought ahead to steps eight and nine, the amends steps, I swallowed hard at the fact that I could

never make face-to-face amends to Selena. All I could do now was make living amends and promise to her and myself that I would do my best never to drink again and never to cause grave harm like that again.

My feelings about making amends were similar when it came to Kira. Though she hadn't died, I had a strong sense she'd never wanted to hear from me again. I gathered that much from how often she wouldn't look at me when we crossed paths at school. In the program, I was taught not to reach out to someone I'd injured if doing so might cause damage, so I chose not to contact Kira. I struggled with whether that was the right move.

While I was in the middle of my step work, I got a shiny new job. After my AmeriCorps year, I'd started working at a startup. It was a new tech company that sold software. There were a lot of loose boundaries in that company: people hooking up, beer on tap, employees working later than 5:00 p.m., none of which were great for my mental health. But I stayed on the right path by working with Elena and my meditation instructor, Anna.

While I was on a spiritual path in AA, I also was walking one in Buddhism. One night after work, my meditation instructor, Anna, and I faced each other while sitting on meditation cushions in the Buddhist center I now attended. Elena had introduced me to the center, and now I was a regular. This was my biweekly one-on-one session with Anna.

"Breathe in 1 . . . 2 . . . 3 . . . 4 and out 1 . . . 2 . . . 3 . . . 4," Anna whispered. "Now open your eyes fully, gently. Bring yourself back to the room."

I slowly raised my eyes to meet hers. Anna rocked a pixie cut, didn't wear makeup, and always wore a pair of eclectic earrings—that night, they were dangly black triangles. She was one of my favorite people in the world because she carried herself

so elegantly but also regularly showed her humanity—like she wasn't afraid to admit when she wasn't sure about something or had made a mistake. She taught me how to do the same.

"Ten minutes is about all I can muster with this much anxiety," I said, outstretching my arms. I let out a deep breath.

"That's okay. Ten minutes is great. Wanna tell me what's going on?" She readjusted her position on her cushion.

"I just finished my fifth step with my sponsor, and after over a year of not dating, I'm ready to get out there again online. But it's been so long. And I've never dated sober before." I was terrified of the raw vulnerability of sober dating. What would it be like without alcohol to comfort me and take the edge off? What would I do without alcohol to hide behind as an excuse for my bad behavior?

"What are you afraid of?" she asked.

"I don't know, exactly." I bit my lip. "Maybe dating people who drink or smoke a lot of weed. Maybe just being sober myself and not being able to have a drink on a date." Playing with my hands, I wouldn't look her in the eye.

"Could you include that you're sober in your dating profile?" I met her eyes again. She had a soft smile. "Being sober is a vulnerable thing, lady. You don't have it easy. I just want to validate that."

"Yeah, I suppose so." Anna was a lot more to me than a meditation instructor; I called her my Buddhist sponsor and life coach. Her mentorship and Elena's were shaping me into a person I never thought I could be. She helped me see everything I was doing through the lens of Buddhism: living honestly and with eyes wide open.

"We can keep talking about it. Just remember to take it one moment at a time. What does your practice look like lately?" she asked softly.

"I haven't been meditating as much as I'd like, especially since the idea of dating again occupies so much space in my head. I know I should get back to practice." Working the fifth step brought up so much trauma, I'd been avoiding meditation. There was a lot I didn't want to sit with.

"That's okay," Anna said. "You're going to your group every Monday, right? That's a whole thirty-minute meditation."

"I guess you're right. I've been sitting still more than I thought." Her words brought a smile to my lips. "I guess I'm ready as I'll ever be to tackle dating."

And so I started to open my heart to the world.

CHAPTER 29

was just a few months into my new job, and I was trying to read my lines on camera for a training video my company was creating.

"You're doing great," said Peter, my coworker and the company's videographer.

I shook my arms out and said, "Why is this so stressful?" Taking a deep breath, I tugged at my shirt, self-conscious about my belly rolls. I hadn't perfected my relationship with my body yet, though I was getting gentler with it.

"Very few people want to be on camera," Peter chuckled. "That's why I like it back here."

I stuck my tongue out and then went back to reading the script. It was our first time working together, and I hadn't noticed him around the office, which was notable because he was pretty cute. Peter had rich brown skin and black hair with shoulder-length dreads. He was a few inches taller than me and wore a shirt with our company logo.

"Could I grab your number?" he asked. "I'll send you some fun GIFs of you later."

Was he hitting on me? No, I thought. It was probably just work stuff. He was wearing a wedding ring. "Sure," I said, and gave him my number.

Later that night, he sent me a silly GIF of me sticking my tongue out. I laughed and returned the text, not thinking much of it. I wrote, *This is great. Thanks for sharing.*

I told myself he was married and I should leave the texting at that. Then he replied.

Sure thing. How are you this evening?

Ah, there it was. *How are you this evening?* In that moment I could feel the exchange stepping beyond the professional. I considered not replying. But that would be rude, wouldn't it?

I'm okay, glad work is over. I'm beat.

Me too. I'm playing video games. My wife, Luna, and I got into a fight.

Okay, I thought, that's inappropriate.

I'm sorry to hear that.

I set my phone down and stared at it. What was this guy trying to do? Crap, I knew where this was headed if I let it go there. He replied.

Yeah, what's going on for you?

I thought about a number of possible replies. I could be brief, sassy, cute, empathetic. I could be suggestive or funny. I could be tightly professional. I decided to just not answer.

A few days later during work, I heard a ding on my work's instant messenger. Peter had sent me a GIF of a dog in a Batman costume. I giggled, and my boss, Carey, who was more like a friend, asked me, "What are you giggling at over there?"

"Nothing. Peter just sent me a ridiculous GIF."

She knew Peter well. "Interesting, he doesn't send me GIFs." I turned around to face her, and she stared at me with her head tilted like she knew we were up to no good.

Yes, it was interesting.

Before long, Peter and I began texting regularly. He'd often be the one to initiate the texts.

It usually started with something like, *Hey lady, how's it going?*

Almost with dread, I began to feel those oh-so-familiar stomach butterflies that had been so important to me for so much of my life. He'd send a text, and my stomach would jump. Eventually, he'd find his way to tell me something about his marriage.

Luna and I have been fighting and I've been miserable.

I'm sorry. What's going on? If you want to talk about it.

It just seems like we can't agree on anything anymore.

I knew how inappropriate it was for a married colleague to vent to me about his marital problems. I knew how inappropriate it was for me to let him do it. But the butterflies.

I daydreamed that maybe he'd leave her. Then I reminded myself that this was sleazy thinking. I knew my two gurus would not approve, so I didn't tell them yet what was going on. I knew they'd tell me to stop talking to him, but I wasn't willing. At this point, I had a full-blown crush on this guy. I opened Facebook and stalked his account. I had to find out what his wife looked like. He listed himself as *in a relationship*, and just reading those words made me feel hot in the head. I was seething with jealousy. I thought she looked European, super thin, stylish, blonde, and beautiful. What did he see in me, a short, chunky American? What was he up to? Did he see anything in me? Was he feeling what I was feeling?

A few weeks later, Peter offered to take pictures of me for my new writing blog. My friend Lucia from my AA meeting joined us because he'd offered to take pictures of her, too, since she was pregnant and wanted to document the moment. When he was photographing me, he was hyping me up.

"You look fabulous!" he said. I wondered again if he was hitting on me. I wanted him to hit on me.

As he took the next round of photos, he kept saying, "Yesss!" and I was able to loosen up a bit and have fun with it.

We took pictures near a public art installation, and I made silly faces. I wondered if he thought I looked pretty, because I sure felt pretty.

Lucia joined me and he took a few photos of us together, then of her alone.

After the shoot, the three of us grabbed coffee at Starbucks.

"How old are you, Peter?" Lucia asked as she and I sat across from him. She seemed to be on a fact-finding mission after I'd told her I really enjoyed his company.

"Thirty-six," he answered.

Oh shit, I thought. *He's a lot older than me.* I hadn't known his age and hadn't thought much about it. Twelve years. Oh well. Guess it didn't matter because I wouldn't be dating him. Right? Peter excused himself and went to the bathroom, and Lucia said, "Too bad he's married. He seems to adore you."

"Really?" I asked, trying hard not to smile big.

"Yeah, the way that he looks at you. Kinda weird he has a wife."

"Damn. His wife is a bombshell, too. I may have crept on her Facebook."

Peter came back, and my mind was in overdrive: *Lucia thinks he adores me? Does he? That's so cool. I mean, I adore him. What if we could be something?*

⬤

The following week, I interviewed Peter for my blog. I was writing a piece about injustice and living in America as a Black man during a time of social unrest. It was during the Ferguson riots and protests after Michael Brown, an eighteen-year-old Black man, was fatally shot by a white police officer. Peter was really passionate about the Black Lives Matter movement, and I was

pissed off, wanting to do something to be part of the solution to the country's out-of-control race problems. I was excited to get his input, and I was excited just to spend time with him, to be near him outside of the office.

I was chronically early for everything, so I was early to the coffee shop and sat there reapplying my lipstick. Did I need to wear lipstick? I wondered. Oh well. I looked damn good. I opened a blank document on my laptop and told myself meeting outside of work alone really meant something—maybe it meant we'd hook up.

He arrived after about ten minutes, on time, and leaned in to give me a hug while I was sitting. I wanted to explode with joy.

"How are you?" I asked.

"I'm okay. Excited to do this with you. How are you?"

Wildly excited, I thought. "Good, I'm good! All right, ready to get started?"

"Ready," he said, his eye contact sending chills through my body.

I asked him my first question, "How can white folks be better allies to people of color during these times of racial injustice?"

His face was serious. "Turn down the news and turn up conversations with Black individuals. Ask Black Americans around you about their experiences."

I stared at him like a captivated interviewer, but my mind was wandering into personal territory. *He's so hot. He's married. He really likes me. He's married. Give it up, Ginelle, he's married. But the butterflies . . .*

Trying to focus on my laptop, I jotted down what he said. I kept interviewing him, and every time we looked in each other's eyes, my stomach became a churning mess. I wanted to crawl across the table and kiss him. Was he thinking the same thing? He couldn't be, right? Not with a hot wife like that.

We finished the interview, then Peter and I walked down the stairs, and our shoulders brushed against each other's. I wiggled my fingers, then squeezed them as I was holding back from grabbing his hand. I was so fired up; I knew I'd jump this man's bones right now if he let me.

He hugged me and we parted ways.

Later that night, I crept on his wife again. I wanted to know what she did for work. What her hopes and dreams were. What would she think of my obsession with Peter? Then my mind jumped back to Peter. What would happen if he did have feelings for me? Should I come on to him? When two people have chemistry this strong, shouldn't they act on it? Isn't it a rare gift that shouldn't be wasted?

Then I woke myself up. I told myself, *Hell no, Ginelle. You're sober. You're supposed to be a woman of dignity and grace. What are you trying to do here? Are you planning to sleep with him? You need help.*

The next morning, when Peter texted me, instead of the usual jolt of excitement, I felt shame and guilt. Physically, Peter and I hadn't done anything more than hug or brush shoulders, but I felt so connected to him emotionally I knew I was doing something wrong. So, I called Delilah, a woman I knew from Alcoholics Anonymous who in a meeting once had shared that she'd gotten herself involved with a married man.

I told her, "I need help. I've gotten myself involved with a married man, and I don't know what to do."

Delilah was a no-nonsense woman from South Boston, and she gave me a very straight answer: "What helped me was going to Sex and Love Addicts Anonymous." *Ughh*, I thought. *Anything but that.* I loved Alcoholics Anonymous, but SLAA was a very different story. All I could picture were those three gross men in the basement Sex Addicts Anonymous meeting I'd attended three years earlier.

"Really? You found it helpful?" I groaned.

"Very helpful. Go to a young people's meeting or a women's meeting. They're great."

I knew I was on the verge of making another mess, and I didn't want to make the situation any worse or sleep with Peter and then regret the shit out of it. Not knowing where else to turn, I agreed to go. I found a young people's meeting online that was scheduled for three days later.

Meanwhile, Peter kept texting me, and I kept answering. I felt terrible about it, but I couldn't stop. Many times before, I'd tried to make a home in a man, and now I was trying to make a home in a man who had already made a home in someone else.

The three days before I made it to the meeting dragged on as I struggled with what to say to him. Flirting no longer felt good, but not talking to him just plain hurt. Around this time, a guy from a coffee shop asked me out. Carey and I were discussing it in our office when Peter walked in.

"Hey there. What's up?" he asked.

Carey answered, "Just talking about how Ginelle got asked out by a cutie!"

"Oh," Peter said quietly as his eyes dropped to the floor.

There was a thick, awkward silence, then I said, "Yeah, I said yes." I knew I was digging the knife in, but my situation with Peter was a mess, and I had to come up with a way out of it.

"Okay then, good luck," he said abruptly, then left.

"That was fucking weird," Carey said. "He likes you. That's trouble."

"You think so?" I pretended to play dumb.

"Ginelle," she said, with a face that said, *Really?* "He just acted like a total weirdo when he heard about you and another guy. There's no other explanation."

I didn't tell Carey I was planning to attend an SLAA meeting. She and I were close, but not that close. I'd told her about

AA, but admitting my feelings for Peter would have been just too embarrassing, too personal.

Sunday arrived, and I made it to my first young people's Sex and Love Addicts Anonymous meeting. It was run much like AA; we met in a church basement with a circle of chairs. Only eight people were there, and a couple people were cute, which, of course, I noticed immediately. They all seemed to be in their twenties and thirties, except for one woman who looked to be in her forties. As the meeting got started, the vibe was totally different than the Sex Addicts Anonymous meeting I had gone to three years prior. The room wasn't full of old men. Instead, it was a mix of people my age talking about chasing unavailable people, getting into messy relationships, and having sex when they shouldn't. Were these people in my head? Halfway through the meeting, I gathered the courage to raise my hand.

"Hi. I'm Ginelle. I'm new here, so I don't know how to identify yet. But I've gotten myself mixed up with a married man." I really didn't want to share. I didn't want to be too honest because I knew, based on the AA tenets, that after honesty they'd expect willingness for me to change my behavior. And that felt too hard. "Ugh, it's all such a mess. In a way, nothing has happened. But, emotionally, everything has happened for me. I adore him and just want to be with him. I'm not sure what to do."

Everyone nodded and thanked me when I finished sharing.

After the meeting, the woman who seemed a bit older than the others came up to me and said, "You know, they call 'the gift of no contact' what it is because it can be a gift." *No contact? That sounds extreme. How is that a gift?* "Would you consider cutting him out of your life while you figure things out?"

Cut him out? Like, entirely? I couldn't fathom it. "Well, our blog post is being published Monday, so I kinda can't." Peter and I worked in the same office but rarely had to collaborate like we

did that one-off time. I could get away with not talking to him at work again, but I couldn't fathom not posting a stupid blog post. I think I wanted to stay connected to him in some way.

"Trash the blog post. Your serenity is worth more."

What the fuck? I thought. *Is this woman batshit crazy?* "I can't," I said. It really felt impossible.

"Think about it, dear."

I thought about it, and I published the blog anyway. I told myself it was because it was a really good message, but in reality, I was having a hard time letting him go.

But I did also send Peter a final text before the blog post went live. What I was doing with Peter was causing me agony. I felt like a royal piece of shit for wanting to sleep with him, and at the same time, I knew that if I had the chance, I'd jump at it. At least this was a world away from when I was cheating on Diego and not feeling bad about it. I felt good that I was making the right decision for once.

I texted him. *Hi, Peter. I've developed feelings for you, and they're confusing to me. I can't be friends with you anymore. I can't talk at all.*

In my mind, he was going to respond by telling me he shared my feelings because obviously, he did, right? I expected him to share that he felt the same and that he was just hoping I would make the first move, that he'd been holding back because he didn't want to make a mistake and blow it with me. I imagined he'd be so devastated at the idea of losing me that he'd even offer to leave his wife.

Then his reply arrived.

Oh, okay. Well, I wish you the best.

Are you kidding me? Blood boiled to the tops of my ears. *That's it? That's all he has to say?* Two months of our back and forth, our obvious chemistry, the intimacy we'd built. All the

hours I'd spent daydreaming about him, cyberstalking him, crafting just the right replies to him! And he writes "okay"? What was this?

I was devastated. I felt cheap. I felt unimportant. I felt used. I wanted to cry. I wanted to slap him. I wanted to tell his wife about us. But I didn't do any of those things. Instead, I cried, got in my car, and drove to another SLAA meeting. After that day, I dodged him at work and avoided eye contact when we passed each other in the hall.

Getting emotionally involved with my married colleague hurt like hell, and the way it ended made me feel extremely bitter and sad. But it wasn't long before I realized what an extraordinary gift the whole mess had been. No, I hadn't had sex with him. I could have pushed for that, but I didn't. And I didn't hurt myself professionally—as far as I know, nobody at work ever knew about our connection that bordered on a full-blown affair. What I did do was commit to recovery from sex and love addiction, and in a way, I have Peter to thank for that.

●

From then on for the next few months, I attended SLAA meetings once a week. I was already going to AA a handful of times a week, and it was difficult to juggle both, but I did. And as clear as I was about needing to be there, I wish I could say that it was a straight, clean shot to recovery from being addicted to unhealthy connections, meaningless sex, and the need for validation that came from the outside.

I sat in my one SLAA meeting, listening to people talk about how the program had led them to make up rules for themselves, and I could hear myself silently judging them. Weren't some of their rules for themselves just a bit extreme? No sex outside of a

committed relationship? Waiting to kiss someone until the third date? No masturbation? Come on.

The truth of the matter was that SLAA didn't tell us what to do. I could choose what not to do. I could look at behaviors that were harming me and choose to stop doing them. Behaviors that harm us and we want to stay away from are called *bottom lines*. They could be anything, ranging from masturbation to sleeping with someone outside of a committed relationship. I didn't understand that I could choose the behaviors I could stay away from. I thought SLAA members were trying to force their beliefs on me by telling me what to do. They weren't.

I chose only one "bottom line." It was not to get involved with married men because people had told me I shouldn't, and I knew inherently that it was wrong. That was all I could muster at the time. I wasn't ready to stop having sex with strangers or to stop pursuing unavailable people like others were doing.

I lasted two months in SLAA—about seven meetings. Then I just stopped going.

CHAPTER (30)

After two months of SLAA, I went on a dating and sex rampage that felt like eating an entire tub of Ben and Jerry's ice cream after restricting myself for months. It was thrilling and satisfying and also kind of a mess. There was a guy whose name I don't remember that I met on Tinder. He had a massive lumberjack beard that grossed me out. I had sex with him on our first and only date even though I didn't want to and wanted to throw up while it was happening. There was Tim, who told me he had herpes. I fooled around with him without a condom. There was Angela, who I adored, but she wasn't interested in a serious relationship. Then there was James, the man I'd been with for two weeks who I thought I'd die without, the one I thought I'd make fall in love with me by going down on him. He saw right through me and didn't want anything to do with the mess I was. I was unhinged, and he knew it.

The night James ended things with me, I sat across from my meditation instructor at a coffee shop, and she said, "Why don't you take a break from dating?"

HA! A wave of nausea took over. "I . . . I don't know how," I stammered. I'd sort of taken a break from dating while I was first involved in AA, but I spent that whole time flirting, obsessing, and even sleeping with that random dude from the train. I looked up from my tea and saw her head tilted in a kind way, a gentle look in her eyes. "I know it's a good idea, and I want to be a strong, independent woman, but I'm terrified."

"Have you considered going back to SLAA?" she advised with a loving voice, likely knowing that was the last thing I wanted to hear.

The idea felt like a punch to the gut. *Ugh. Please, no. They'll make me stop dating. And then I'll die.* "I know, you're right. I probably should. But I don't want to." I was terrified of stopping my behavior. Who would I be if I wasn't in constant pursuit of a lover? Who would I be without a lover? It was unfathomable.

But I knew I didn't have anywhere else to turn. Either I got back into the program, or I'd be looking at a lifetime of chaos and pain. It was just after 6:00 p.m., and I knew of a 7:00 p.m. SLAA meeting nearby.

"What if I went to the meeting tonight?" I said. "I've been before. I'd probably even know people there."

"I think that's a great idea," she said, nodding. "We can hang out for a few more minutes, and then you can head over?"

"Okay." I swallowed hard, my whole body trembling. What was I getting myself into? How in God's name was I going to survive all this change, all this structure, all these rules?

"Give it a chance. Ready to go?"

I nodded but closed my eyes for a second and pictured the parlor of the church where the meetings were held. I could smell the mustiness. I could see the worn-out couches and fold-out chairs lined up on the ratty old carpet. The place was crammed with people, the air a loud buzz of voices chattering about recovery and life without any of the vices they'd sworn to give up.

"Okay, I'm ready," I said as I drank the last bit of my tea and put my cup away.

Was I, though?

CHAPTER Ⓐ

ight months after turning my back on SLAA in favor of
diving back into the arms of a bunch of strange men and
a few women, I walked with my head down into a church
just outside of Boston. When I looked up, I saw about forty peo-
ple there, mostly men. *Oh great, probably another bunch of creeps.*
I looked around and realized I recognized several folks there, a
woman whose sobriety I had admired when I was in before and
an old guy who was one of the few who didn't creep me out. I
nodded at them and took a seat. *I can't believe I'm back here*, I
thought. *Do I really need to put myself through this? Ugh.*

The meeting began and proceeded as they always do, with
the Serenity Prayer and the requirement for being there (a desire
to stop living out a pattern of sex and love addiction). During the
meeting, I faded in and out of focus. I thought about my most
recent two-week fling, how he didn't want to see me anymore.
My heart ached about it, and I wanted to cry. And by the end
of the meeting, I did cry. When it came time for newcomers to
introduce themselves, I raised my hand, tears already streaming
down my cheeks before I could get the words out.

"I'm Ginelle, and I'm a sex and love addict. I'm just coming
back." I breathed heavily, grasping my skirt.

People said in unison, "Welcome back," and I wiped my face
with my sleeve, smearing black mascara all over my pink sweater.
After the meeting, the one girl I knew came up to me and gave
me a big hug.

"Hey, we've missed you."

"Oh, yeah. I got myself into some trouble. I think I need to be here." She gave me another hug, and I worried that I was mucking up her sweatshirt with my running makeup. She didn't seem concerned, as she held me for a long time.

Two other women came up to me to offer hugs and their phone numbers. I still felt scared that I was going to be told to stop dating, but I hung in there anyway.

The next day, I called Jessie, one of the huggy women. I knew her from my previous stint in SLAA and she seemed to be in a healthy relationship, showed up to meetings, and had answered my calls before.

"Hi, Jessie, it's Ginelle."

"I know. Hi, Ginelle! How are you doing after yesterday's meeting?"

"I'm struggling, but I was hoping to talk to you about something."

"Sure, anything. What's up?"

"I was wondering if you'd be my sponsor. I'm finally ready to stop my shitty behavior and actually do the program."

"Of course. I'd love to be your sponsor, but we have to set some ground rules. If you're going to work with me, you have to take a break from dating and sex."

I told her, "I've taken breaks from sex and dating in the past because my AA sponsor suggested it while I did the steps, but I guess they weren't true breaks. I was intriguing"—which in SLAA means any interaction that can lead to acting out—"and feeding my obsession. Plus, I had sex with a stranger I met on the T."

"I see. I get it. I tried to take breaks in the past, too. But they weren't true SLAA breaks. This time I want you to make it a time of self-healing and growth."

A real break meant not flirting with people, not telling them I'd get to them later (also known as rain checks), and not acting out in any of my bottom-line behavior. A true SLAA break meant committing to just being alone and feeling my feelings. Terrifying for a sex and love addict.

I took Jessie's advice and deleted all my dating apps. I deleted the numbers of anyone I might booty call, and whenever someone contacted me trying to date or hook up, I blocked their number. Committing to sobriety in SLAA was one of the hardest things I'd ever done, much harder than getting sober from alcohol and drugs. I think this was my core addiction, one that preceded drugs and alcohol all the way back to when I was webcamming as a child. It wasn't as simple as just not drinking, there was a bunch of behavior, a lifestyle I had to change.

I was attending two meetings a week, occasionally seeing my sponsor at one of the meetings. A few weeks into my commitment to SLAA, I called her and sobbed, "I don't know what to do. Not dating is making me feel like I'm going to die. I know it sounds dramatic, but it feels like a hole is going to rip through my chest."

Jessie's voice stayed low and calm, not elevating to meet my drama even one bit.

"Ginelle, all you have to do is not date one day at a time. Do you think you can get through the rest of this day without texting anyone, flirting, or downloading a dating app?" she said. Just like Elena had said to not drink one day at a time, SLAA taught the same concept, just get through one day at a time.

"I guess. I can try. But I really want to download a dating app."

"Just try to make it through one day without downloading an app. Just give it a try."

"What's the point of all this?" I knew the point. I knew it was to get healthy. It just felt so hard living without the gratification and attention I was used to.

"The point is that you heal and discover yourself so that you can be a whole person. Then, eventually, you can bring that whole person into a new relationship. But, for now, it's time to heal your wounds." Ugh, I knew she was *so* right, but it was *so* hard!

Withdrawing from my addiction was a shock to my system. It was as though all my feelings were attacking me at once. I'd gone from back-to-back dating and as much casual sex as I wanted to being completely alone with a quiet phone. I wasn't even flirting with anyone. This was unheard of—night after night spent not texting, sexting, flirting, opening the doors for the next encounter. The nights often felt blank, empty.

It was horrible. But there were also moments of beautiful healing. I did have meaningful friendships that helped me feel less alone. I reached out to friends on the phone and hung out with them, and slowly but surely began to feel that maybe, just maybe I could do this!

I stuck with it. And more and more as I freed space in my head, I became present with friends and family. When I was out with friends, I wasn't constantly checking my phone or leaving early to be with my flavor of the week. I began to pursue more interests and activities that I desired for myself, such as writing, playing recreational floor hockey, doing yoga, and trying new things like Krav Maga classes. I was no longer the product or the object of who I was dating. And I continued to make peace with my past—acknowledging that although I had done terrible things, *I* was not those terrible things.

After about a month in SLAA, attending twice a week, I began to create bottom lines with my sponsor, behaviors I needed

to avoid doing because they caused me harm. I'd rebelled against setting bottom lines in the past because I didn't want my behavior restricted. To create such rules felt to me like a punishment. But this time around, I understood that the restrictions were meant to keep me safe. Some of the bottom lines I chose were:

No sleeping with anyone outside of a committed relationship
No chasing emotionally unavailable people
No unprotected sex
No dating at all until I finished the steps

The behaviors I'd listed were my usual suspects. They were the ones that had always gotten me into trouble. Unless I stayed away from them, I wouldn't be sober according to SLAA. And dammit, I was going to get sober if it killed me.

While I was getting used to the routines and requirements of SLAA, I became a sponsor in AA. My twelve-step mentors had done so much for me that I wanted to give back to the program. I had completed the AA steps, and I wanted to light a path for a woman who needed it, as so many extraordinary women had done for me.

I was now five years sober. I was speaking at meetings, sponsoring, and doing service like leading meetings or being the treasurer of a meeting. It was interesting to me that my sponsees and some of my fellows admired me in AA, and I felt high levels of self-esteem in that program, but I just couldn't measure up in my efforts to develop a healthy sex and love life. This felt like a weird contradiction; I was crushing the twelve-step thing on the booze side, so why couldn't I make the same kind of progress on the sex and love side?

Because recovery is a layered onion.

The current layer I was uncovering was my ability to listen to what was right and wrong for me. I'd always had good sense in me, as in, I knew what a good or bad move was, but before

SLAA, I didn't have the strength, didn't have the tools to choose in my best interest. Although I'd honed this sense in much of my life, it seemed to be broken with lovers. My picker was off. I was choosing those who weren't best for me, hadn't listened to my gut. This was starting to change.

Three months into SLAA, during a break from listening to my AA sponsee read her fifth step to me, I got a Facebook message from Peter, the married man. I felt that familiar flutter in my chest. I went to his Facebook profile, and a few quick clicks told me that he and his wife were no longer together. For a moment I considered messaging back because maybe he'd changed. Right? I opened our message and stared at it. Then I closed the app. And opened it again. Finally, I reminded myself how he'd behaved with me even though he had a wife; he'd certainly do the same to me if we were ever together.

I pressed the "block" button and didn't respond. Wow. Relief washed over me, and I let out a big sigh. I was choosing myself for once. My intuition, strength, conviction, and adherence to boundaries were getting stronger. I was learning not only that I needed this period of no sex or love shenanigans, but that by God, I deserved better. I deserved to date someone who could show up for me. And this person deserved a whole me, so I was working on becoming whole.

●

For six months, I stayed single. Truly single. No flirting or obsessing or intriguing with people. And a real turning point in my recovery happened when I realized that my predicament wasn't situational, which is to say that I'd had these problems for a long time. I began to recognize the *pattern* of problematic sex and love situations that had held control of my life for as long as I could

remember. Now I no longer allowed myself to think of or refer to a bad date, bad weekend, or bad relationship. Now I had recognized the pattern and was calling it by name.

Walking through the steps with my SLAA sponsor meant looking back on my life so far. That was rough, and I would have loved to have skipped it, but I'd made a deal with myself to get to the other side. That meant looking honestly at the choices I'd made along the way.

There was Anthony, who beat the crap out of me. He physically and emotionally abused me, and still I stayed. I thought possessiveness was love and care. I now know that this is far from the truth. In SLAA, we say that love is a thoughtful choice rather than a feeling in which we are overwhelmed. I now know that love is not that fiery passion; rather it's safe and warm.

There was Peter, who was physically and emotionally unavailable because, well, he was married. I chased after a completely unavailable person. Now I knew I deserved someone who was whole because I was working to become whole myself.

There was Penny, who I couldn't show up for because I feared my own queerness, and her overwhelming love scared the crap out of me. I left her hanging for a while, and that was far from cool. Now I knew I could be with anyone, regardless of gender, because my queer identity *is* valid, and I can accept people's love.

There was Diego, who I couldn't seem to connect with in a meaningful way. I cheated on him and felt resentful of him for most of the relationship. Now I knew I didn't have to stay in a relationship that wasn't working. I could show both parties dignity and respect by leaving when I felt it wasn't working.

Despite how bad all of those relationships were for me, I chose to give a lot of myself to those flawed people. But I also brought all my flaws to their tables. I wasn't consistent or

trustworthy or emotionally available for Anthony, Penny, Diego, or probably for anyone I dated.

This was my life. I was a sex and love addict.

Working through the program made me open my eyes to how I'd tried to make homes in other people. I saw people as foundations and tried to build on that but was using some of the worst materials available. I was going forward without building permits, not following any safety regulations, and not even worrying about who else might already live there. Back in those days, I didn't yet know where the best home for me was, but at least now I knew where it wasn't.

It was six glorious months into my self-assigned singlehood when I sat on the beach at the edge of Thoreau's beloved Walden Pond. I'd never been there before, but I chose it because multiple people had told me it was a beautiful and serene place to be. It was about a forty-five-minute drive from where I was living, and on a warm, sunny afternoon, I set out to spend some quality time with myself.

Wearing a red polka-dot bikini and stretched out on a beach towel, I scribbled in my notepad and soaked up the soothing August sun. I was working through Julia Cameron's *The Artist's Way: A Spiritual Path to Higher Creativity*. In her book, Cameron presented a program to encourage creativity and build self-esteem. I progressed through the workbook at the same time I was working the steps of SLAA, so every day my head was full, and every night I fell asleep with a satisfied thump. Each day I would write my "morning pages," whose purpose was to get everything out of my head and onto the page, all my thoughts about my relationship with myself and a Higher Power, and my connection to my creativity. It felt like emptying the contents of my mind onto paper. As instructed, I let go, suspended judgment, and just wrote everything I was thinking.

When I was on week four of *The Artist's Way*: "Recovering a Sense of Connection," I realized that for once, I was learning to reconnect with myself. Much as I imagine Thoreau must have been—thriving in nature's solitude, free from distraction—I was focused, thinking, breathing, dreaming. Feeling utterly connected to myself and to the greater universe. Sitting near Thoreau's own writing spot, I thought I might even be able to become a writer. I certainly had stories to tell. Maybe I could write something important and lasting, as he did.

Shutting the notebook, I rolled onto my back to enjoy the summer heat, and it occurred to me that I was there alone. I'd never really spent any quality time alone before this round of SLAA. Even when I'd been "alone" in AA, I was always pining for someone, always reaching in the wrong directions.

But here I was, taking myself on an artist's date. Just me for the day. According to Cameron's program, I'd been assigned to spend two hours alone in a place where I felt creative, and right away I knew I wanted to go where Henry David Thoreau had written *Walden*, where he'd spent that extraordinary two years and two months all on his own, living "deliberately." Sitting there, digging my toes in the sand, I thought with great comfort, *He was a weirdo loner, too. Maybe I can do this.*

I thought back to the Serenity Prayer that Nana had taught me so long ago and that was now such a regular part of my life. I'd now found some of that serenity in my acceptance that I was an addict to my core. That no matter how healed I'd become, I might always feel a tug to do something toxic and have the desire to reach for a locked door, might even try to start a fire within a healthy partnership in the future. That addicted person will always be part of me, but she has a strong support system now and a whole lot of powerful tools.

I recognize my courage when I catch myself obsessing about a stranger on the bus or feeling an urge to reach out to exes but use my bravery to choose a different path. And I revel in how much I've learned. Instead of trying to make a home in someone else, I can choose to build my own home from materials that will last. The floor will be constructed with my self-respect, self-acceptance, and self-love. The walls, from the support of friends, twelve-step fellows, mentors, therapists, and sponsors. The roof, from my self-forgiveness, knowing that while I needed to do much better than I was doing, at the time I was always doing the best I could. The fireplace will burn with my determination to never again accept the unacceptable, not from myself or from anyone else. And from now on, I'll be honest with myself about whether a door I'm about to open is a healthy one or one that should remain forever closed. It's with a contented sigh that I realize I now have the wisdom to know the difference.

ACKNOWLEDGMENTS

This book was a kernel of an idea in 2016. I thought I had stories to tell, so I began jotting them down. The process took about seven years from idea to finished product, and boy, was it a journey! I feel like I pulled out a chunk of my heart to get this thing written, and there was an abundance of people during that time who helped me stay sane, motivated, and hopeful.

I have countless people to thank for this book coming together—from friends to editors, beta readers to family, my publisher to blurbers, Instagram pals to NaNoWriMo buddies, everyone who voiced their encouragement to those who quietly supported me through the madness of writing this book.

I have to start by thanking my amazing, patient, and talented editor, Jodi Fodor, who worked with me steadily for a whole year to get my book to its final, beautiful stage. I so appreciated your candor and ability to help get onto paper exactly what I wanted and didn't even know I needed to say. I truly don't believe my book would have come together in such a lovely way without you.

Thank you, She Writes Press, and specifically Brooke, for believing in my memoir. I struggled with rejection from agent after agent until I submitted it to SWP, and you saw the vision and invested in me. Without you, *Make a Home Out of You: A Memoir* may not have gotten into the world, and for that I am eternally grateful.

Thank you to my beta readers—some who worked with me for literally years, like Morgan, and some who were my biggest cheerleaders, such as Justin. I so appreciate your patience, support, and compassionately critical eye as you worked with me through draft after sometimes crappy draft.

To my early blurbers, thank you for seeing the heart behind my words, for your willingness to be cheerleaders, and for sharing your amazing thoughts about the book. Especially to August and Shary, both of whom I have admired for years; I feel so lucky that you were willing to read my book.

Thanks to my NaNoWriMo buddies (like Chuck), who wrote with me toward an insane goal year after year and cheered me on through the process. Thanks to NaNoWriMo itself, for being a jumping-off point to getting this whole thing started.

I want to thank my early developmental editor, Lynne, for helping me believe that this book was worth investing time, energy, and money into and that my early words had the potential to be really beautiful. Thanks for your compassionate feedback and encouragement.

I'm grateful for everyone who cheered me on along the way. My friends asked over and over again how the manuscript was going. My dad, despite knowing there would be some messy points in my book, supported my writing it and always asked me how the process was going.

To my Instagram buddies—those many who read parts of the book, and even those who didn't—who cheered me on all the time, telling me how excited they were for the release: every message, comment, text, and call made a difference and kept me on track toward success.

I want to thank twelve-step programs, like AA and SLAA, for being the absolute best resources for healing. Although upon

publication of this book, I no longer attend, they did so much for me. They helped me discover that I am lovable, worthy, and capable of healing, and that I belong in this world. I know I wouldn't be where I am without them.

I want to pull a Snoop Dogg now, and say I want to thank *me*! From the start, I believed that one day this book would get published. No matter how often I lost faith or got frustrated, I always found that hope again and pushed through. If it weren't for my dedication, it would have stayed an idea in the back of my mind.

But it didn't. It was published. Thanks to me and to all of you. I am so grateful.

ABOUT THE AUTHOR

photo credit: Kaylee Nocturne

Ginelle Testa (she/they) is a writer originally from Hudson, NH. She has an MS in digital marketing and design from Brandeis University and a BA in sociology from Rivier University, and has been featured in *Insider*, *Byrdie*, *Tiny Buddha*, and other places. She's a queer person in recovery. When she isn't writing, she enjoys doing restorative yoga, playing video games, and thrifting eclectic clothes. Ginelle lives in Boston, Massachusetts.

Looking for your next great read?

We can help!

Visit www.shewritespress.com/next-read
or scan the QR code below for a list
of our recommended titles.

She Writes Press is an award-winning
independent publishing company founded to
serve women writers everywhere.